WORLD PRESS PHOTO 10

Thames & Hudson

Francesco Claudio Cipolletta

*Pietro Masturzo was born in 1980
in Naples. After receiving a master's
degree in international relations in
Naples, he moved to Rome to study
photography. He has been working
as a professional photographer
since 2007, collaborating with
different photojournalism agencies
and publishing his pictures in
leading Italian newspapers. Since
2009, he has been a member of
Kairos Factory, an Italian collective
of documentary photographers.*

How did you become interested in photography?
I've had a passion for photography since I was very young,
but it didn't really come to anything until my last years at
university, when I thought for the first time of becoming
a professional photographer. I was studying international
relations at the time, but in a sense it was not such a big
change. To me, becoming a photographer was doing the
same thing as a career in international relations — it's just
that photography did the job better. I communicate better
with pictures than with words. So I completed my degree,
but then went to Rome to study photography.

What motivates you as a photojournalist?
I'm very interested in the dynamics of war, in what is going
on in conflicts around the world. I suppose my studies
have a lot to do with that, but for me it is a question of
involvement. That doesn't necessarily mean that I think
photography can change things, but it is important in
letting people know things. That said, I am not trying to
give answers, but to ask questions.

What first took you to Iran?
I had been interested in the political situation in Iran and
the Islamic revolution for a while, and thought it was time
to go there and see things first hand. The 2009 elections
seemed the perfect time. I knew even before I left that it
would not be easy to take pictures, especially of religious
or political subjects. I entered the country on a tourist visa
because I thought that would be more low-profile, so
I didn't have official permission when they did catch me
taking photos. I was arrested after three days.

*Can you describe the circumstances around the winning
photo?*
When I was arrested, the police took everything. They gave
back my equipment, but had deleted all the pictures, so
I had to start from scratch and, of course, after I was
released it was even more difficult photographing in the
street. Also, people knew my story and were afraid to come
with me. The day after the elections, people were out on
the streets and protesting on Enghelab Square. It was all
happening out there. I didn't know how to work. But then
a few nights later I began to hear voices coming from the
rooftops. Someone explained to me what was going on —
that they were shouting 'Allah is great', something that

reminded people of the 1979 Islamic revolution, when
people did the same thing as part of their protest against
the Shah. So I thought I'd go up onto the roof to see what
was going on. I started to take pictures — and then I
realized that this was the way to tell the story of Iran. In the
end I did also go out into the streets, but when I under-
stood what was happening on the roofs at night I thought
that this was a more interesting way of tackling the subject.
I did not want to get the people in the picture into trouble
with the authorities, so I deliberately shot it in a way that
you cannot recognize them.

How do you think winning the prize will affect your future?
I had problems publishing the rooftop story. The day after
I returned, I was interviewed by Italian television, and they
bought a series of images, but it was July by then and too
late for many magazines. Editors said it was difficult to
publish because it was not the kind of photography they
wanted. It was not direct enough, it didn't show everything,
in the classic style. But I really believed in this work, and
now it is fantastic because suddenly things have changed,
and people are phoning and asking for photos. It is very
difficult for a young photojournalist to make a living at the
moment. There's a lot of competition out there, magazines
want very specific sorts of photos. You end up feeling
forced to work in a way agencies or newspapers want,
without thinking for yourself. Yet so many photographers
I know want to do this less classic sort of work, and so
many people I know who are not linked to photography
really like this kind of picture. So winning the prize gives
me hope to try again. Not just for myself, but for so many
other young photographers out there, too.

Women shout their dissent from a Tehran rooftop on 24 June, following Iran's disputed presidential election. The result of the 12 June ballot proclaimed an overwhelming victory for President Mahmoud Ahmadinejad over opposition candidate Mir Hossein Mousavi, but there were allegations of vote-rigging. In the weeks following the election, violent demonstrations took place in the streets. At night, people continued their protest from windows, balconies and rooftops. Their cries echoed similar nighttime protests, last heard during the 1979 Islamic Revolution, which led to the overthrow of the Shah.

People in the News > **Pietro Masturzo** > Italy > 1st Prize Stories

World Press Photo of the Year 2009 >

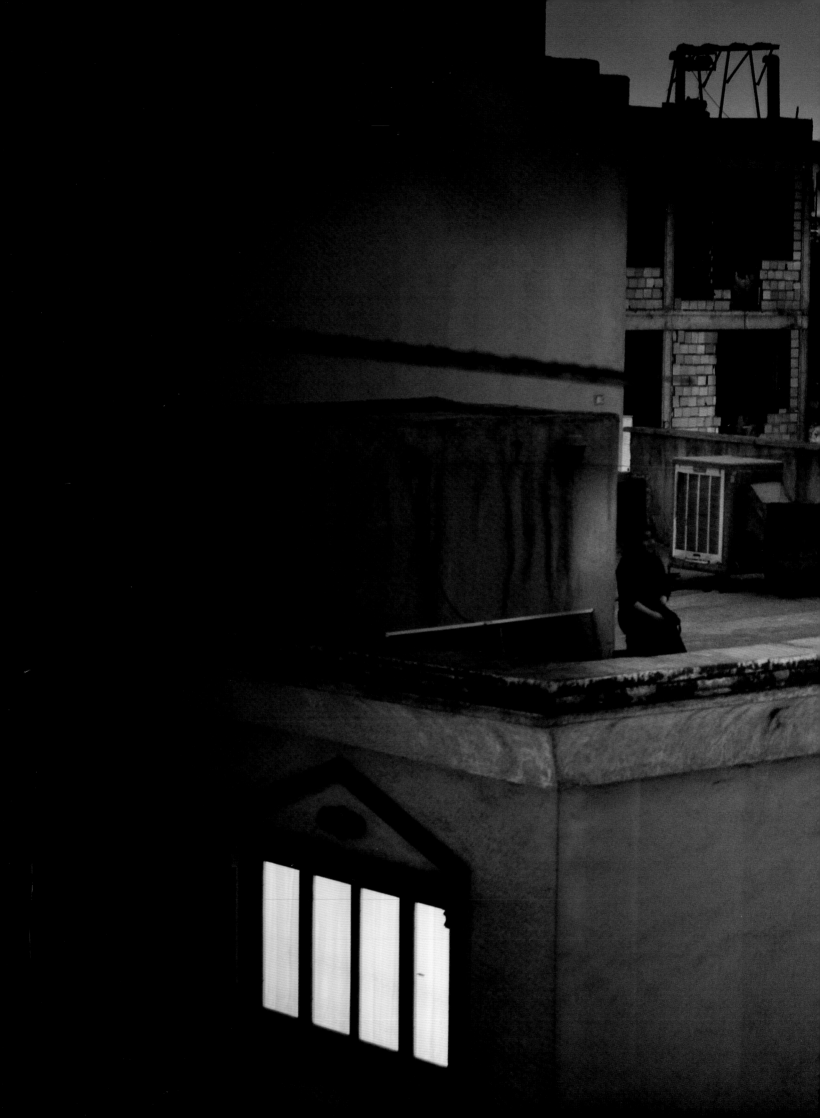

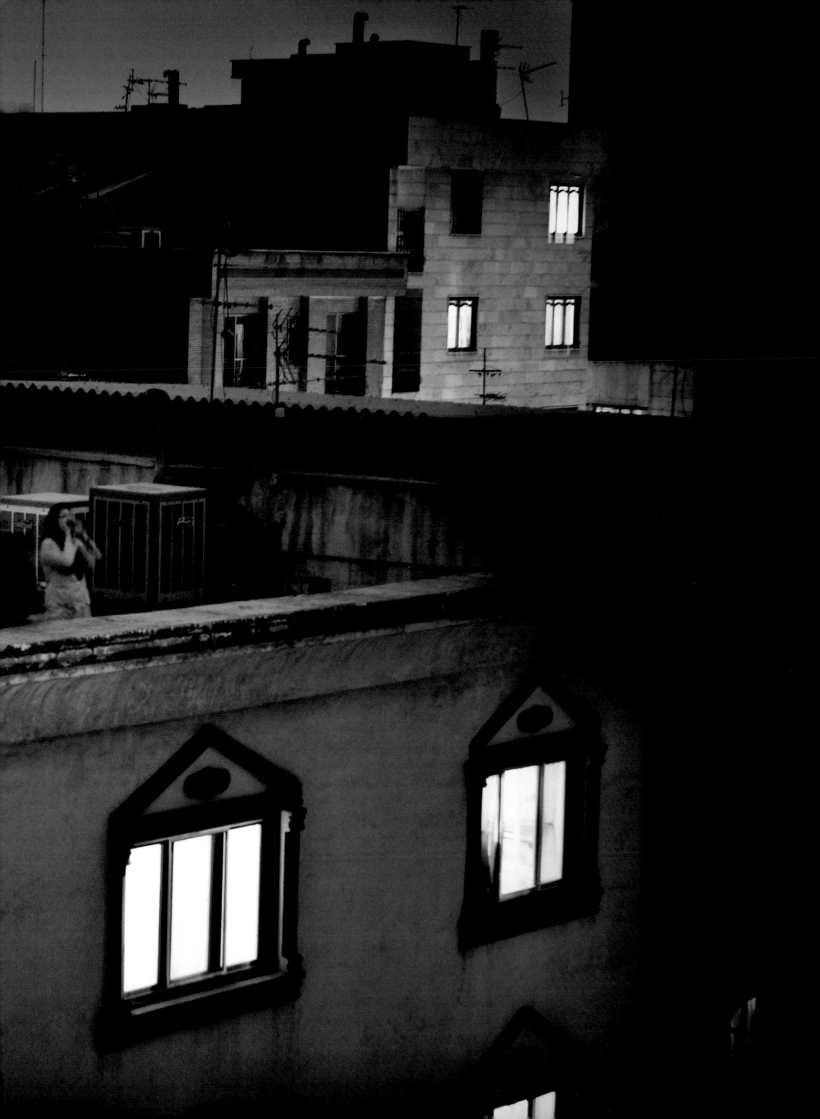

"How can we grant the premier award for a picture that is not immediately identifiable?"

This was one of the key questions discussed by the 2010 World Press Photo jury.

While some of us were drawn to the winning Pietro Masturzo image from the start, sensing that it enticed us to discover something more, others remained untouched by its lack of immediate context. Some stated that a photograph should be able to express 'everything' within one frame, while others thought that this 'everything' was an illusion. They said they did not want to be told what to think, they simply wanted the photograph to open doors creatively, to nurture reflection and spark emotion.

The World Press Photo of the Year, depicting women chanting at dusk on rooftops in Tehran, invites us to discover an important news story differently, calmly, while sensing strong tension. Its beauty adds value and access to information.

All jury members shared a stark feeling of how little of the world's sorrow we were actually able to absorb, faced with 101,960 competing images. It was as if the intensity of the drama had a paralyzing visual effect, because it was so often repeated.

Looking at the winning images elicits, in each case, a rich and complex array of reactions:

A desire to find more personal ways of communicating. The sense of a conflict evoked by a bombed living-room in Gaza; the emptiness surrounding the portrait of an anorexic young man; the systematic devouring of an elephant by hungry villagers; the devastating effects of war revealed through wounded soldiers photographed in suburban homes.

Reaction and response to the absurd violence of events. Every day this offers new challenges, forcing us to react afresh to conflicts in Iraq, Afghanistan and Gaza; opening our eyes to other tragedies not yet in our collective conscience, such as that in Madagascar.

Identification and questions around our own lives. Seeing how photography can magically transmit the emotions and aspirations of a single mother isolated in Detroit; of a comfortable Sunday picnic on a beach in Mozambique; of stunning nature and breathtaking sports.

There are many ways of relating to these images, but information is always the core element: Had you ever seen pictures documenting the takeover of Guinea Bissau by drug lords? Did you realize that an orange poisoned by pollution looks like the earth seen from space? What are these cone-shaped, white clouds over Gaza?

This competition is not about lining up awards for the profession in some sort of hierarchy. All the winning pictures, the news stories as well as the aspects of daily life and leisure, are part of a whole. Taken together, they make a statement about photojournalism and our age.

In a year where media budgets were violently cut, where many journalists lost their jobs and photo assignments have decreased drastically, the World Press Photo selection continues to offer a unique insight.

This selection is not an inventory of world events. It is a photographic journey, a visual puzzle celebrating the photographer's point of view, offering the very best in each category for you to reflect, question and enjoy.

Ayperi Karabuda Ecer
Vice President Pictures
Reuters

People in the News

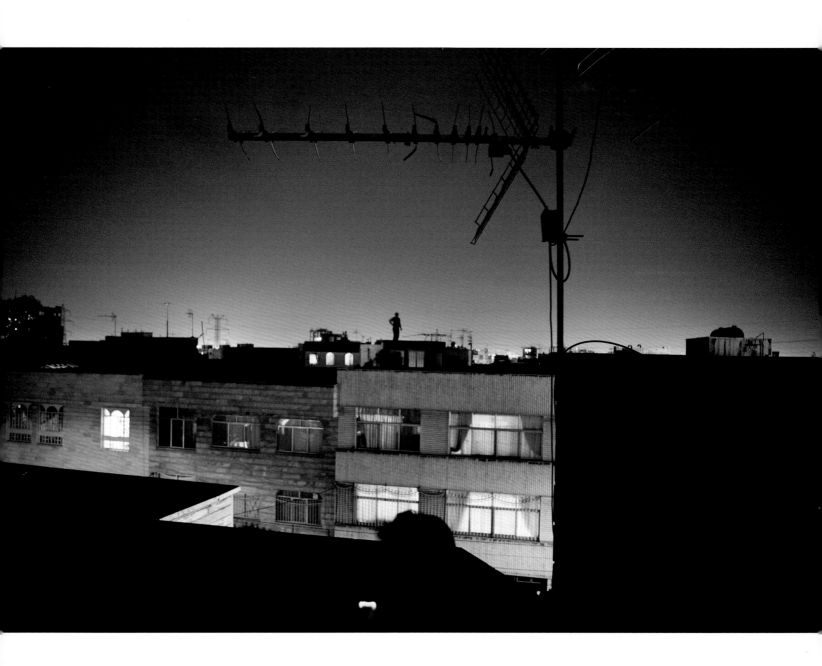

Following the disputed result of the Iranian presidential election, supporters of the losing candidate Mir Hossein Mousavi began to climb to their rooftops in the evenings and shout 'Allahu akbar' (God is great), to express their discontent. As the streets emptied and went quiet after daytime demonstrations, cries of 'Allahu akbar!' and 'Death to the dictator!' filled the night air. This page: A man stands on a Tehran roof, on 26 June. Facing page: A woman shouts from the roof, on 25 June.

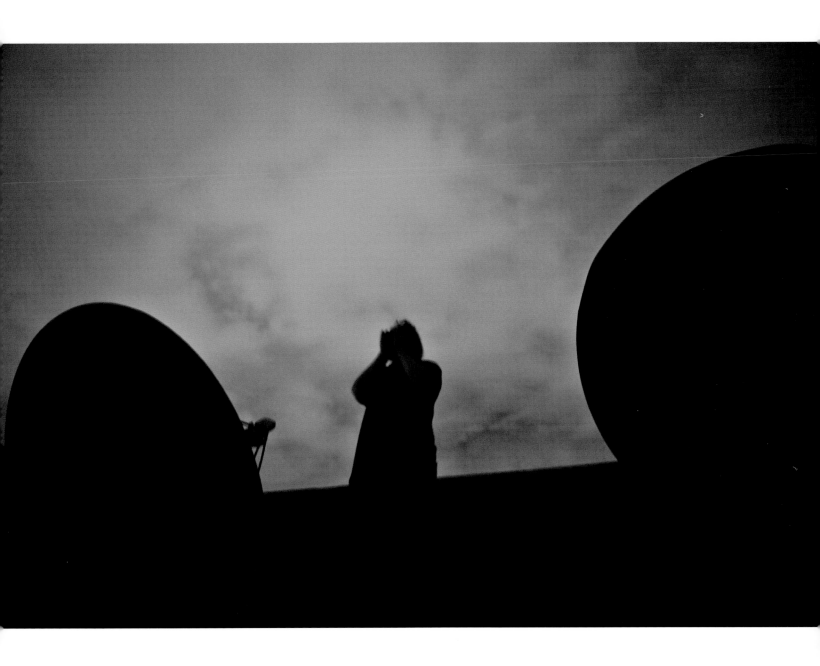

A man cradles a stone during a pro-separatist demonstration, following Friday prayers in downtown Srinagar, India-administered Kashmir, on 23 January. Kashmir, which is over 60 percent Muslim, has been disputed by India and Pakistan since the partition of the subcontinent in 1947. The neighbors have twice waged war over the territory, which is currently split between them. Since 1989, a growing Muslim separatist movement against Indian control has moved either for Kashmiri independence, or for Kashmir's incorporation within Pakistan. Pro-separatist rallies in India-administered Kashmir are common. On 23 January some 17 people were hurt in the clashes.

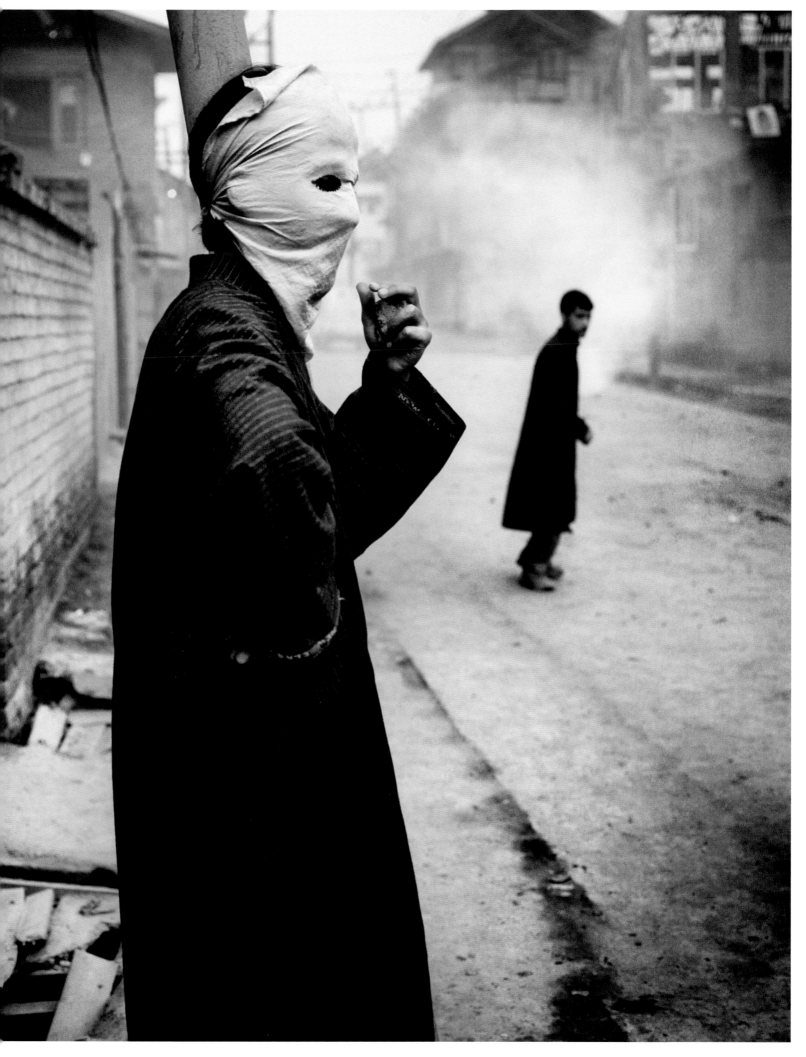

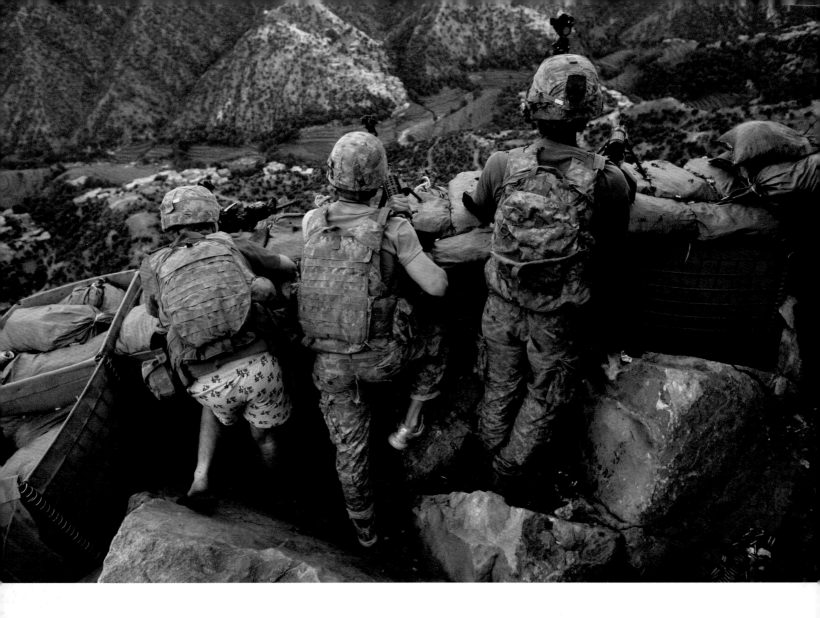

us soldiers take defensive positions after receiving fire from the Taliban, in Korengal Valley, Afghanistan, on 11 May. Specialist Zachery Boyd was wearing 'I Love NY' boxer shorts when he rushed from his bunker to support fellow platoon members. In February, President Barack Obama committed an additional 17,000 troops to Afghanistan; at the end of the year he issued orders to send another 30,000 reinforcements, an increase that would nearly triple the American military presence since he came to office.

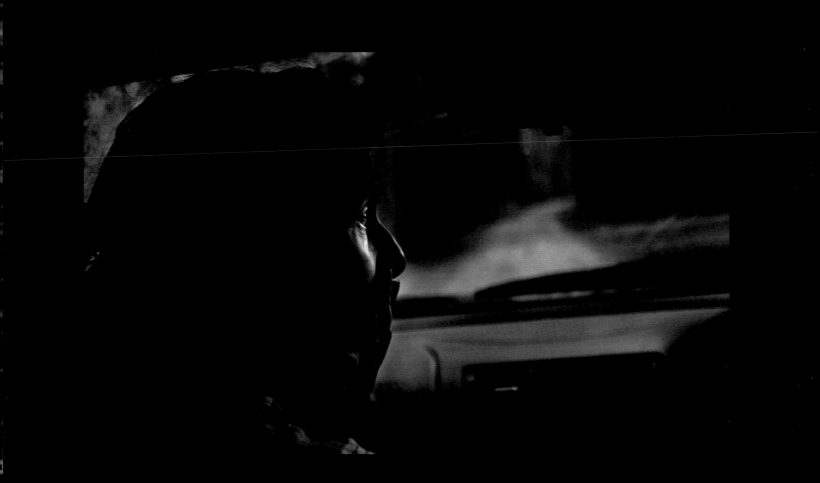

Jennifer Wood finds most of her street reduced to smoldering ruins, on returning to the town of Narbe-thong, northeast of Melbourne, Australia, on 8 February. Bushfires had raged in the area on 'Black Saturday', the day before. Jennifer had been visiting friends, and was unable to return home as roads were impassable. She had also not been able to contact her partner Mark and young child. Extreme temperatures, years of drought and strong winds had resulted in unprecedented fire conditions in the area north of Melbourne. By mid afternoon of 'Black Saturday', two huge fire fronts were burning out of control in what was to become Australia's worst ever natural disaster, claiming 173 lives, destroying over 2,000 homes and wiping out native fauna and farm stock. Jennifer's partner and son survived.

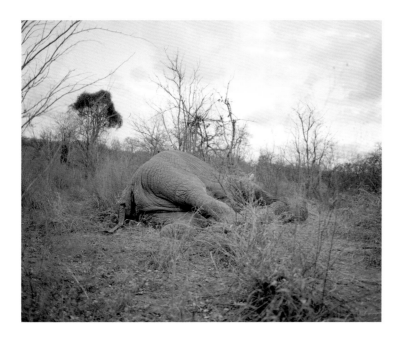
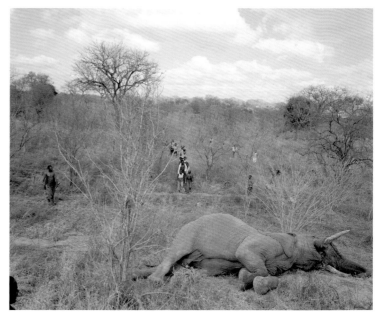
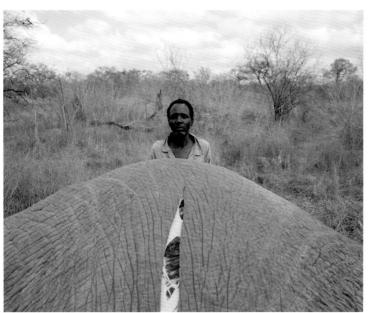
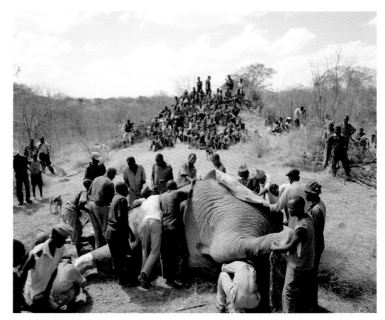

Villagers starved of protein reduce a fallen elephant to bones in just over two hours, in the Gonarezhou National Park, a remote part of Zimbabwe. A day later, even the bones are gone. The elephants are hunted as they pass into the park from Mozambique at night, in search of water. All other plains game in the area has already been killed and eaten. The villagers listen out for gunshots, and try to locate the carcass at dawn, hoping to find it before scavengers such as hyena and vulture arrive. They strip the carcass with their bare hands, or with knives fashioned from old tin. In Zimbabwe, years of hyper-inflation, acute shortages of basic supplies and a series of very poor harvests up to early 2009 had led to widespread hunger. The UN registered 47 percent of Zimbabwe's population as undernourished.

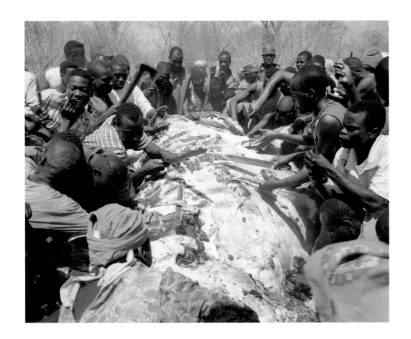
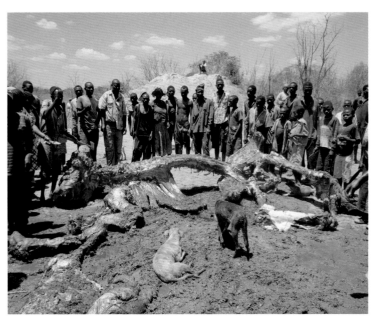
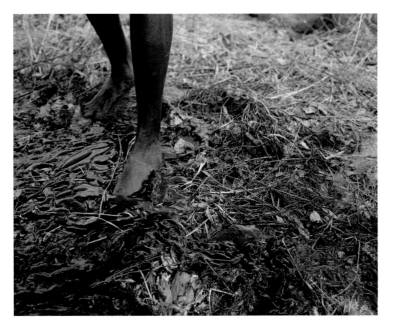
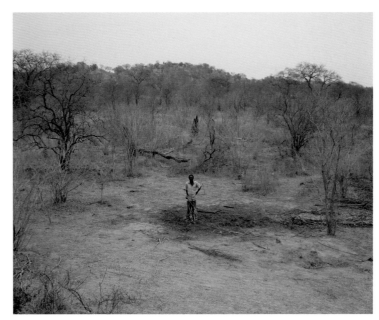

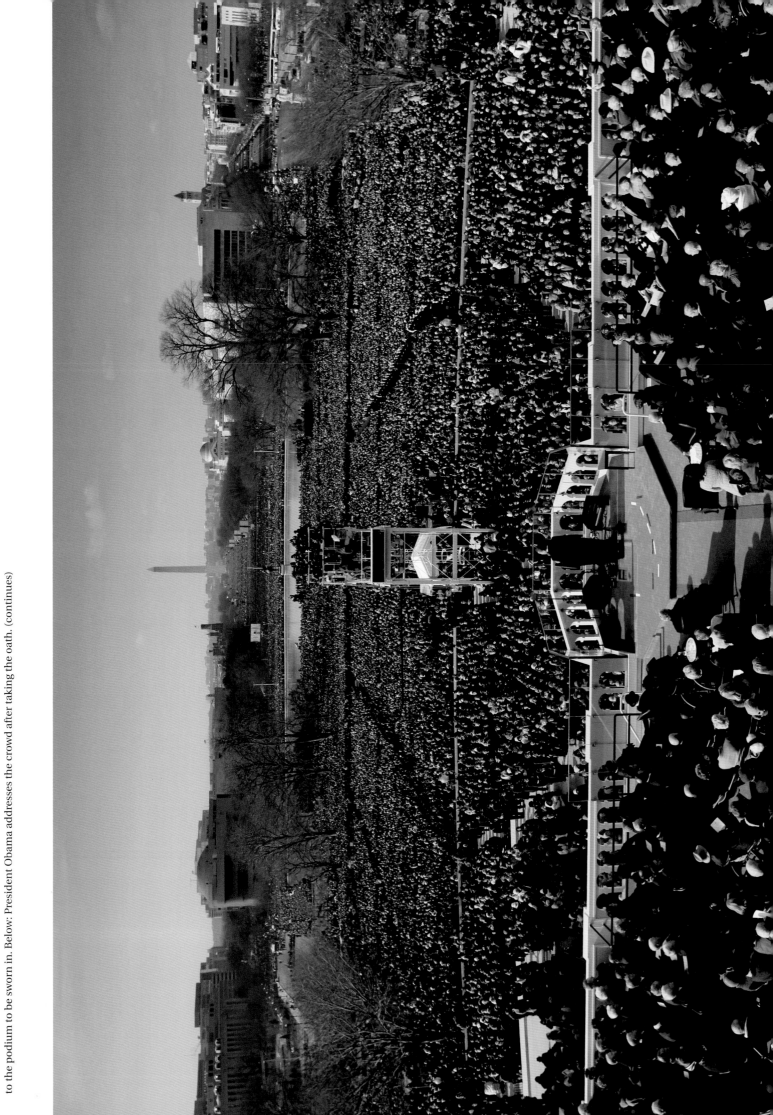

Barack Obama was sworn in as the 44th president of the United States, at the West Front of the Capitol in Washington, D.C., on 20 January. Obama was the first African-American in the country's history to hold the office. Above: Obama pauses for a moment before walking out to the podium to be sworn in. Below: President Obama addresses the crowd after taking the oath. (continues)

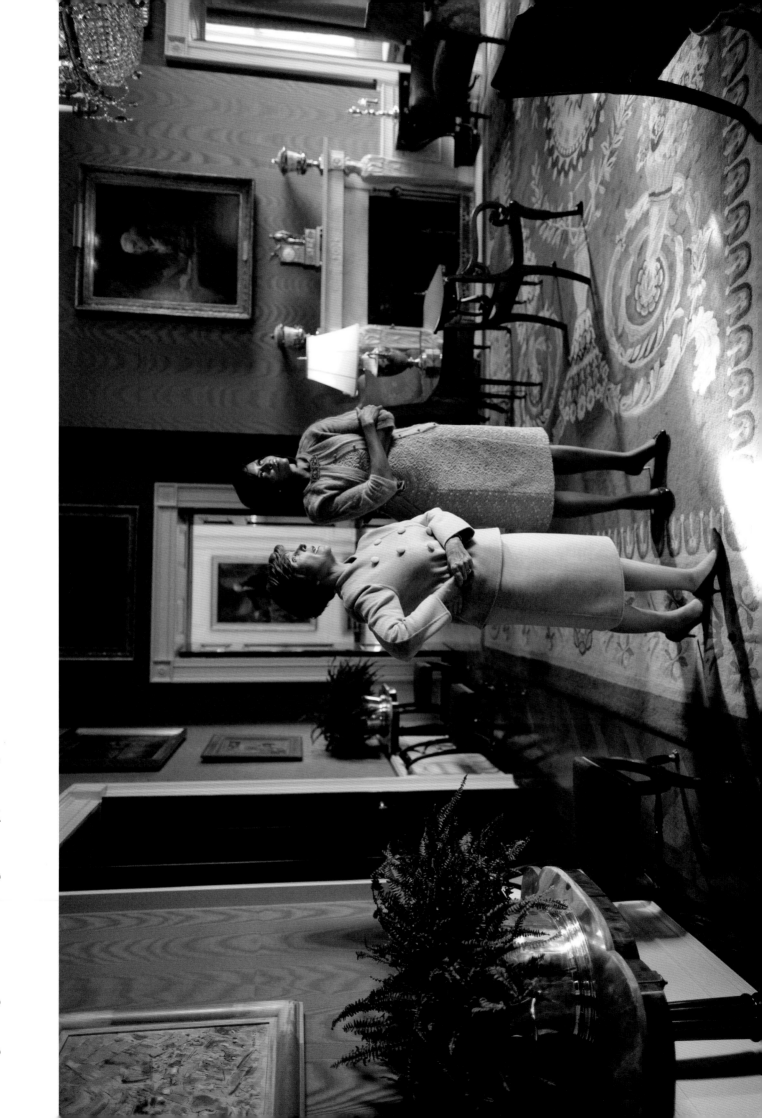

(continued) First Lady Laura Bush takes Michelle Obama for a private tour of the artwork in the East Wing of the White House, during a coffee morning with congressional leaders on Inauguration Day. (continues)

(continued) Former president George W. Bush waves to the new First Family, as he departs from the Capitol after President Barack Obama's inauguration.

Spot News

Lance Corporal Joshua Bernard is tended to by fellow US Marines, shortly after being struck by a rocket-propelled grenade during a Taliban ambush in the village of Dahaneh, in Helmand province, Afghanistan, on 14 August. He lost one of his legs in the attack and died later at a Marine compound during surgery. Controversy arose when Bernard's father objected to publication of the photo as dishonoring his son's memory. Those in support of publication countered that it was a scene rarely shown to the US public, and was an immediate and compelling visual record of the consequences of war.

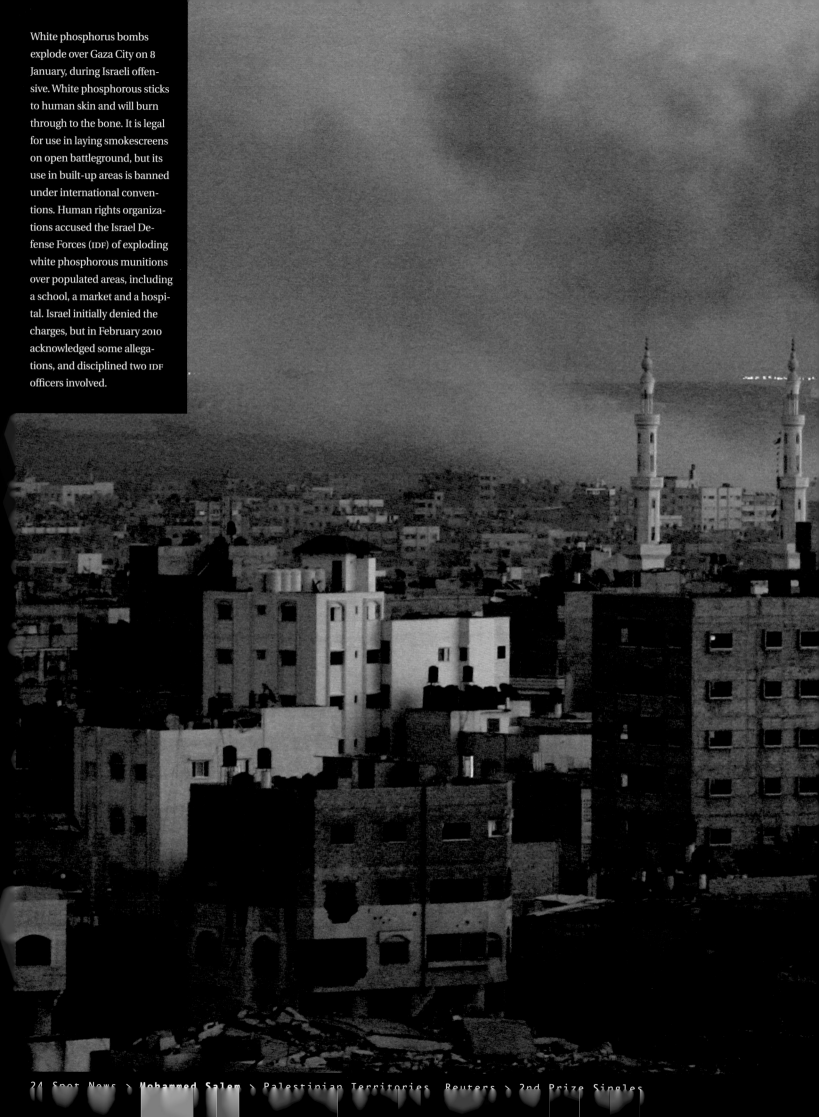

White phosphorus bombs explode over Gaza City on 8 January, during Israeli offensive. White phosphorous sticks to human skin and will burn through to the bone. It is legal for use in laying smokescreens on open battleground, but its use in built-up areas is banned under international conventions. Human rights organizations accused the Israel Defense Forces (IDF) of exploding white phosphorous munitions over populated areas, including a school, a market and a hospital. Israel initially denied the charges, but in February 2010 acknowledged some allegations, and disciplined two IDF officers involved.

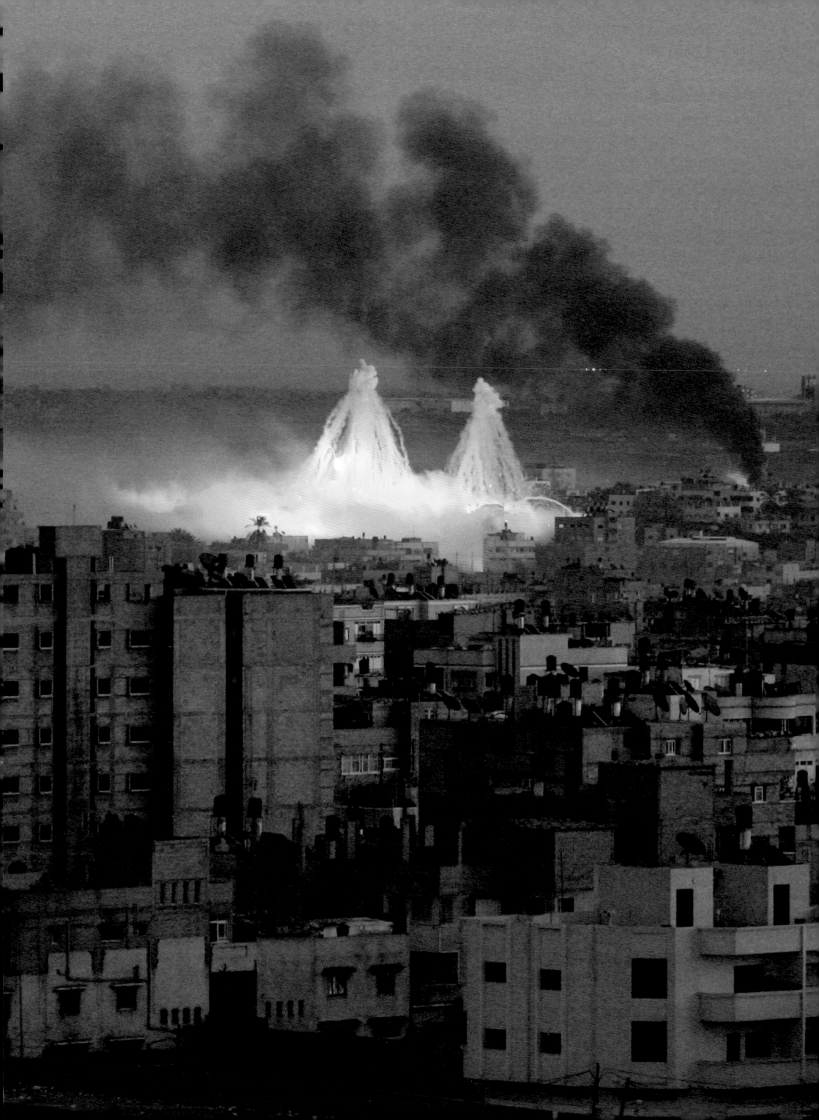

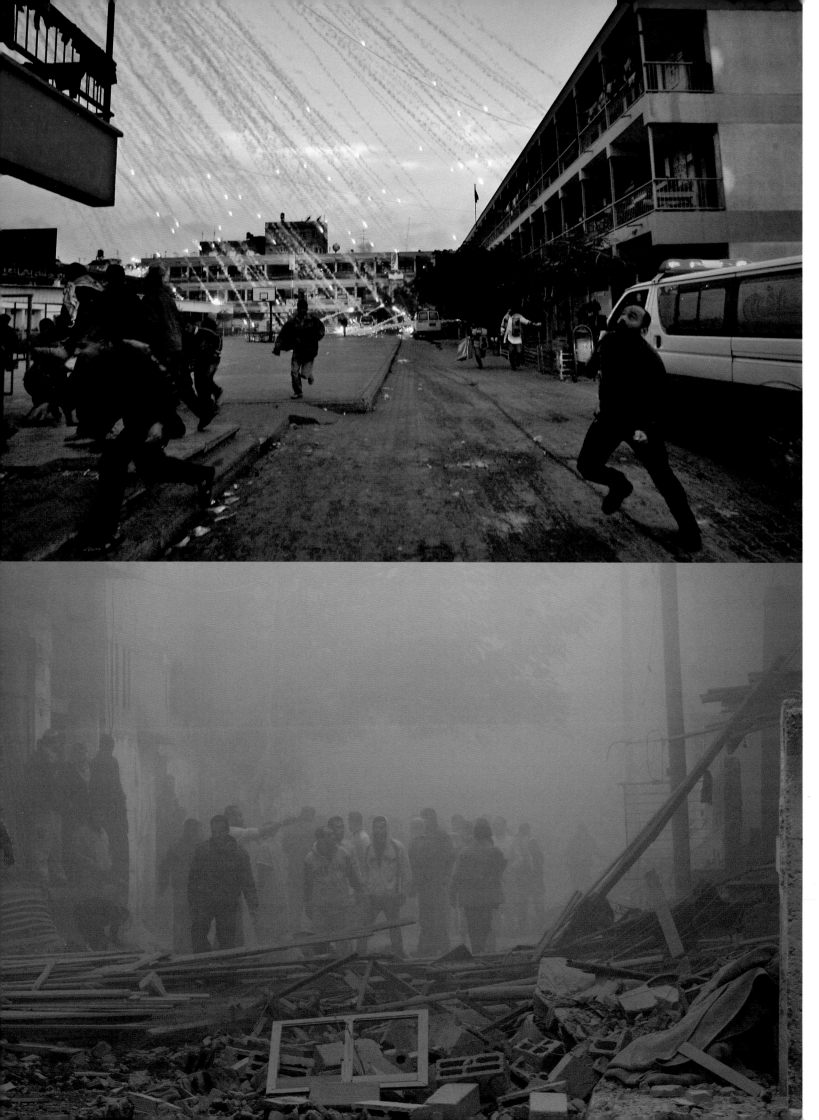

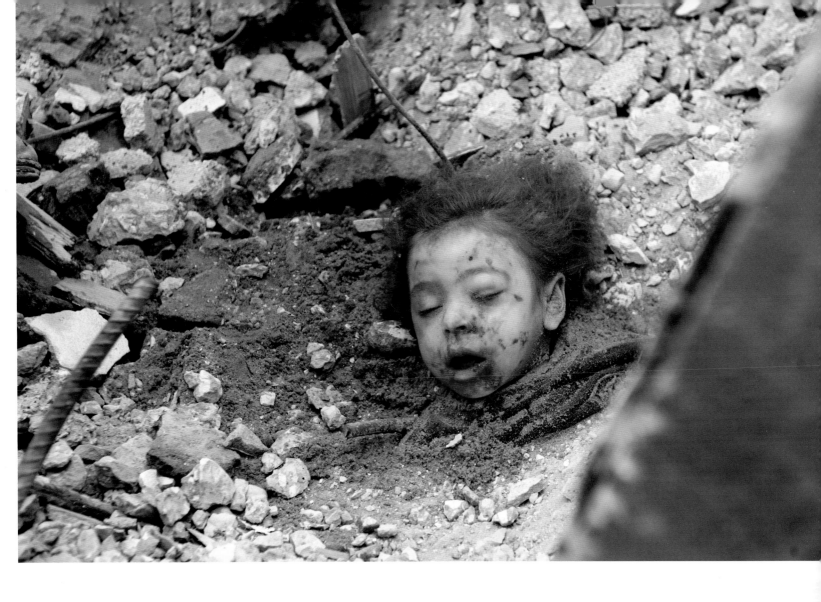

At the end of December 2008, Israel launched a series of air and missile attacks on Gaza, in retaliation for rockets fired into Israel by Hamas militants. Codenamed 'Operation Cast Lead', the offensive — which was later extended to land and naval assaults — was to last for three weeks. Palestinian sources said that 1,409 people had been killed, of which 916 were civilian; Israeli sources registered 1,166 dead, of which 295 were civilian and 162 'unknown'. Israeli fatalities numbered 13. This page: The body of a Palestinian girl is uncovered in the rubble of her home, a house belonging to a Hamas member in eastern Gaza City, after an air strike on 6 January. Facing page, top: Palestinian civilians and medics run to safety during an Israeli strike over a UN school in Beit Lahia, northern Gaza Strip, on 17 January. Below: People stand amidst thick smoke after an Israeli air strike, in the Jabaliya refugee camp, outside the city of Jabaliya, northern Gaza Strip, on 1 January.

A woman is rushed from the scene of a suicide car bombing in Kabul, Afghanistan, on 15 December. The bomb exploded near a hotel in the Wazir Akbar Khan neighborhood, home to many embassies and Western aid groups and one of the most heavily guarded areas of the city. At least eight people were killed and around 40 injured in the blast, which was the first significant attack in Kabul since Afghan president Hamid Karzai was sworn into office for a second term a few weeks previously.

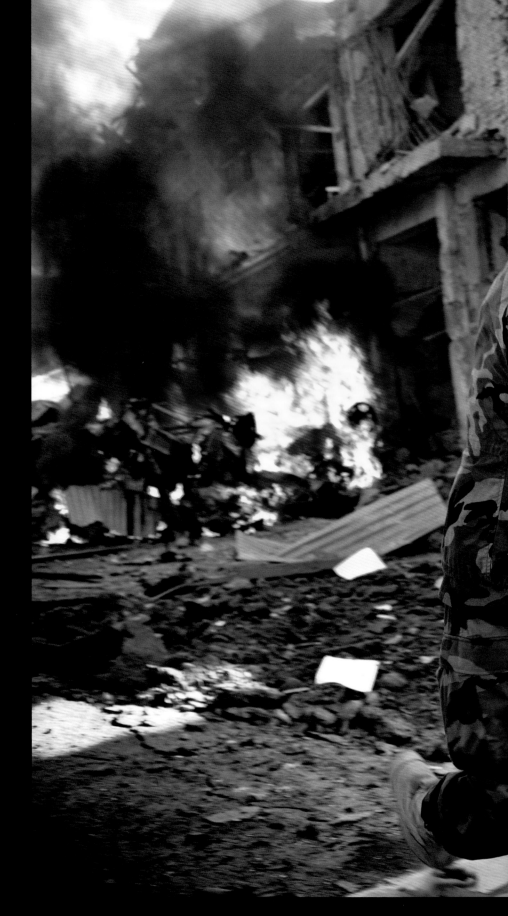

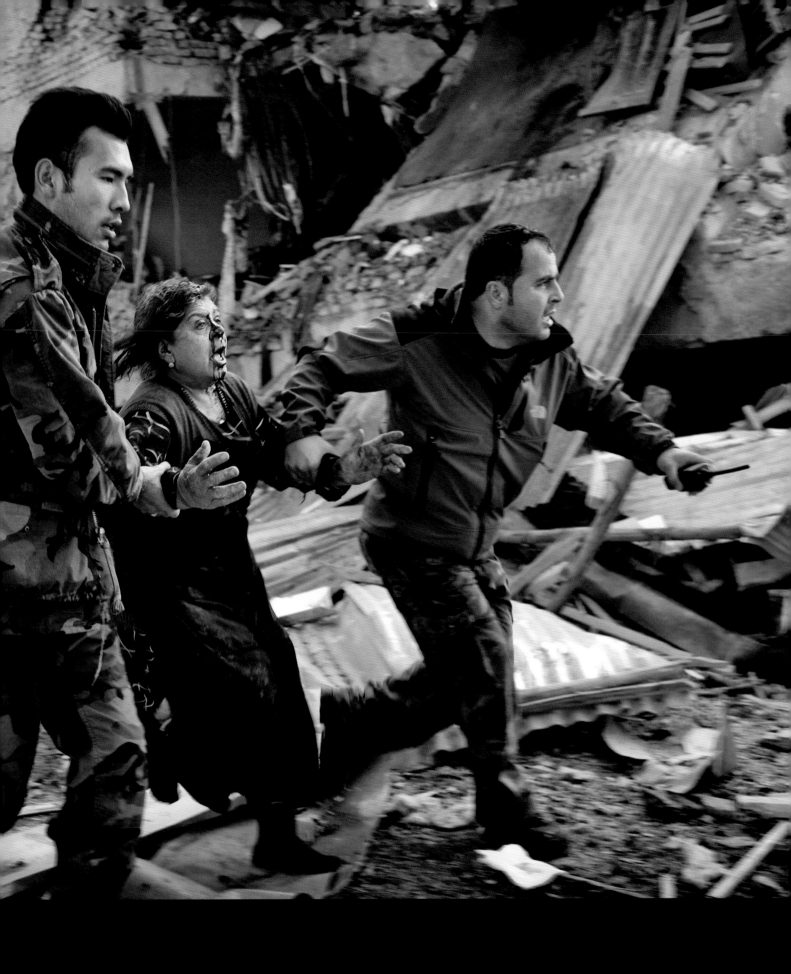

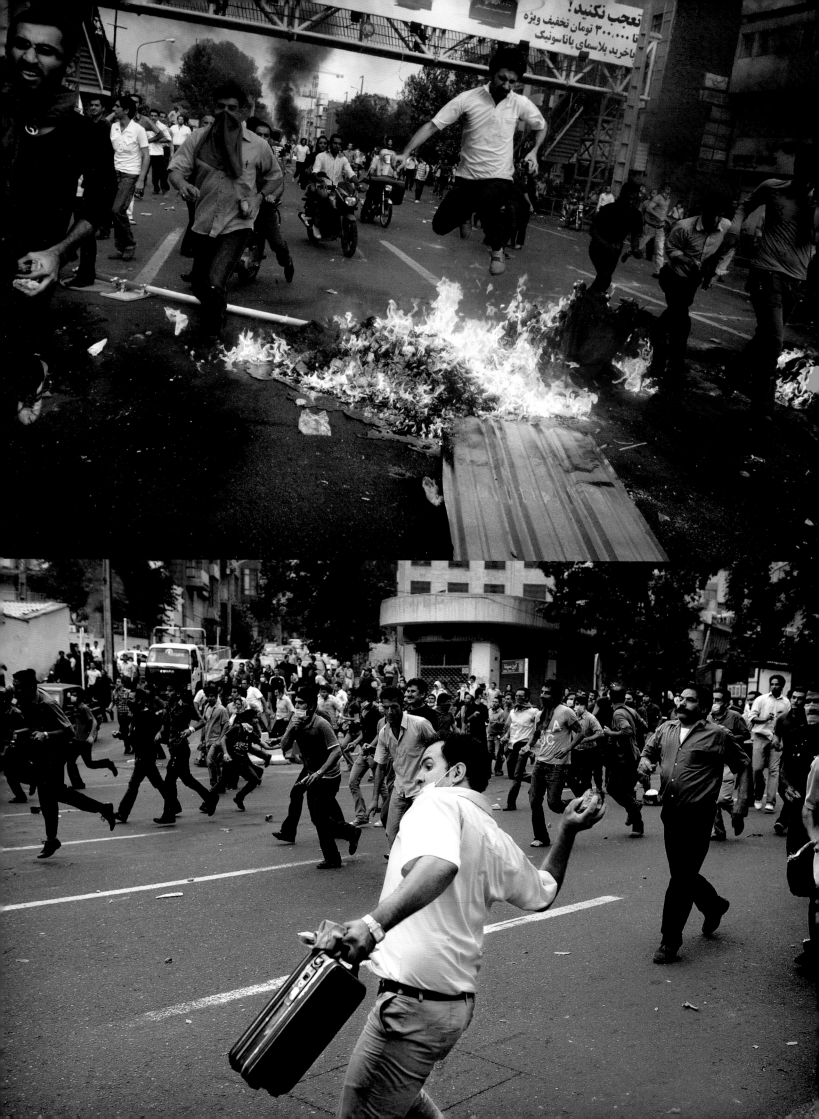

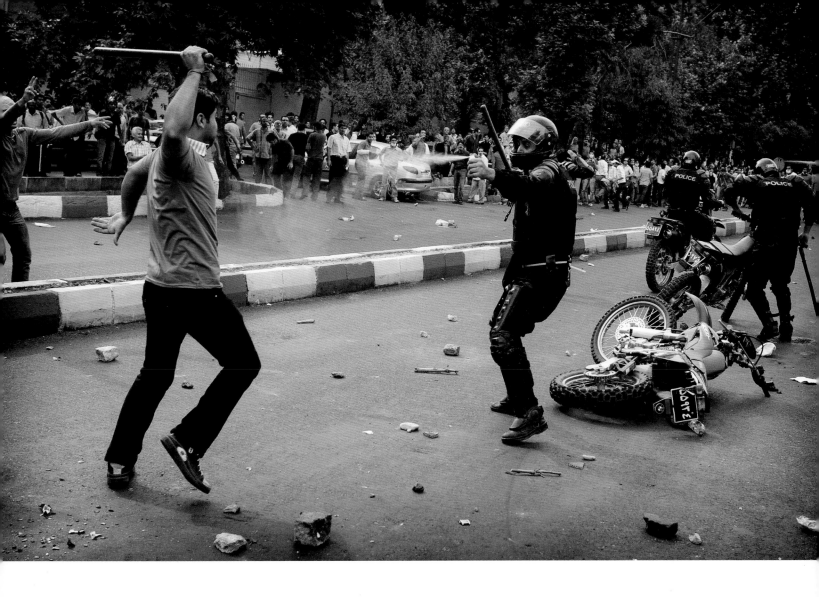

Supporters of Iranian opposition leader Mir Hossein Mousavi took to the streets of Tehran in protest in June, disputing the result of the country's presidential election. Incumbent president Mahmoud Ahmadinejad had been declared the overwhelming winner of elections held on 12 June, but the opposition leader's supporters claimed ballot rigging. In the days following the vote, thousands gathered in the streets in what became the largest protest in the capital since the 1979 revolution. Social networking media played an important part in spreading communications about protests, despite government efforts to block access. At times, angry crowds broke into shops, tore down signs and started fires. Violent clashes broke out between Mousavi supporters, many wearing the opposition color green, and backers of the president. Government security forces cracked down hard on the demonstrators, and by 22 June, 457 people had been arrested and at least eight reported dead. President Ahmadinejad was sworn in for a second term of office on 5 August. This page: A riot-police officer sprays tear gas at an opposition supporter, on 13 June. Facing page, top: Protestors run past burning debris during riots. Below: A protestor aims a stone at riot police, in Tehran on 13 June.

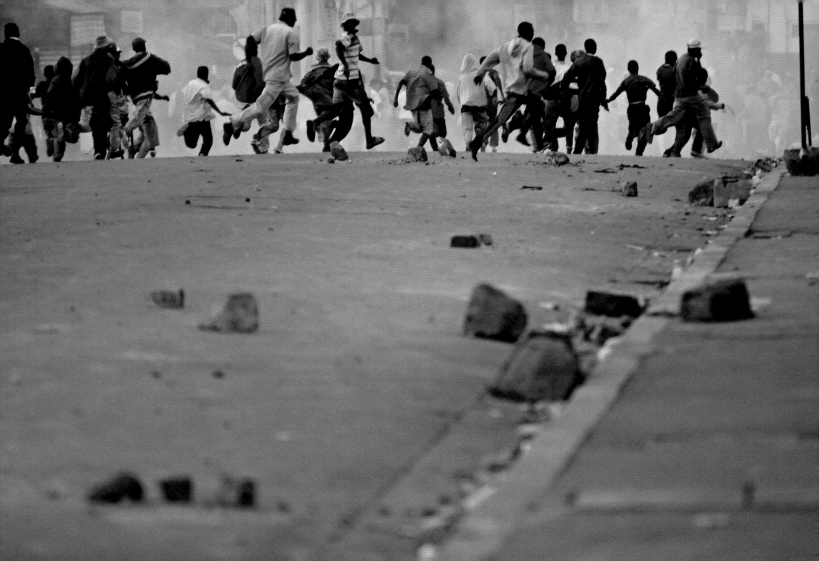

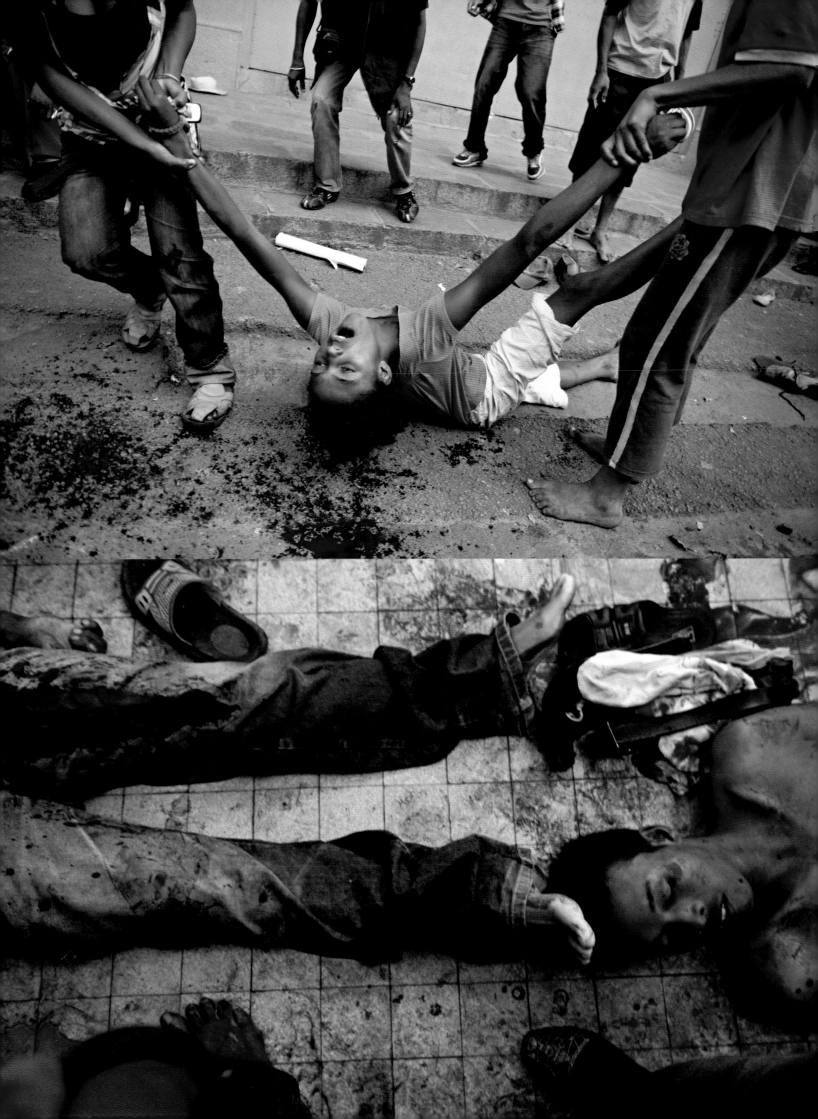

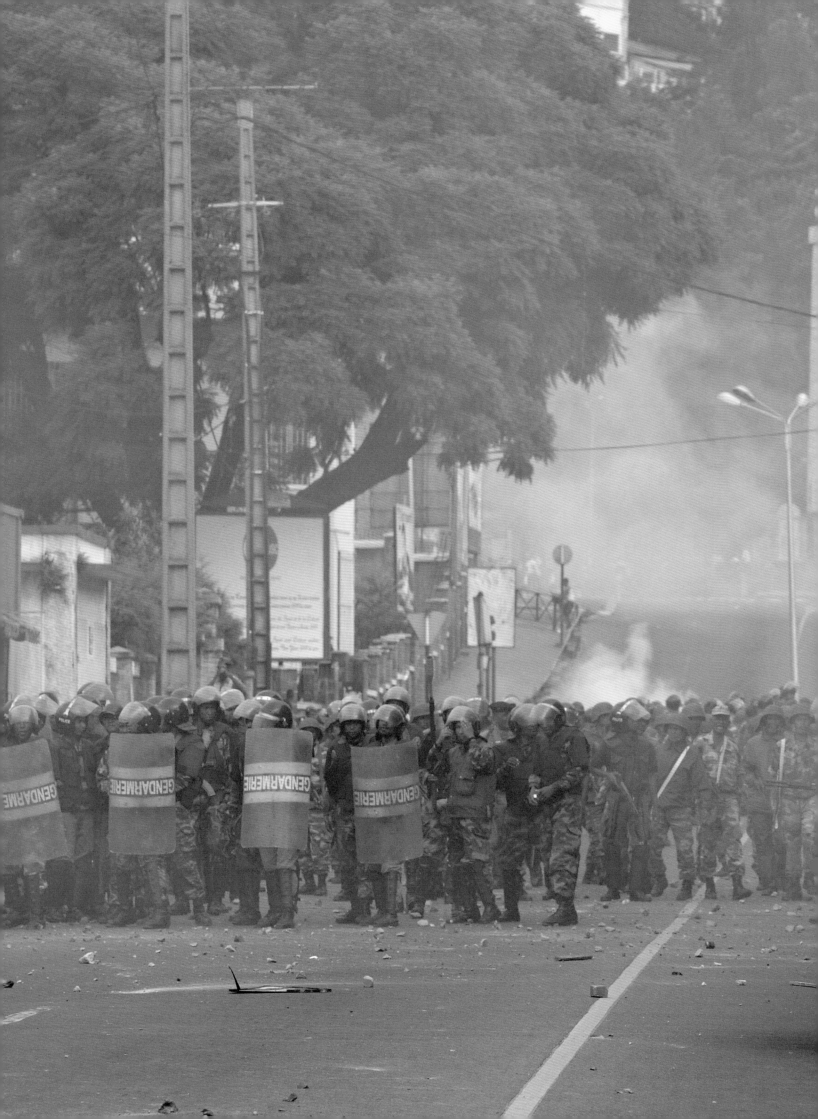

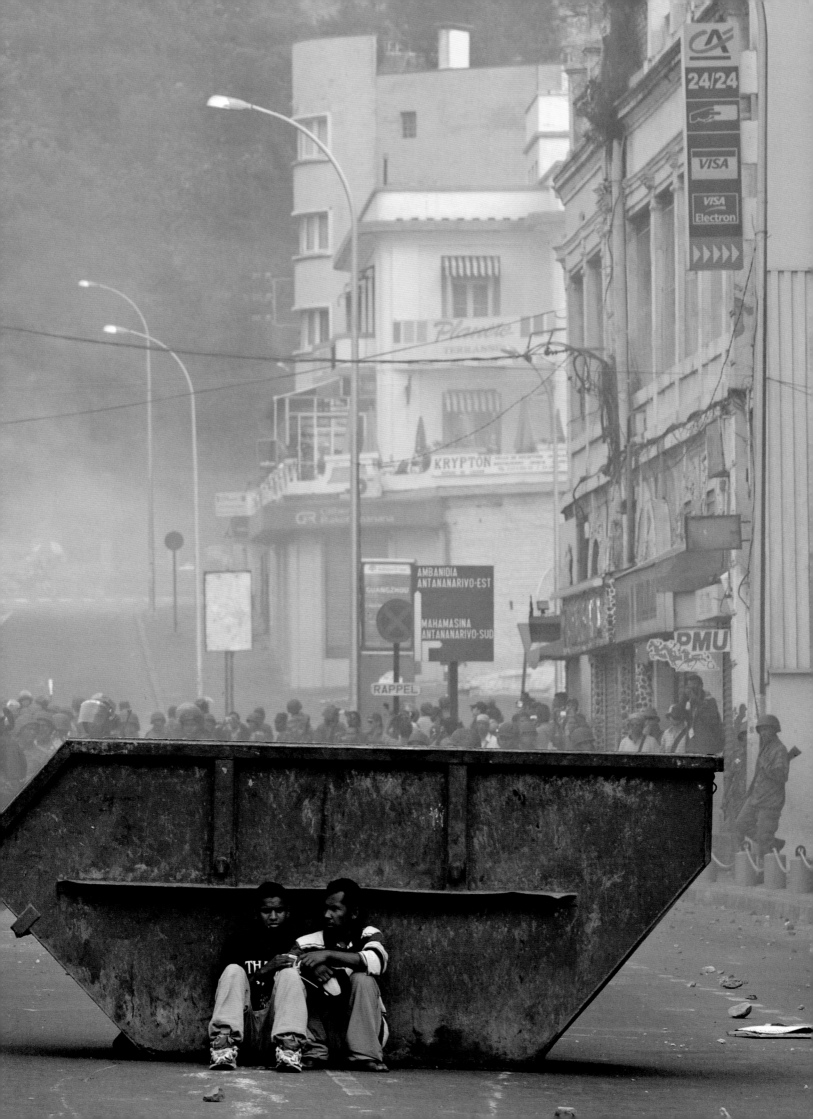

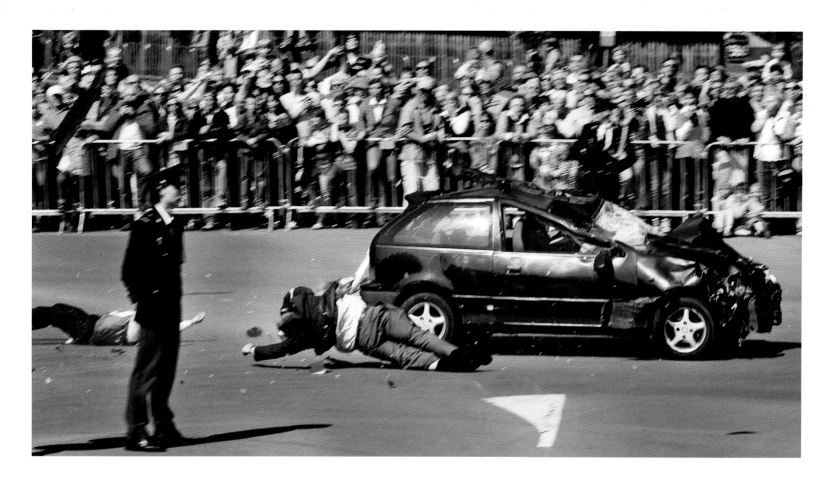

A car crashes through the crowd watching a royal parade in the Dutch town of Apeldoorn, on Queen's Day, the official celebration of the monarch's birthday. The car then crashed into a monument, just meters from an open-topped bus carrying Queen Beatrix and other members of her family. Eight people, including the driver of the car, died as a result of injuries sustained during the incident, and ten others were hurt. The royal family was unharmed. It appeared that the driver, Karst Tates, had been attempting an attack on the royals, but after investigating his car and home, authorities ruled out terrorism, saying that he appeared to have been acting alone.

General News

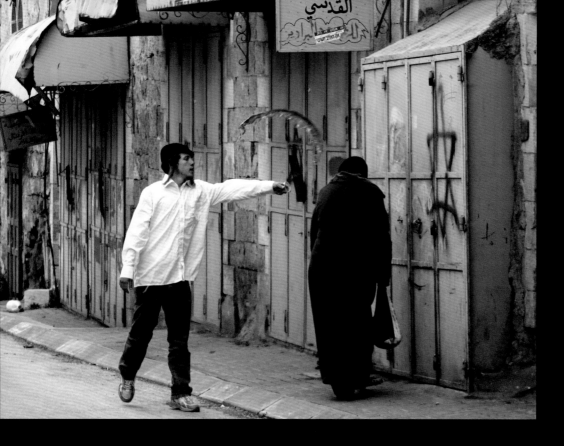

A Jewish man throws wine at a Palestinian woman before a Purim parade in the West Bank city of Hebron, on 10 March. Purim is an annual Jewish festival, with celebrations that include feasting and wine drinking. Hebron is divided into two zones. In one, under Israeli security control, several hundred Jewish residents live among tens of thousands of Palestinians. Tension between the communities is expressed in acts of harassment and provocation from both sides. This, together with the impact of curfews and restrictions on movement, has led large numbers of Palestinians to move out of the city center.

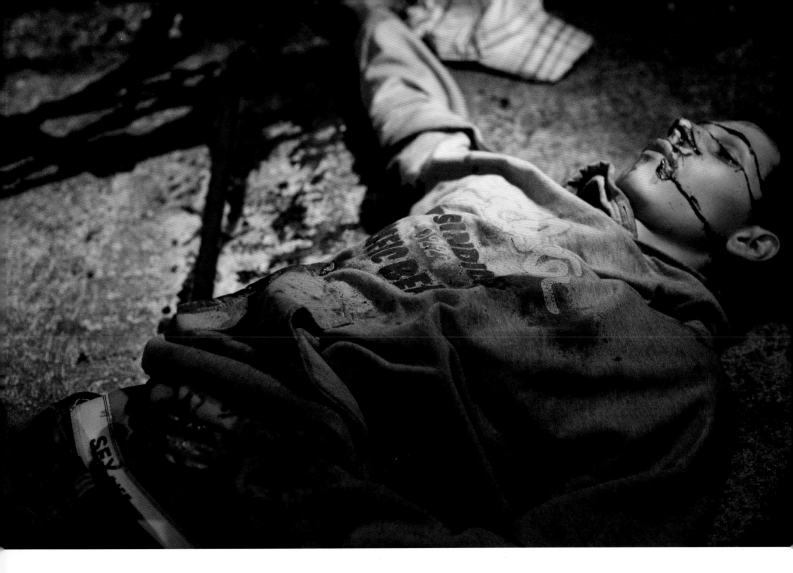

A youth lies dead in a pool of his own blood, in a commune of Medellín, Colombia. Since being elected in 2002, Colombian president Álvaro Uribe has had some success in his move against international drug cartels in the country. But as the big players moved out, largely to Mexico, their place in Medellín was taken by gangs fighting for control of the local drug trade. After international traffickers left, there was a substantial dip in homicides in Medellín, but figures are once more on the rise. Violent deaths doubled in 2009, sometimes involving innocent bystanders to clashes between gangs.

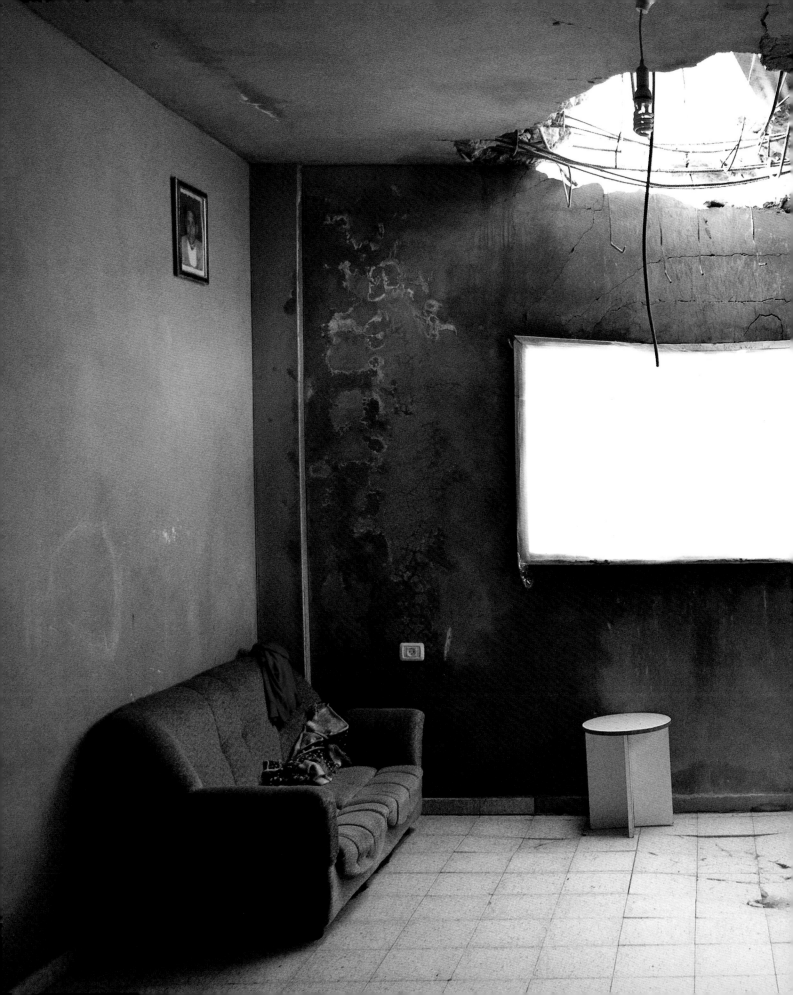

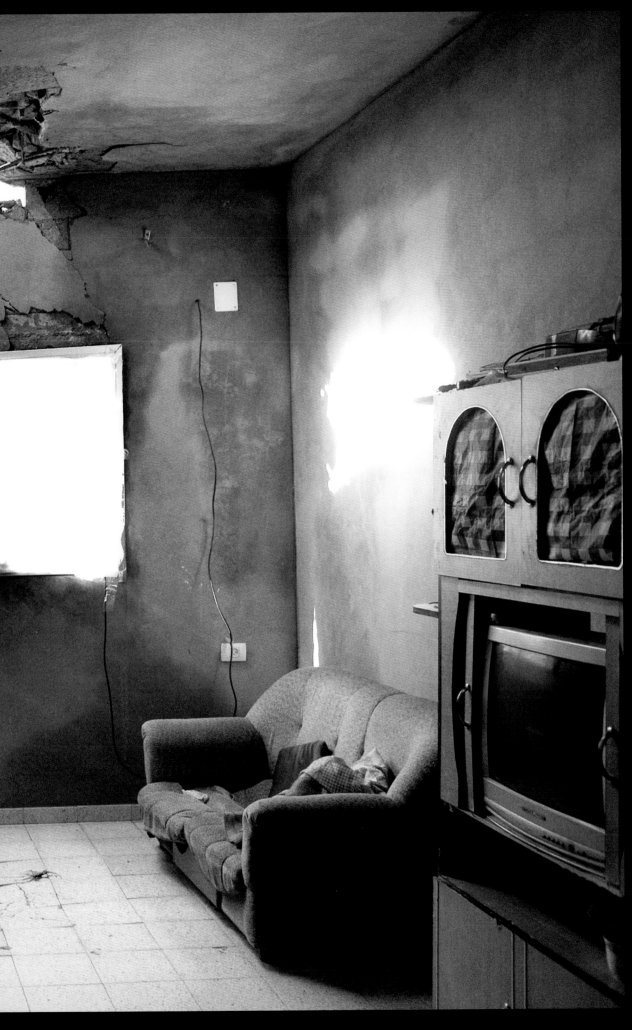

Light enters through a hole in the roof of a house hit by a tank shell, in Tuffah, northern Gaza. The family that lived in the house had fled during 'Operation Cast Lead', the Israeli attack on Gaza that began at the end of December 2008. Mohammed Shuhada Ali Ahmed, 39, had gone back to fetch clothes for his children, and was killed when the shell struck.

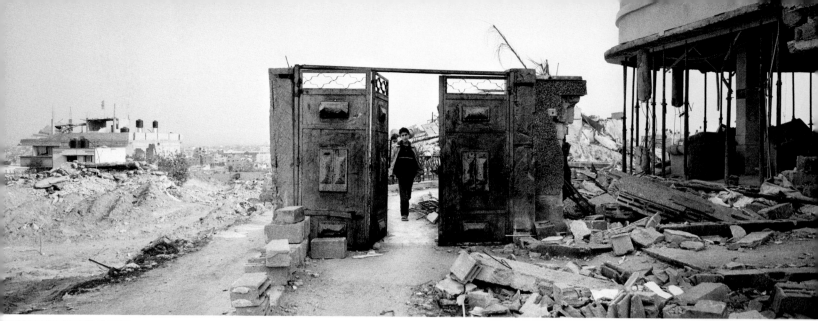

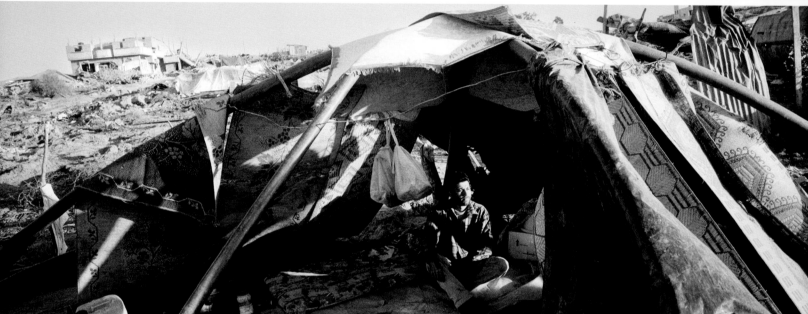

The Israeli military campaign against Hamas militants in Gaza came to an end on 18 January, after 22 days. Israel completed its withdrawal by 21 January, but did not lift its siege on the Gaza Strip. Intense bombardment had left thousands of homes destroyed, and tens of thousands of people displaced. In the early days of the recovery process, the United Nations Development Programme removed some 600,000 tonnes of concrete rubble. This page, top: A boy walks through the entrance of the house where his family once lived, in the Hai al-Salam neighborhood of East Jabaliya, on 25 January. Below: A former resident of Djuhr al-Diek sits amidst the remains of the village in a self-made shelter. Facing page, top: The Hai al-Salam neighborhood, just 3 km from the border with Israel, was almost completely destroyed. Below: Cows killed by heavy bombing lie strewn on the ground in East Jabaliya.

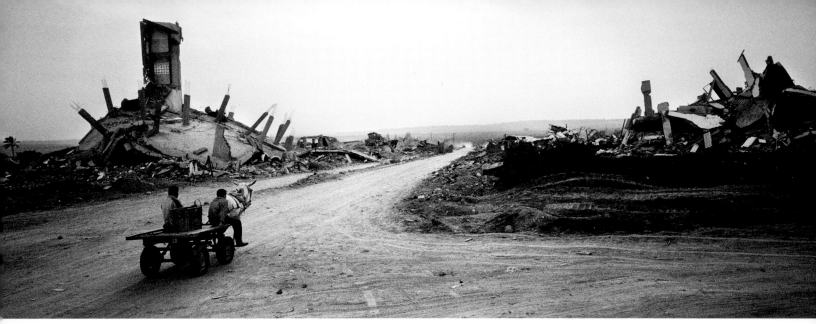

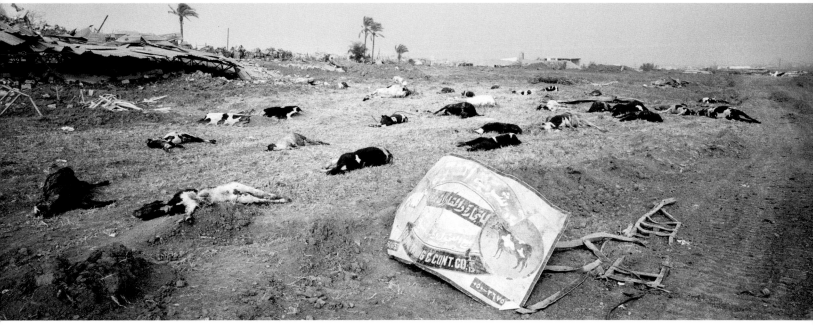

Since 2007, Guinea-Bissau, one of the poorest nations in the world, has become a hub for cocaine trafficking, as South American drug cartels seek new smuggling routes to Europe. With over 100 islands off its coastline, and a navy with no working boats on duty, Guinea-Bissau offers a haven for drop-offs, storage and moving of huge hauls of cocaine. Military officers and leading politicians have become embroiled in the lucrative drug trade. According to Interpol, former president João Bernardo Vieira, who was assassinated on 2 March, was personally involved with trafficking, and in conflict with some of his generals, whom he was trying to marginalize within the trade. This page, below: The scene of President Vieira's assassination. The president was shot and then hacked with a machete. Following spread, top left: Men prepare capsules containing cocaine, which will be swallowed and smuggled into Europe. Right: Crack was unknown in Guinea-Bissau until the traffickers targeted the country. Now, addiction has led many local women to prostitution. Below, left: President Vieira's alleged assassins pose for a portrait seven hours after his death. Right: A score between small drug dealers is settled. In the end, the captive was abandoned, but not killed.

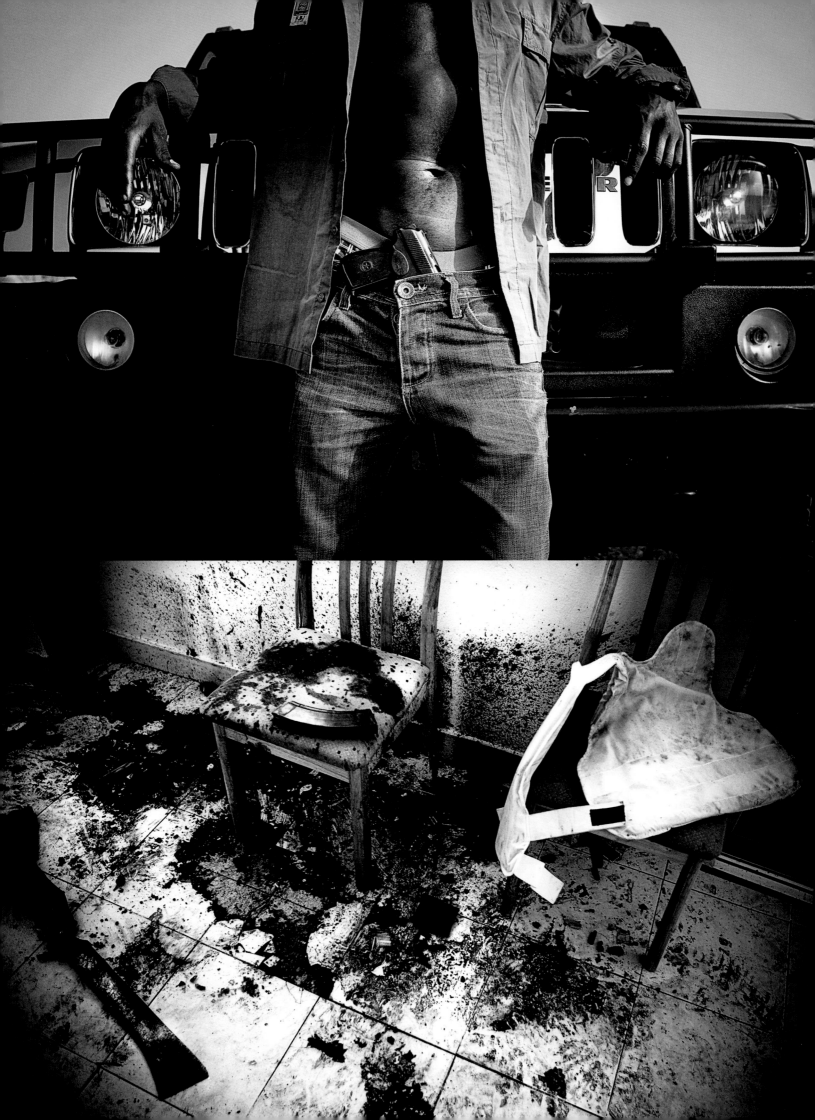

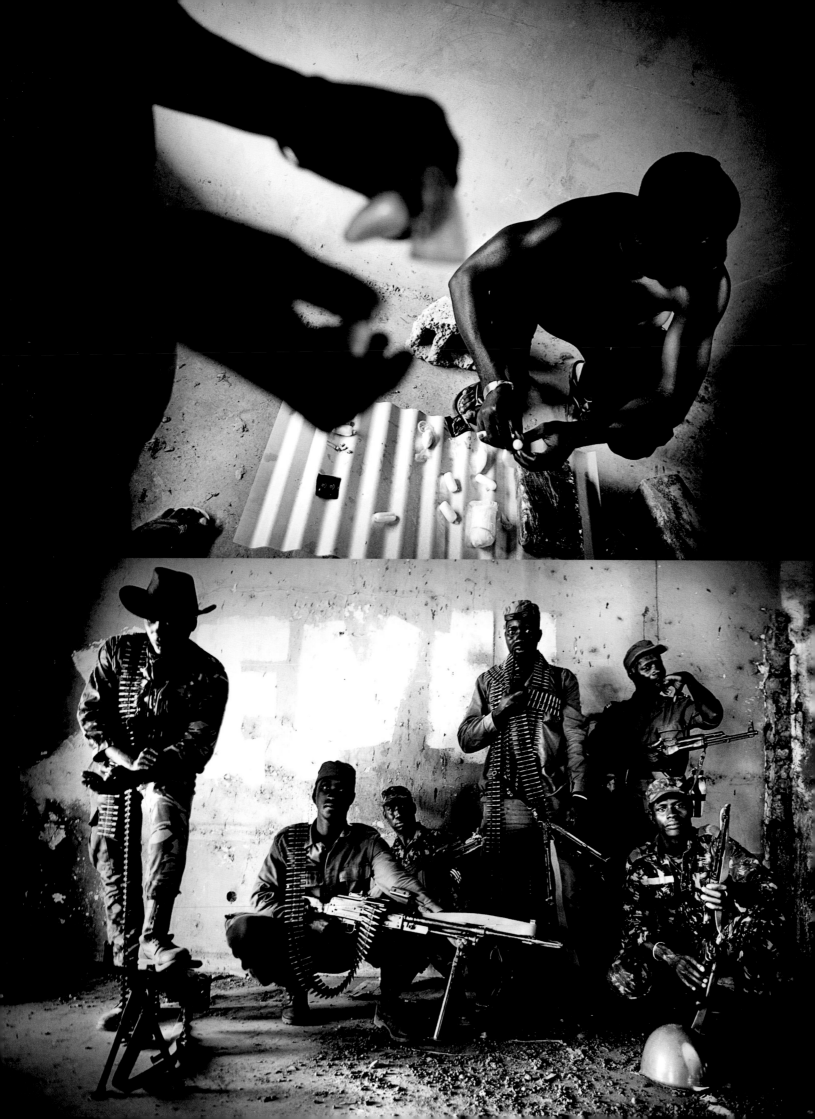

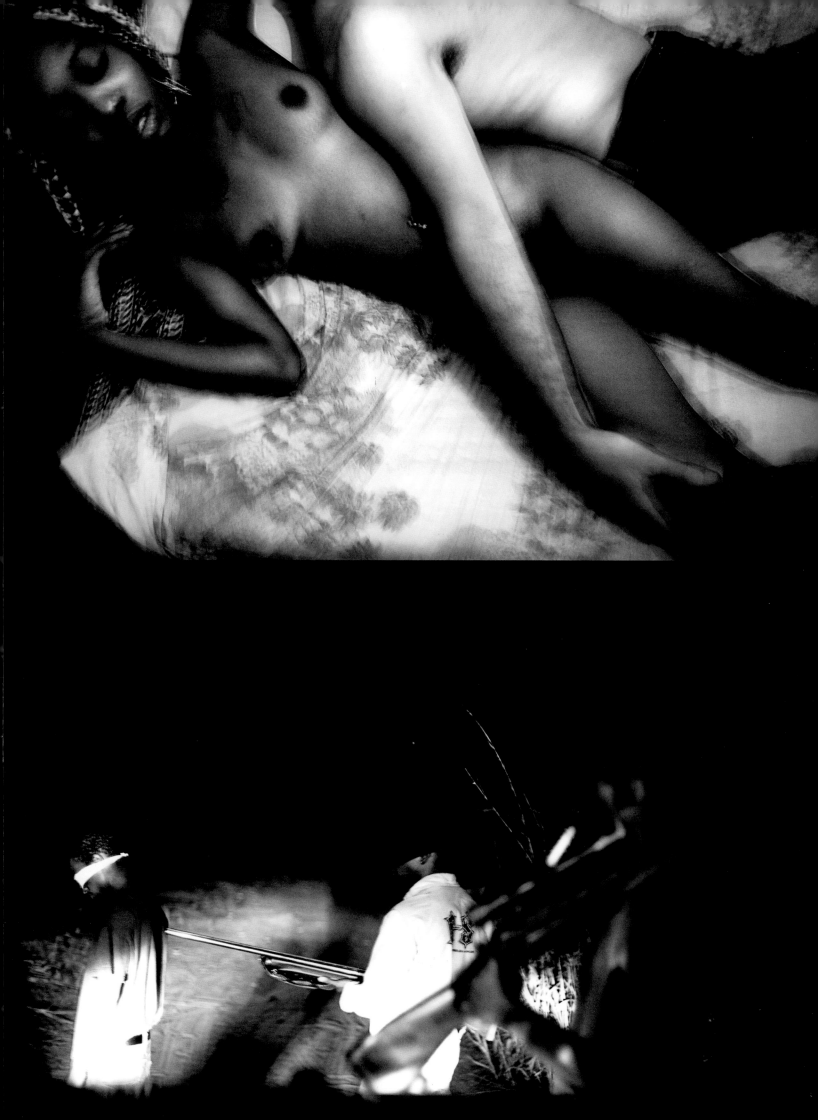

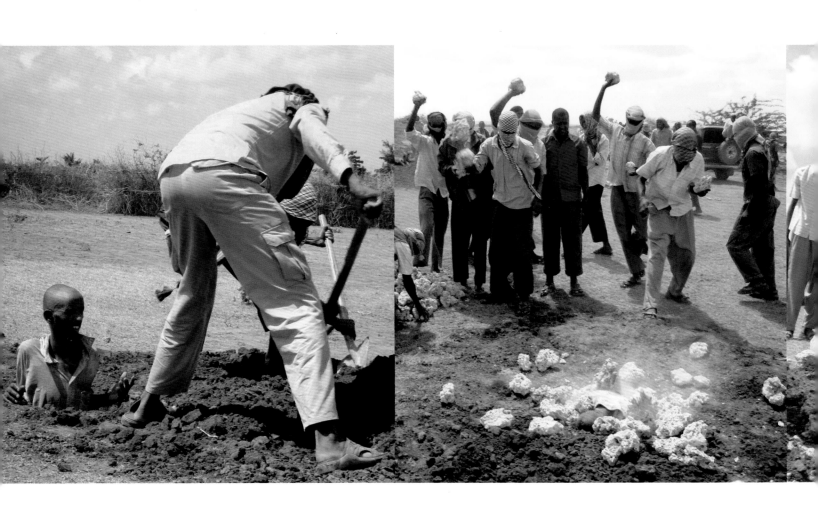

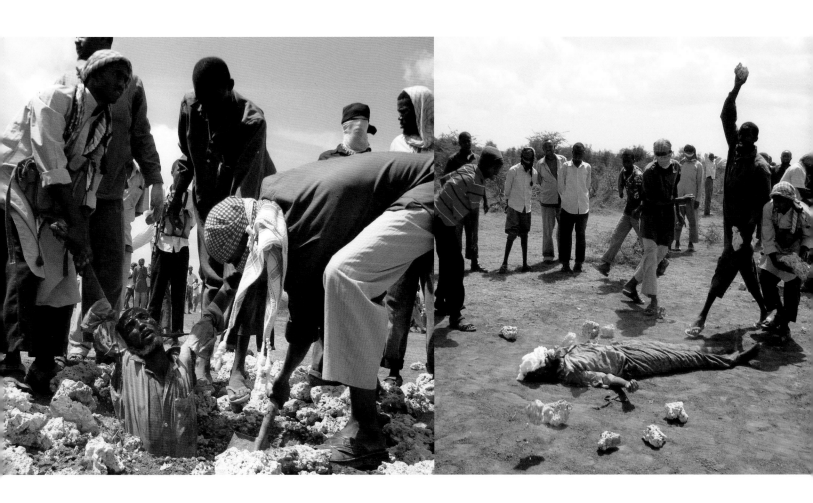

Mohamed Abukar Ibrahim, 48, is stoned to death by members of Hizbul Islam, a group of Somali Islamist insurgents, in Afgoye, 30 km from the capital Mogadishu, on 13 December. Ibrahim had been found guilty of adultery by a local Sharia court. Fifteen years of civil war and an absence of effective central government had left the population of Somalia in the hands of local courts and clan-based militia. In February, the president of a transitional government had agreed to the introduction of Sharia law in Somalia, in order to defuse clashes between the government and its clan opponents.

Daily Life

SINGLES
1st Prize
Michael Wolf
2nd Prize
Joan Bardeletti
3rd Prize
Luca Santese
STORIES
1st Prize
Gihan Tubbeh
2nd Prize
Matt McClain
3rd Prize
Simon Roberts
Honorable Mention
Pieter ten Hoopen

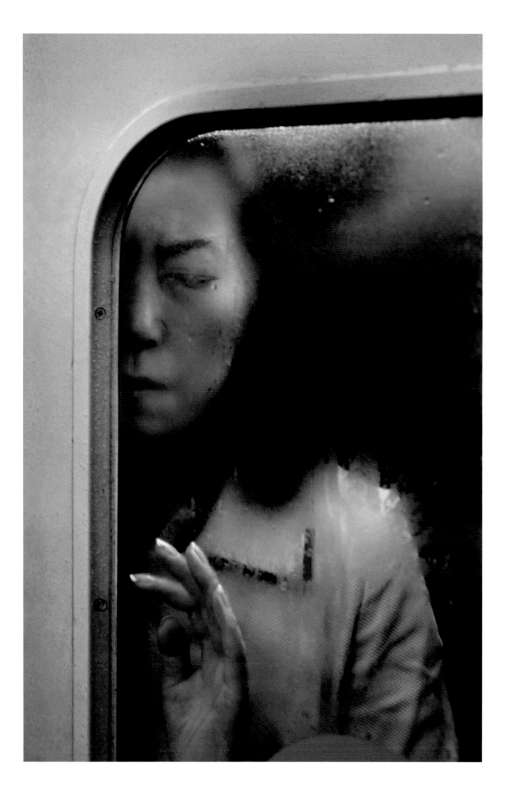

A woman travels at rush hour on the Tokyo subway. Some 8.38 million passengers use the system daily.

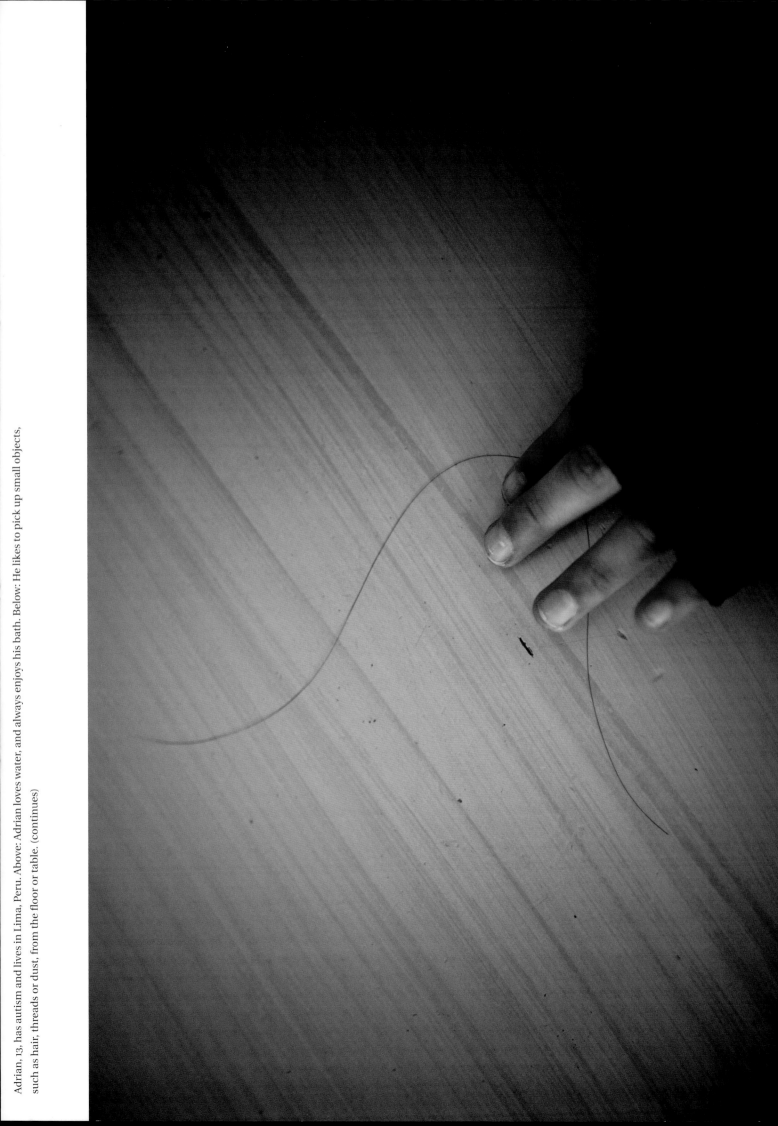

Adrian, 13, has autism and lives in Lima, Peru. Above: Adrian loves water, and always enjoys his bath. Below: He likes to pick up small objects, such as hair, threads or dust, from the floor or table. (continues)

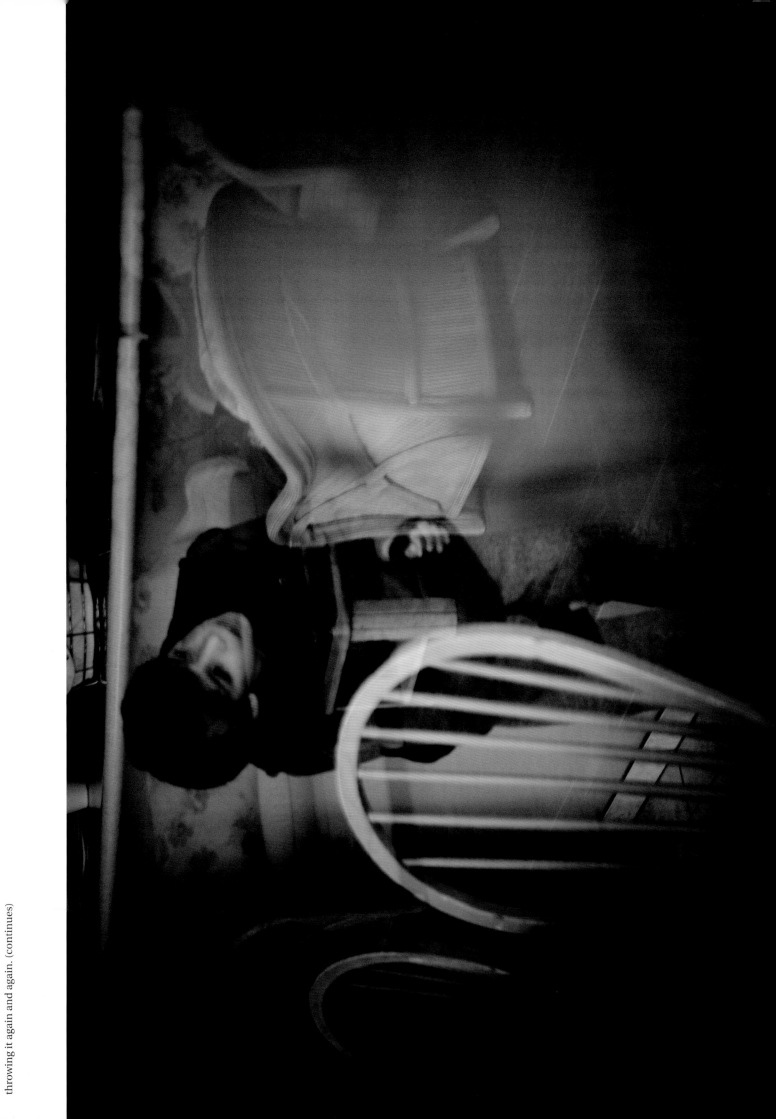

(continued) Adrian searches for the piece of cloth he always carries to wipe away his dribble. He treats it as a plaything, picking it up and throwing it again and again. (continues)

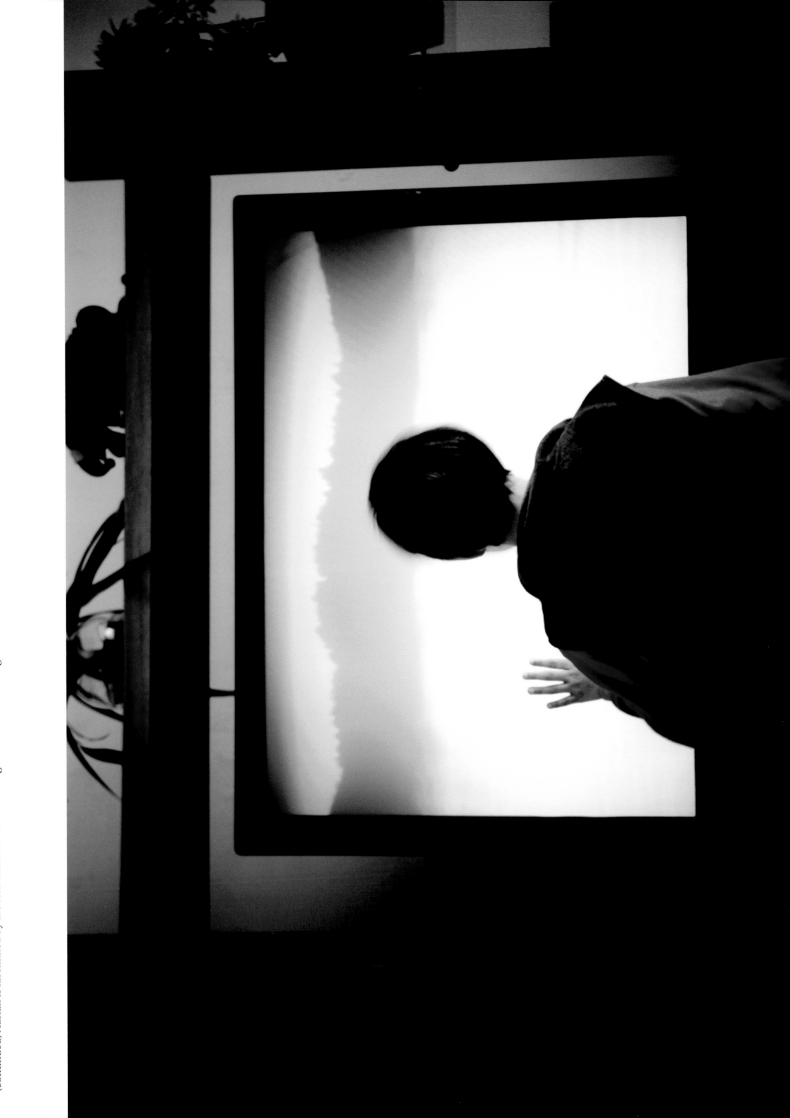

(continued) Adrian is fascinated by the television. He likes touching the screen and feeling the tickle of static.

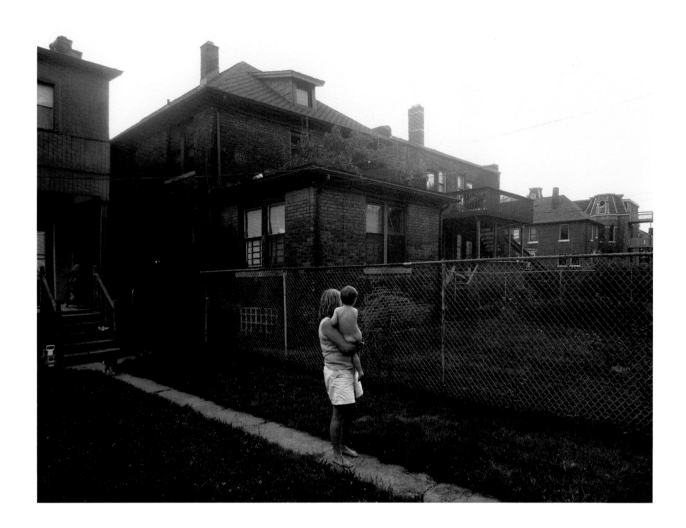

Mary, a single mother, lives with her son in downtown Detroit. Her family lives out of town, and visits her rarely as they are afraid of problems with crime. Detroit tops the list of America's most dangerous cities, with 1,220 violent crimes per 100,000 people, although figures have dropped substantially in recent years. Crime is particularly prevalent in downtown areas. Since the 1960s, there has been a steady exodus of those who can afford it to the suburbs.

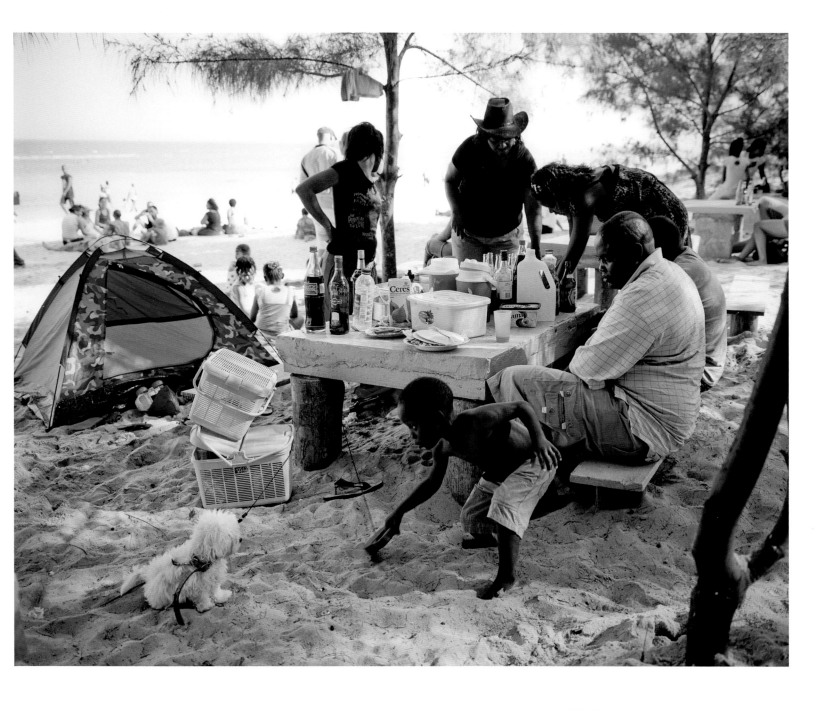

A family enjoys a picnic on a beach outside Maputo, in Mozambique. According to the World Bank, the number of people that can be classified as belonging to the middle classes in developing countries is on the rise, and by 2030 will have reached one billion.

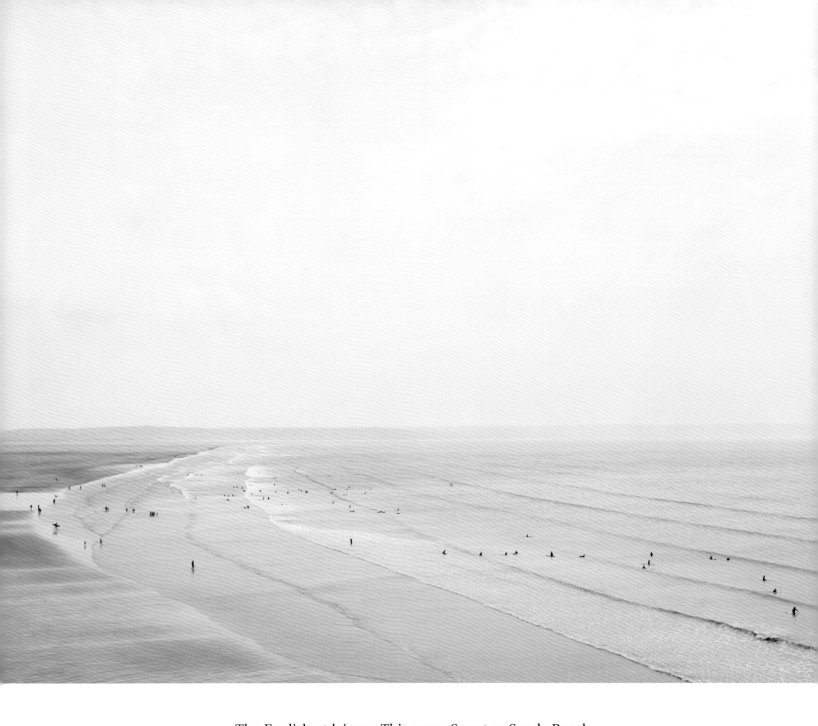

The English at leisure. This page: Saunton Sands Beach, Devon, on a public holiday weekend, 23 May. Facing page: Ladies' Day at Aintree Racecourse, Merseyside, 4 April.

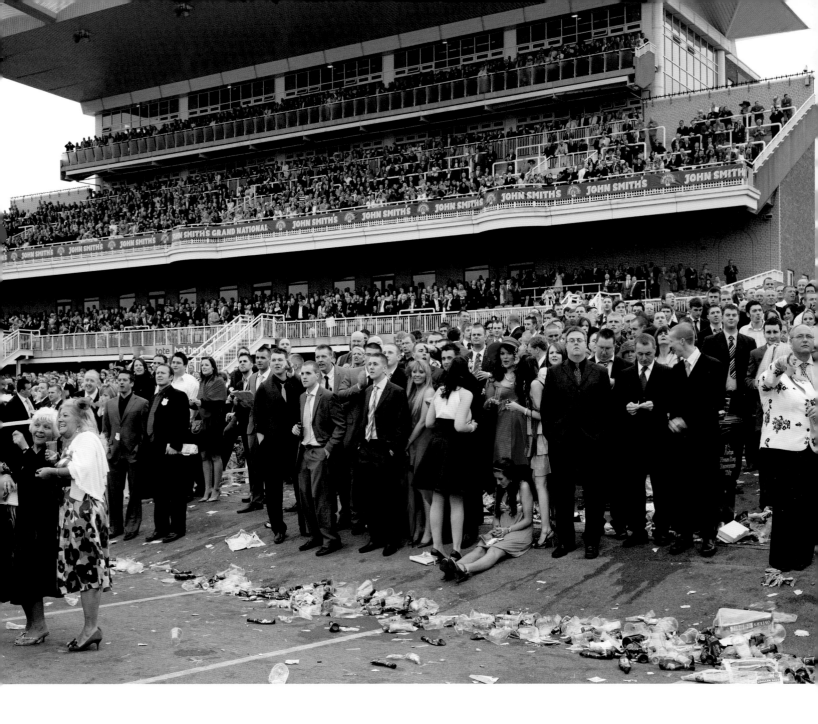

Blind from birth, Pandu Fayre, 6, was living in an orphanage in India when he was adopted by Americans Jason and Lalena Fayre, in November 2008. Jason is himself visually impaired, and wanted to pass on the skills that he had learned in coping with everyday life to his adopted son. Top row, left: Pandu sits in the evening light, after finishing dinner with his parents in Englewood, Colorado. Right: Jason walks with Pandu on an outing at Cuernavaca Park in Denver, Colorado. Second row, left: Reading a bedtime story, in braille, is a daily ritual for father and son. Right: Jason comforts Pandu before he has an operation to remove a cyst from his eye socket. Third row, left: Molds are taken in order to have prosthetic eyes made for Pandu. Right: Jason cradles Pandu as he recovers from the anesthetic, after having molds taken of his eyes. Bottom row, left: Lalena cries when seeing Pandu for the first time after the fitting of his prosthetic eyes. Right: Jason tickles Pandu.

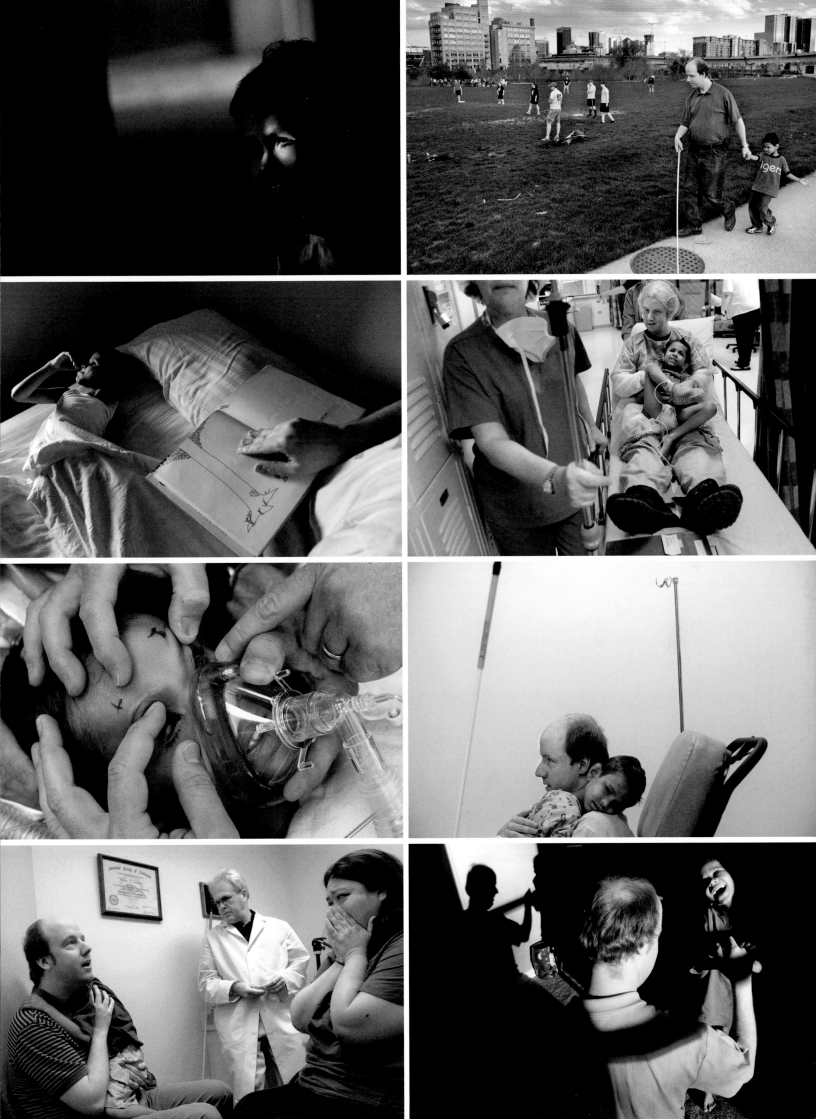

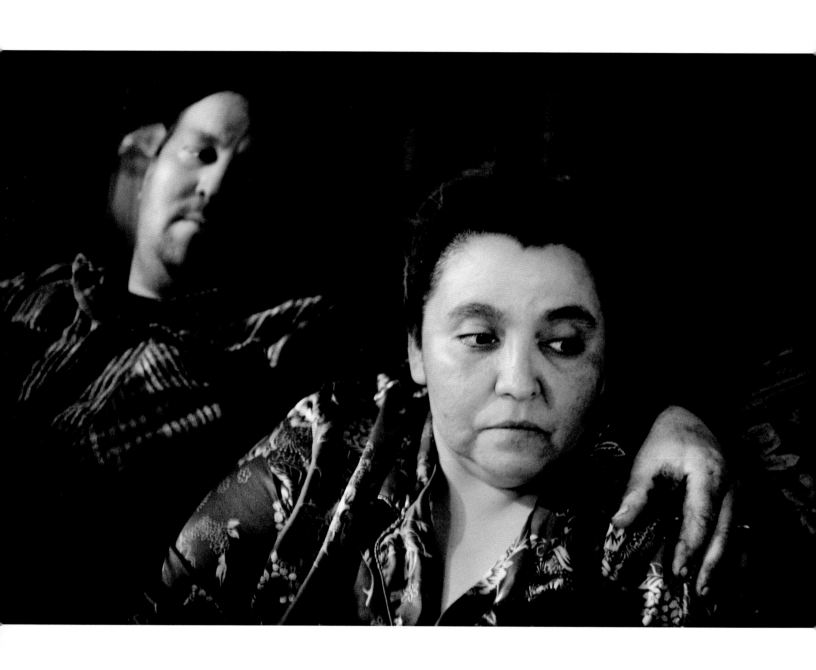

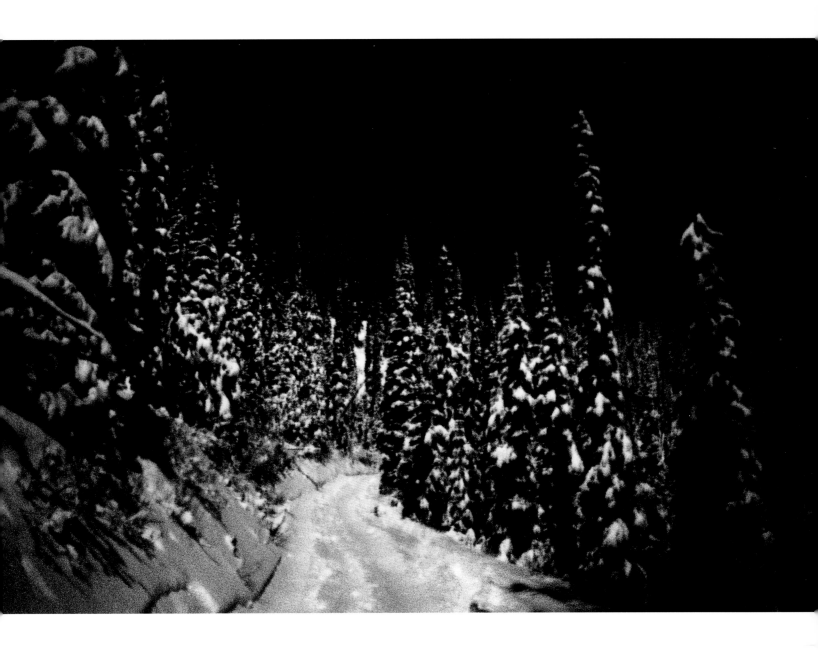

Hungry Horse is a small community located in the Rocky Mountains in Montana, USA. In 1953 a dam was built there to meet the increasing demand for energy in the northwest. Large numbers of construction workers swelled the population of Hungry Horse, but when the dam was complete most moved to other parts of the country. Today the community comprises just 900 residents, struggling with unemployment. Many younger people join the army, or head to the city in search of better prospects. Facing page: Shoan and Jim lived together in Hungry Horse, but Shoan later moved out and went to live in Browning, an Indian reservation some miles away. Jim works for his brother's construction company.

Contemporary Issues

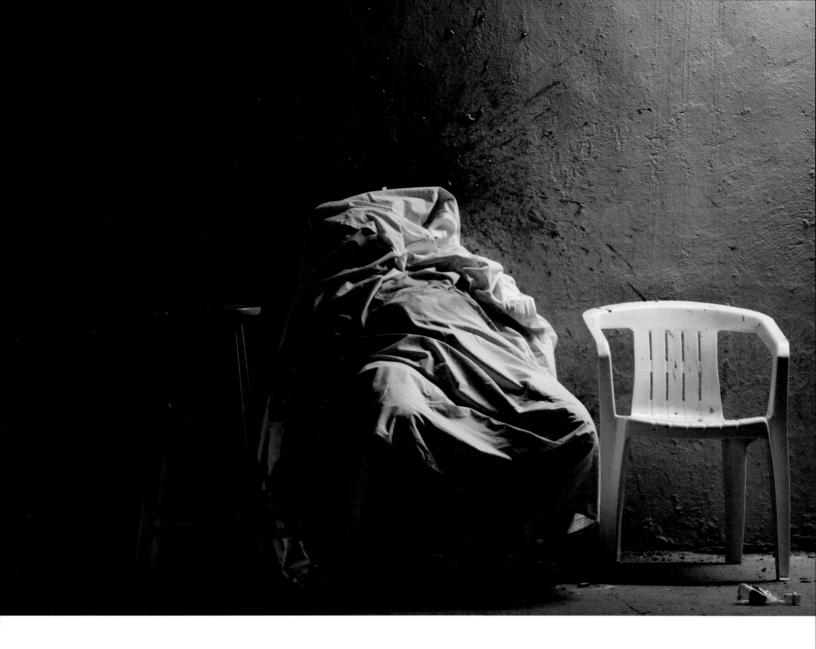

The body of an alleged drugs dealer lies covered by a sheet after being shot to death outside his home in Tijuana, on Mexico's northern border. At the end of 2006, President Felipe Calderón launched a determined assault on powerful drugs cartels operating in Mexico. A number of high-profile arrests followed, including the detention of corrupt officials in the police force and judiciary. In an ensuing wave of violence, decapitated and bullet-riddled bodies began to appear in Tijuana and other cities on drug transit routes. Many attributed this to reprisal killings of people believed to be informants. Some sources estimated that the number of drugs-related homicides in Mexico in 2009 was over 7,000.

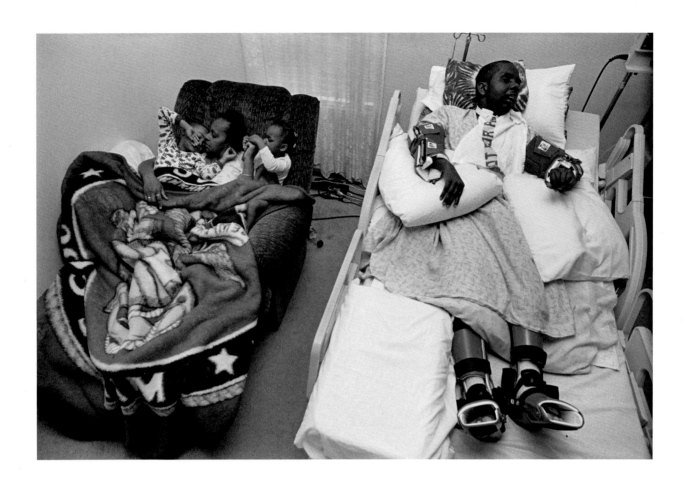

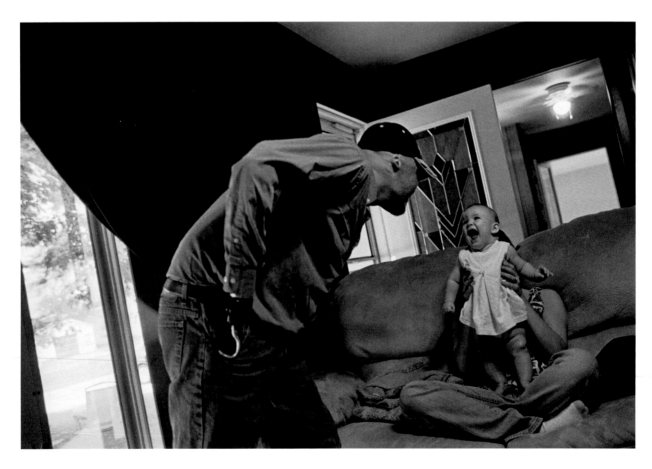

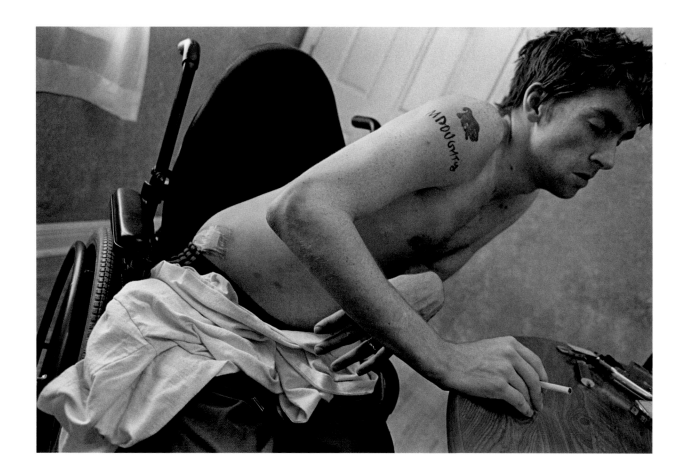

By the end of 2009, over 4,300 men and women from us military forces had been killed, and some 30,000 maimed or wounded since the beginning of the conflict in Iraq. This page: Tomas Young was paralyzed from the chest down after being shot in the spine during an ambush on his fourth day in Iraq. Facing page, top: A brain injury following an anti-tank mine explosion left Shurvon Phillip unable to speak and in need of constant care. His mother Gail Ulerie sleeps beside him every night. Below: Dusty Hill, a former sergeant with the Illinois National Guard, lost both hands and an eye and suffered fourth-degree burns on a third of his body during an insurgent attack in Baghdad. He has learned to change his daughter's diapers and feed her with his mechanical right hand. (continues)

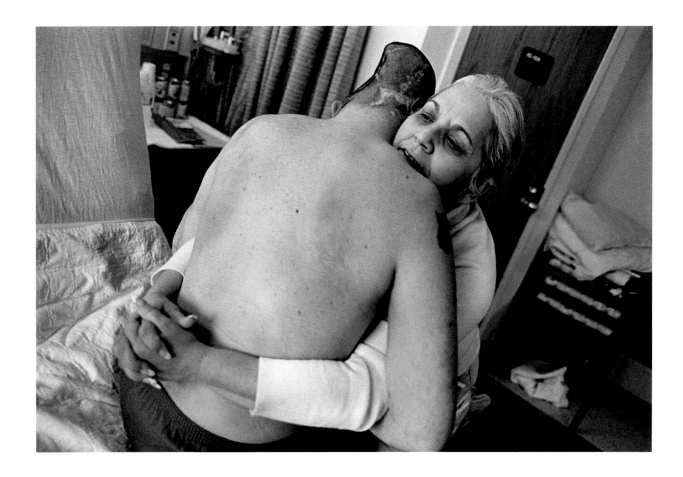

(continued) President Obama announced that he planned to withdraw most US troops from Iraq by the end of August 2010. On average, there were 128,000 US combatants in Iraq during 2009. In addition to the growing number of fatalities and wounded, the incidence of stress-related illness and military suicides also increased. This page: Nelida Bagley helps her son Jose Pequeño from his bed at the West Roxbury Veterans Medical Center in Massachusetts. He lost 40 percent of his brain when a grenade exploded in his vehicle while on patrol in Ramadi, in central Iraq. Facing page, top: Army Sergeant Princess C. Samuels was killed in indirect fire (gunfire delivered at a target that cannot be seen from the firing position) in Taji, north of Baghdad. She was one of more than 100 female troops killed in action since the war started in 2003. Below: Former US Army medic Michael Harmon, who shares a small apartment in Brooklyn with his mother, grandmother and stepfather, has suffered from severe anxiety attacks since returning from Iraq.

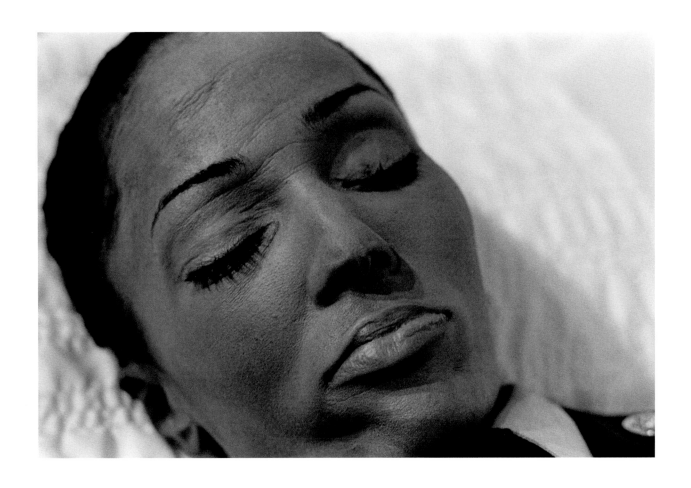

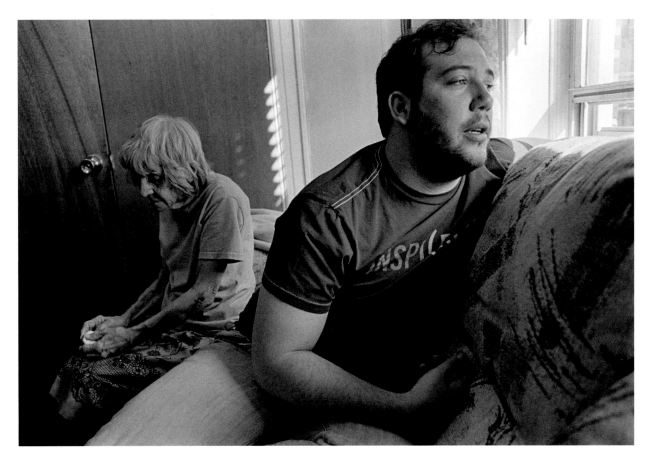

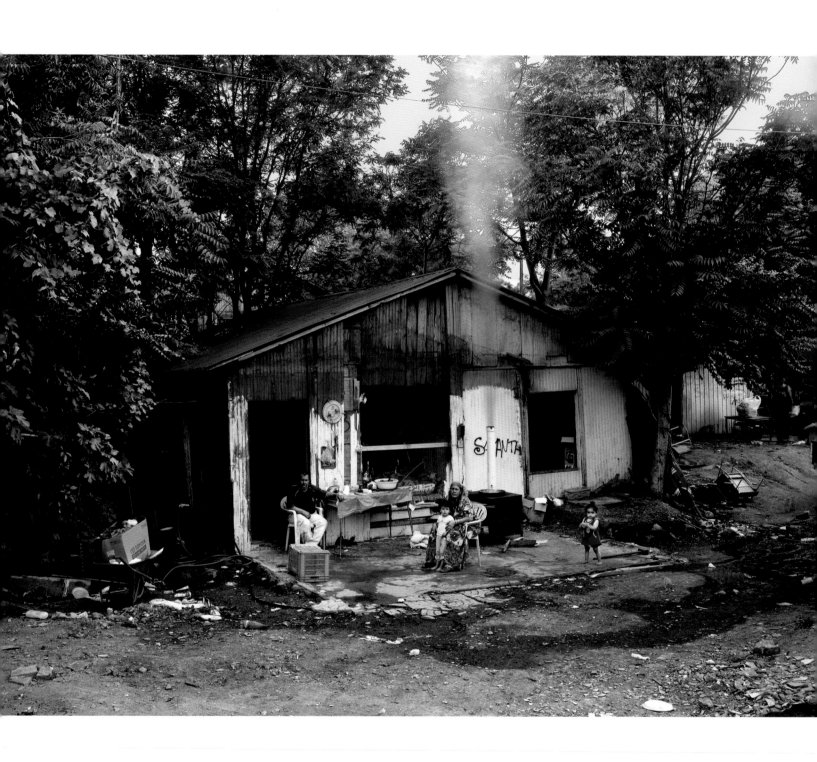

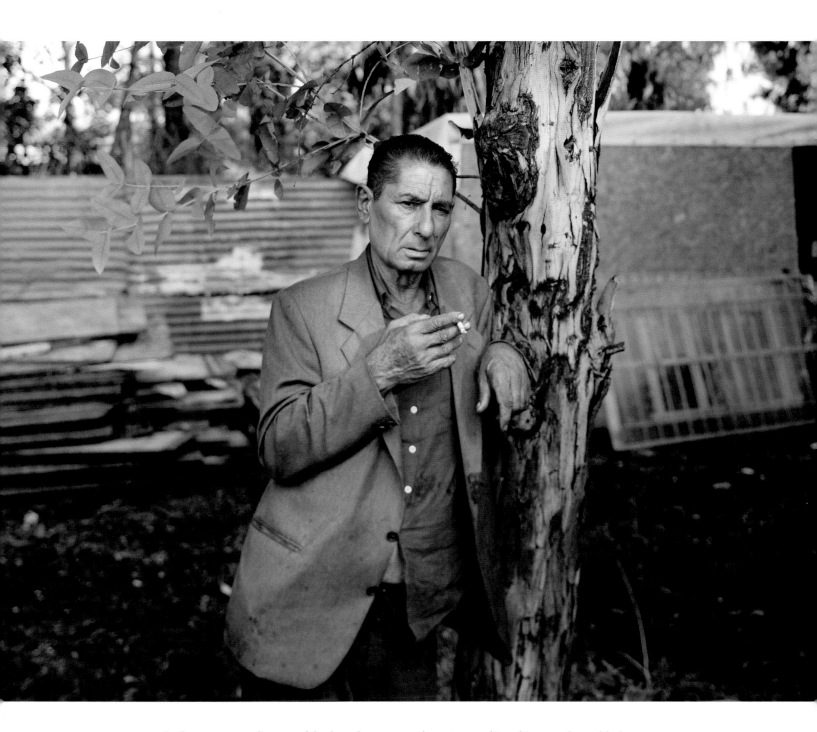

Casilino 900, a sprawling area of shacks and caravans on the eastern outskirts of Rome, and one of the largest Roma (gypsy) settlements in Europe, was threatened with evacuation. The camp dated back to the end of the Second World War, when the area was squatted by people coming to the capital from the South to seek work. As that community grew more prosperous, members moved into the suburbs and their place was taken by Roma, largely from the former Yugoslavia. Over 600 Roma lived at Casilino 900, with no public sanitation or electrical supply. They were caught up in a national anti-immigrant backlash, despite a long-standing presence in Italy. Casilino 900 was demolished at the beginning of 2010.

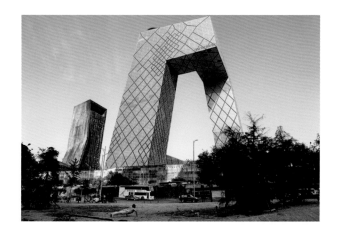

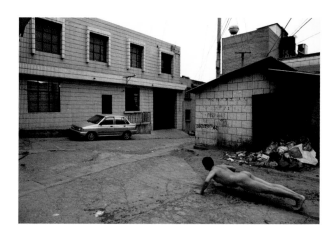

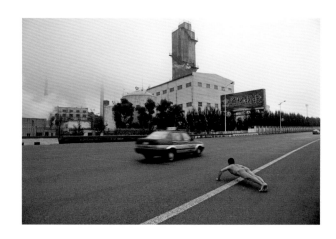

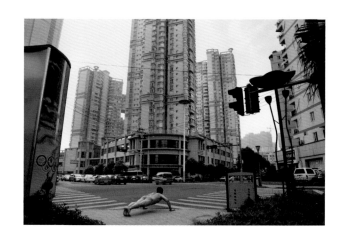

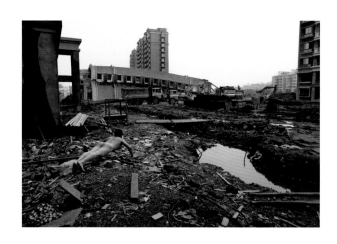

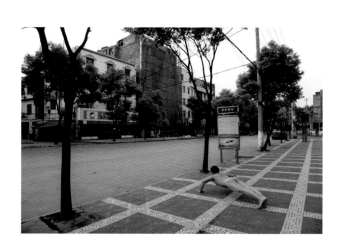

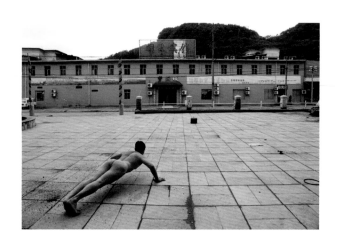

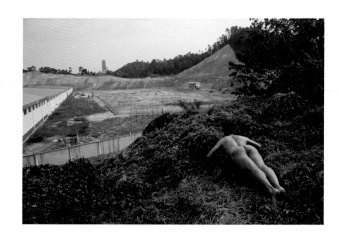

The Case of the Burning CCTV Building — On 9 February, fire raged through the studios of China Central Television, shortly before the new building was opened. The blaze had been started by huge fireworks set off without the requisite government permission, by a squad allegedly hired illegally by CCTV officials.

The Case of Violence at the Tonghua Iron and Steel Company — On 24 June, workers at the Tonghua Iron and Steel Company in northeastern China staged a protest against a threat of massive job-cuts as their state-owned company was set for privatization. The protest became violent, and a manager from the company that was due to take over the steelworks was killed.

The Case of the Collapsed Residential Building in Shanghai — On 27 June, a 13-story apartment block collapsed, killing a construction worker. The building fell over as workers were excavating an underground car park for the complex. The construction company's license to build had expired in 2004.

The Deng Yujiao Case — On 10 May, at a hotel in Hubei province, pedicurist Deng Yujiao tried to fend off the advances of a local official seeking sexual favors. In the process she stabbed him, severing a vein in his neck and killing him. She was charged with murder but claimed self-defense in the face of attempted rape. Deng became a national hero for resisting official abuse of power. Her charge was later reduced to the lesser offense of 'intentional assault'.

The Case of the Death at Yunnan Prison — On 12 February, prisoner Li Qiaoming died from a brain injury sustained at a detention center in the province of Yunnan. Police claimed he was injured while playing a game of hide-and-seek with fellow prisoners.

The Case of the Wenzhou City Resettlement Office — On 7 April, a blogger on a popular Chinese website posted a document listing names of people who had bought apartments from the Resettlement Office in the affluent city of Wenzhou, at a significantly discounted price. The apartments were the best units in the best locations, in blocks designated for families relocated due to city development. The list included 49 Resettlement Office staff and 94 local government officials.

The Shishou Case in Hubei — On 17 June, chef Tu Yuangao died at the Yonglong Hotel, which some locals claimed was a center of drugs activity, in the city of Shishou, in Hubei province. His family refused to accept the hotel management's explanation that he had committed suicide by jumping out of a window. Thousands protested in support of the family. Riots broke out and the hotel was set alight.

The Case of the Trash Incinerator in Guangzhou — In late September, residents of Panyu in Guangzhou, capital of Guangdong province, began protesting against the planned construction of a trash-burning power station in their district. They were concerned with health issues and the effect on property value. Officials promised an environmental assessment, but insisted the incinerator would not pose a health threat. One said that the plant would be safe because it was surrounded by mountains on three sides.

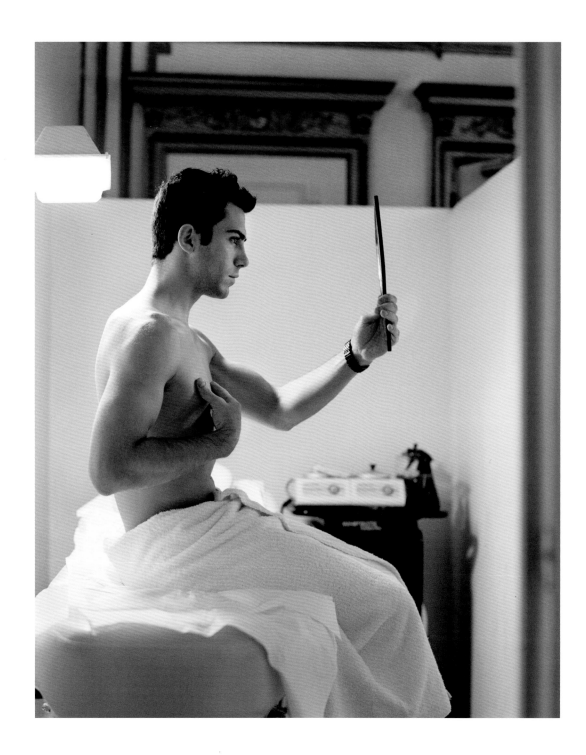

People worldwide experience pressure to conform to specific, often commercially created, ideals of beauty. Christopher, 22, examines his chest after a waxing treatment to remove hair, in a New York beauty salon.

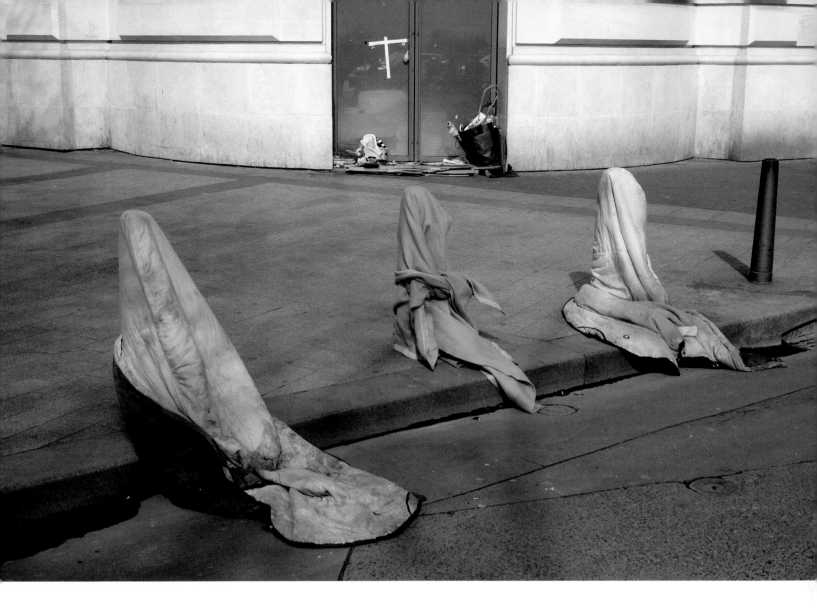

Bedding belonging to homeless people is set out to dry, on the Champs Elysées in Paris. Up to 30,000 people sleep on the streets in Paris – a hard core of over 10,000 habitual rough-sleepers, with the rest made up of people spending a night or two on the streets for more transitory reasons.

Slaughterhouses in Umbria, Italy. Neatly packaged meat in supermarkets is often completely detached in consumers' minds from the process of its production.

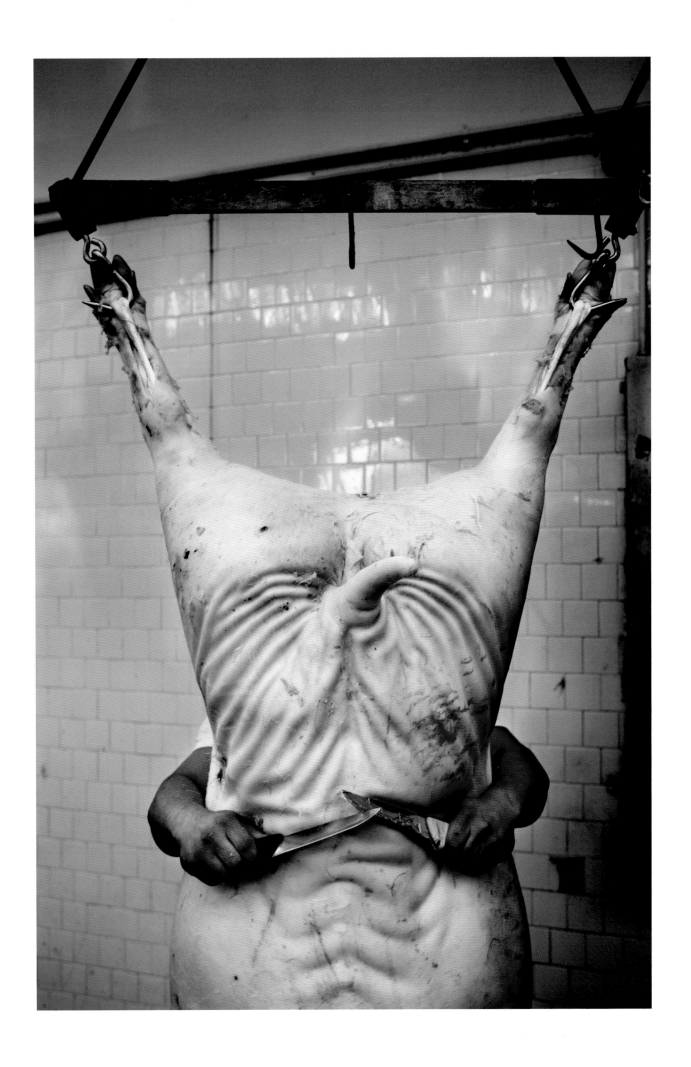

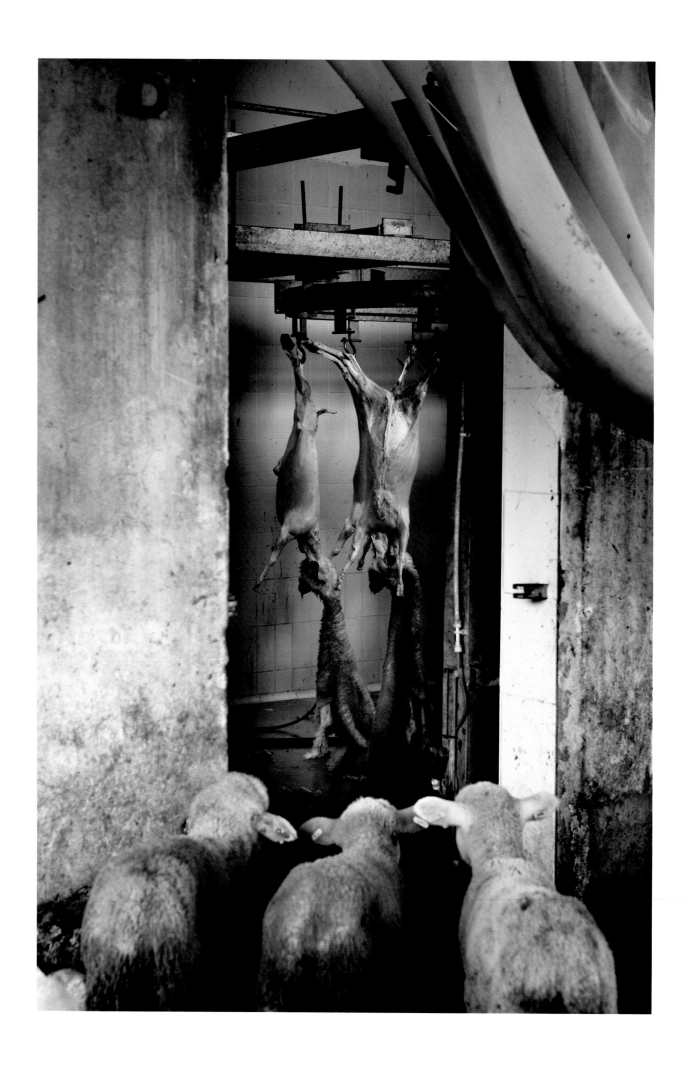

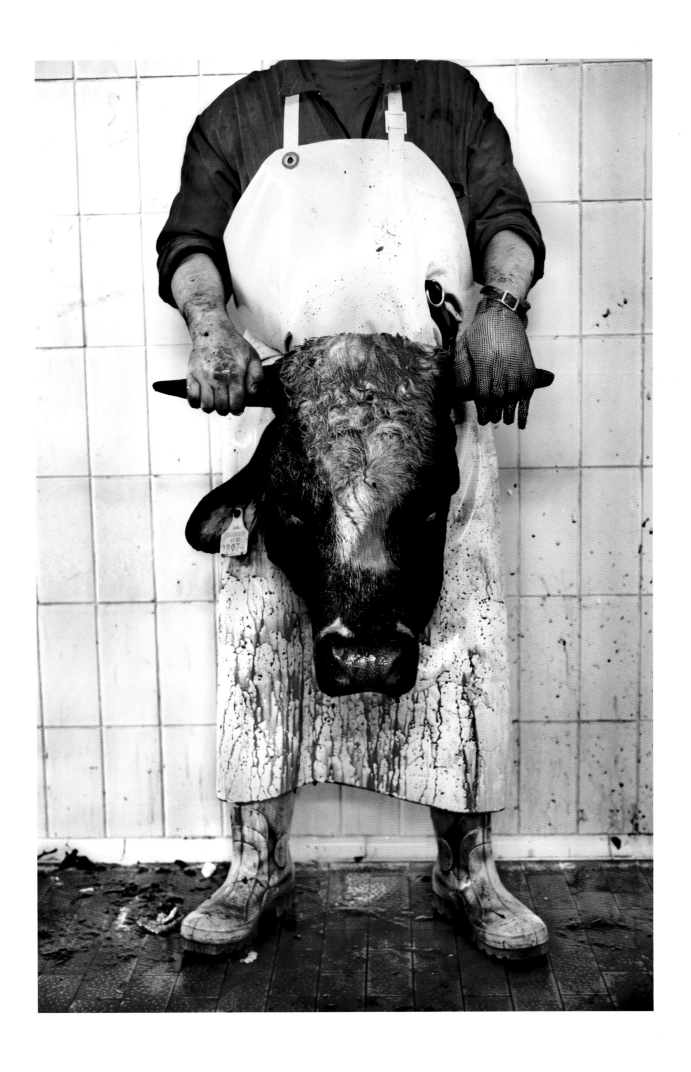

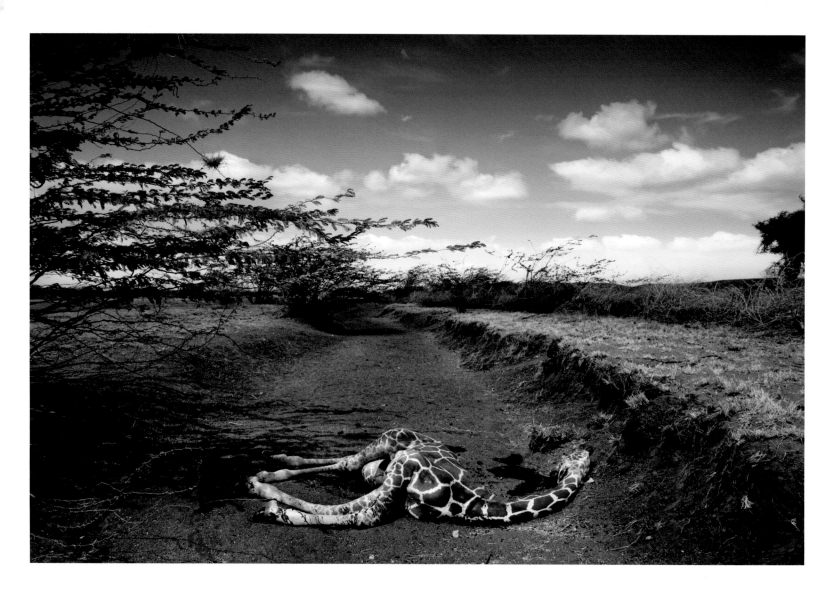

A giraffe, killed by drought, lies in a dry river bed in Wajir, northeastern Kenya. Wet-season rains in the region had failed completely for three years running. Many natural water sources had dried up, and even the more resilient animals such as elephants and giraffes were dying, alongside those more susceptible to water shortage. The drought also caused immense suffering among nomadic pastoralists in the area, as their herds were decimated and grazing land turned to desert.

Nature

SINGLES

1st Prize

Joe Petersburger

2nd Prize

Nick Cobbing

3rd Prize

Paolo Patrizi

STORIES

1st Prize

Paul Nicklen

2nd Prize

Peter Bialobrzeski

3rd Prize

Fang Qianhua

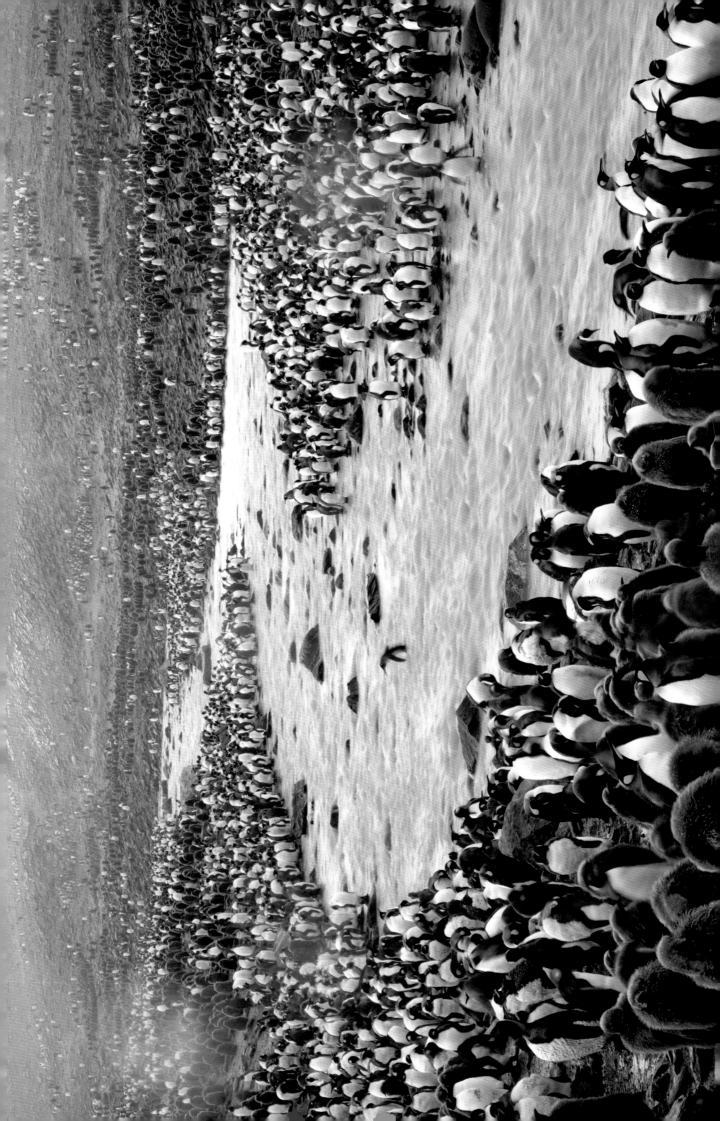

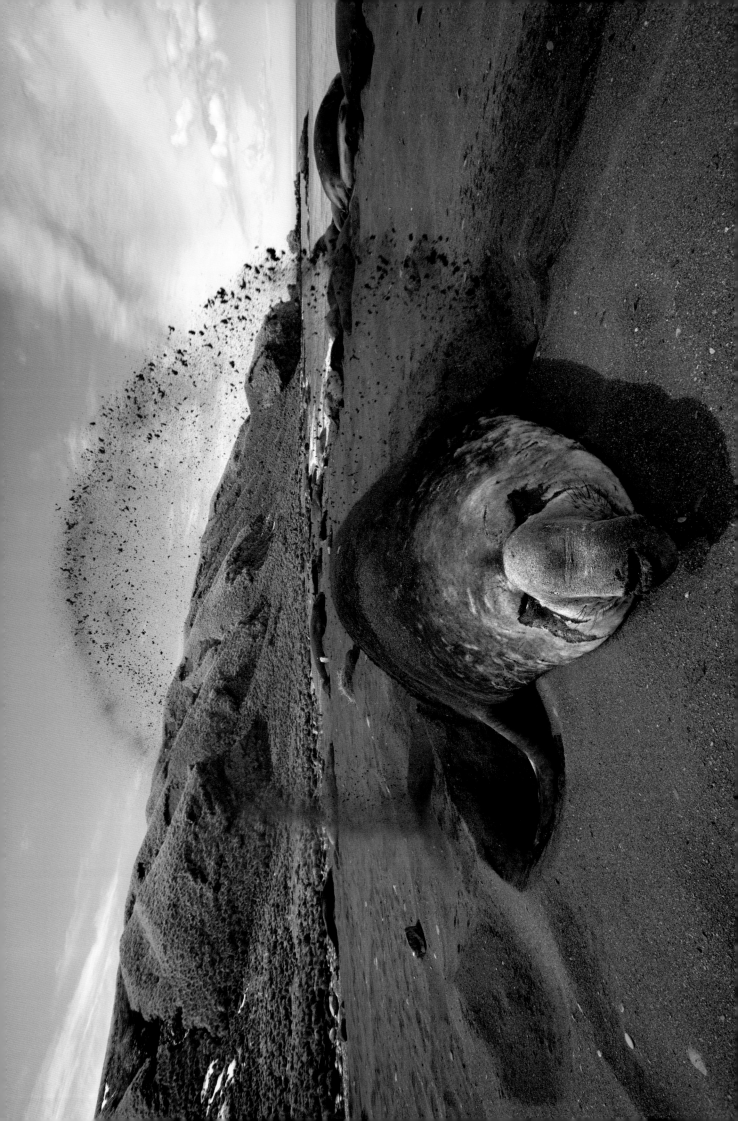

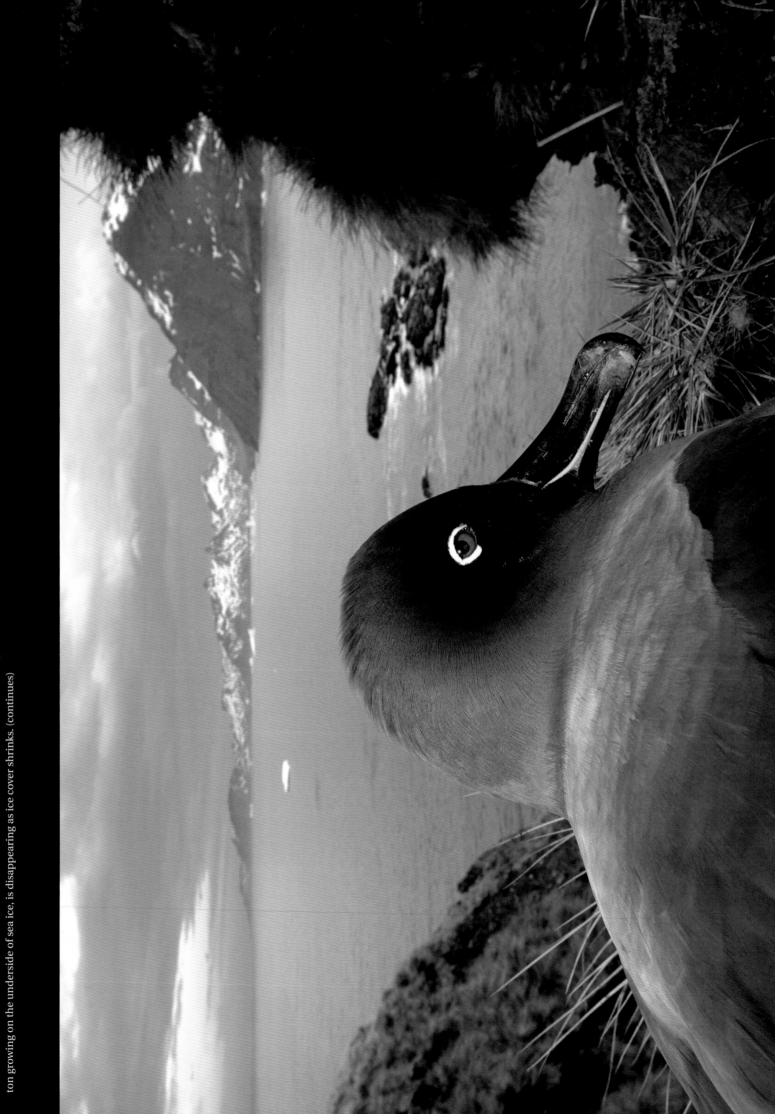

(continued) Krill — small, protein-rich crustaceans — are a vital part of the entire Antarctic food chain. Their own food source, phytoplankton growing on the underside of sea ice, is disappearing as ice cover shrinks. (continues)

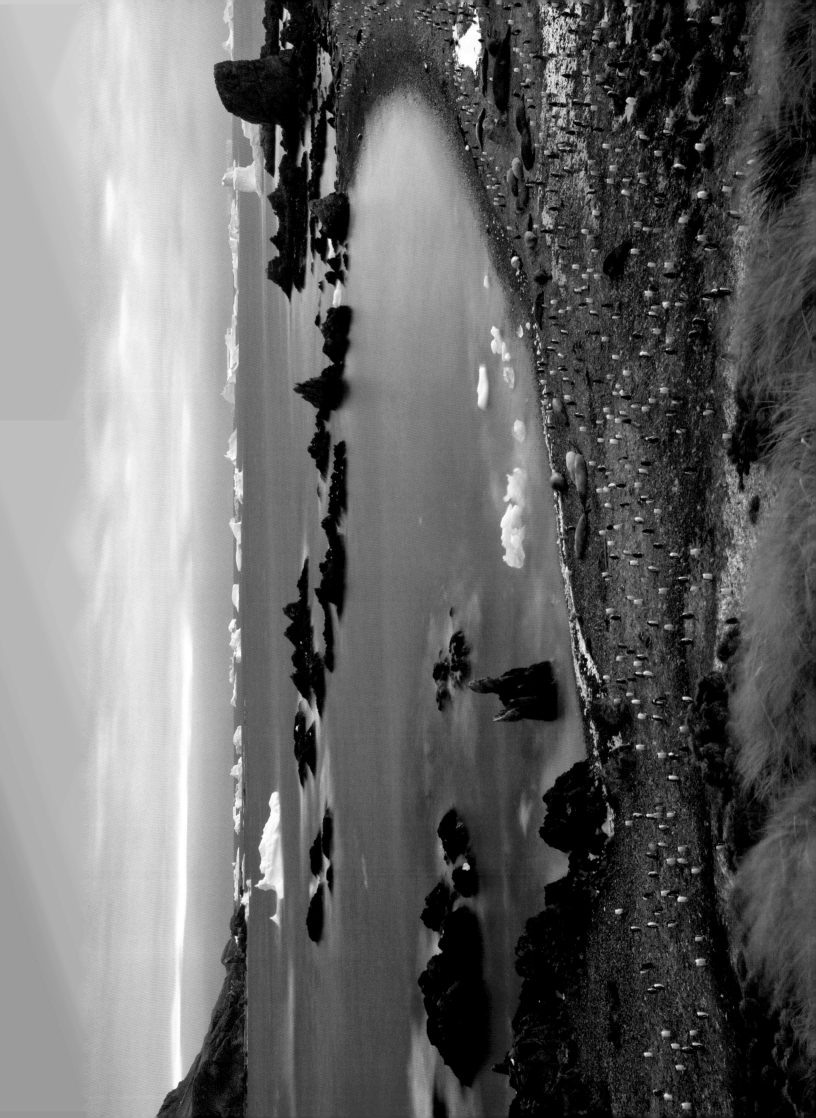

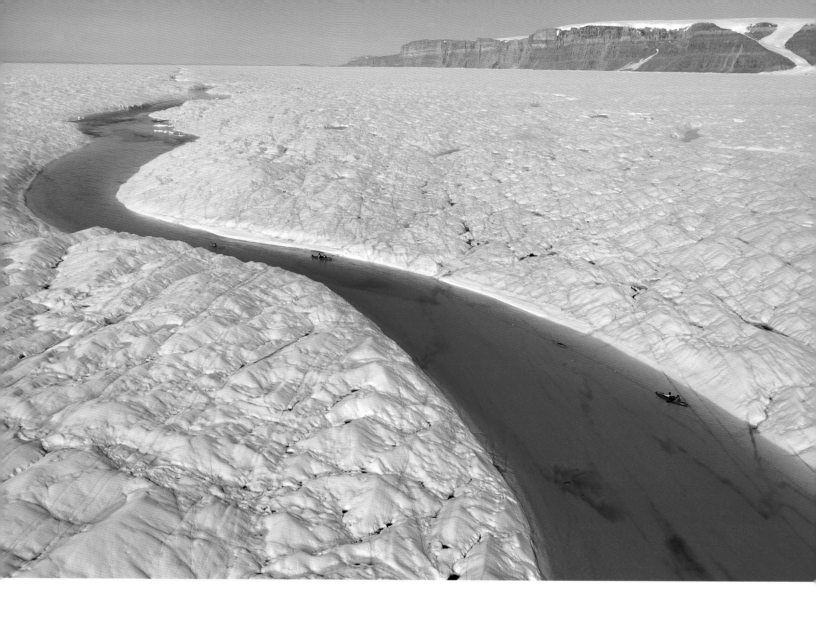

Glaciologists tow an ice-sounding radar between kayaks along a melt-water ravine on Petermann Glacier, one of the most northerly glaciers on Greenland. The radar scans the changing structure, the thickness and melt rates at the base of the glacier, which is one of the largest on Greenland. The scientists kayak over an area where the landward glacier starts floating and thins rapidly, due to incoming warm currents. The data they gather is vital in making predictions about how an influx of glacial melt water into the ocean might affect rises in sea level.

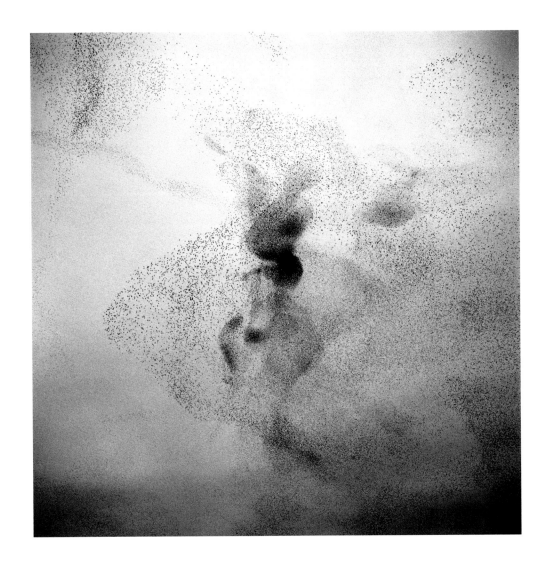

Thousands of European starlings flock above Rome in January, as they prepare to roost for the night. Though the birds have long flown from northern Europe to the warmer environs of Rome in winter, they used to remain outside the city limits. As Rome expanded after the Second World War, the starlings adapted to living in an urban environment, which offered warmer temperatures and fewer predators than the countryside, though they still fly out of the city to feed. They are considered pests, both for the large quantities of droppings that foul Rome's buildings, streets and monuments, and for devouring fruit and olives in surrounding farmland.

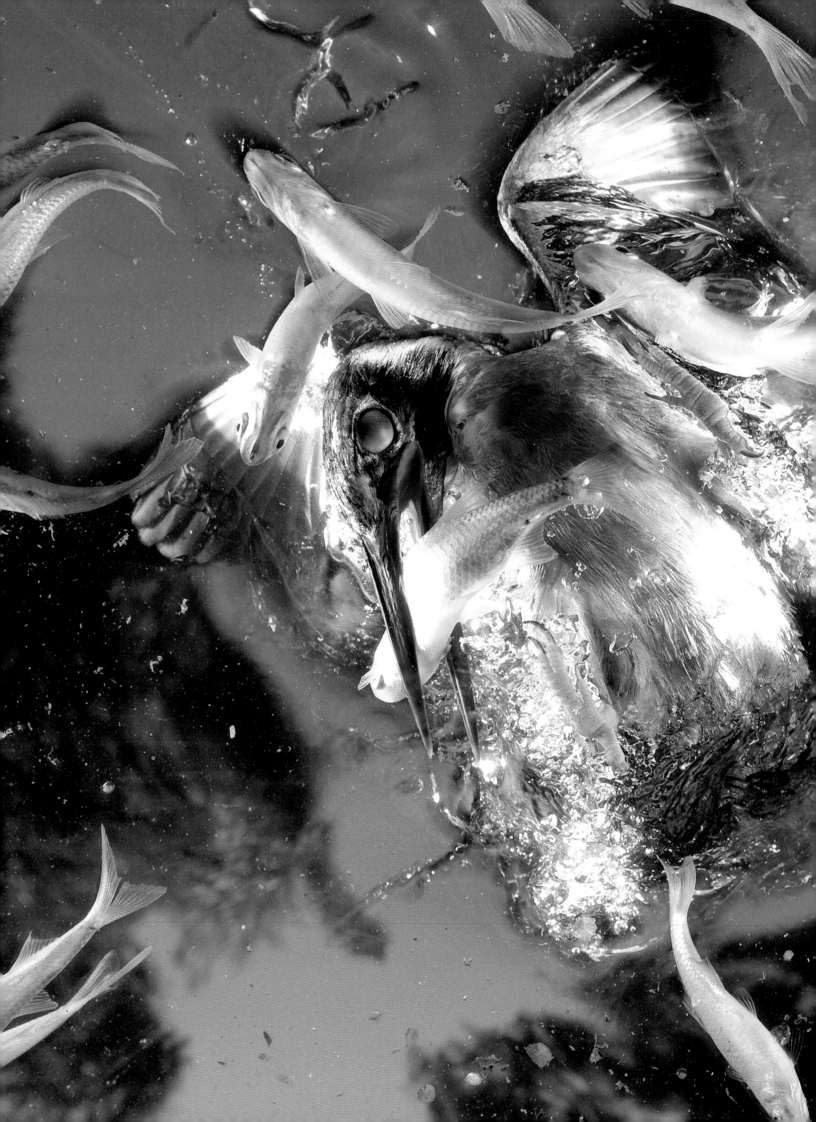

A kingfisher catches a fish, closing its third eyelid. When the kingfisher dives, this lid protects the eye from damage, yet is still sufficiently transparent for the bird to follow its prey underwater.

Oranges affected by cadmium contamination, near the Xianghe Chemical factory, Liuyang, Hunan province, China. The factory illegally processed ore from zinc production to extract the heavy metal cadmium. Waste water and earth remaining from the process was dumped into a narrow valley behind the factory. The chemical plant was closed down in 2009, but environmental experts discovered surrounding soil to be severely contaminated. Officials said that the poisoning reached a radius of about 500 meters from the factory, but evidence from poisoned crops up to 1.5 km away pointed to a more serious situation.

Lush vegetation grows in the artificial light of large Asian cities. Unlike natural sunlight this radiance from sodium lamps, automobile headlights and illuminated skyscrapers comes from all directions. Jakarta, Indonesia.

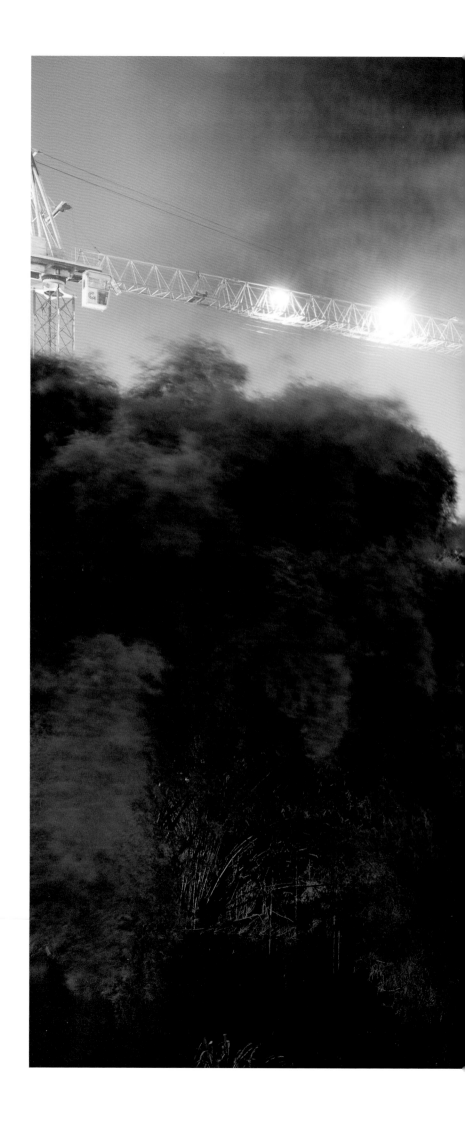

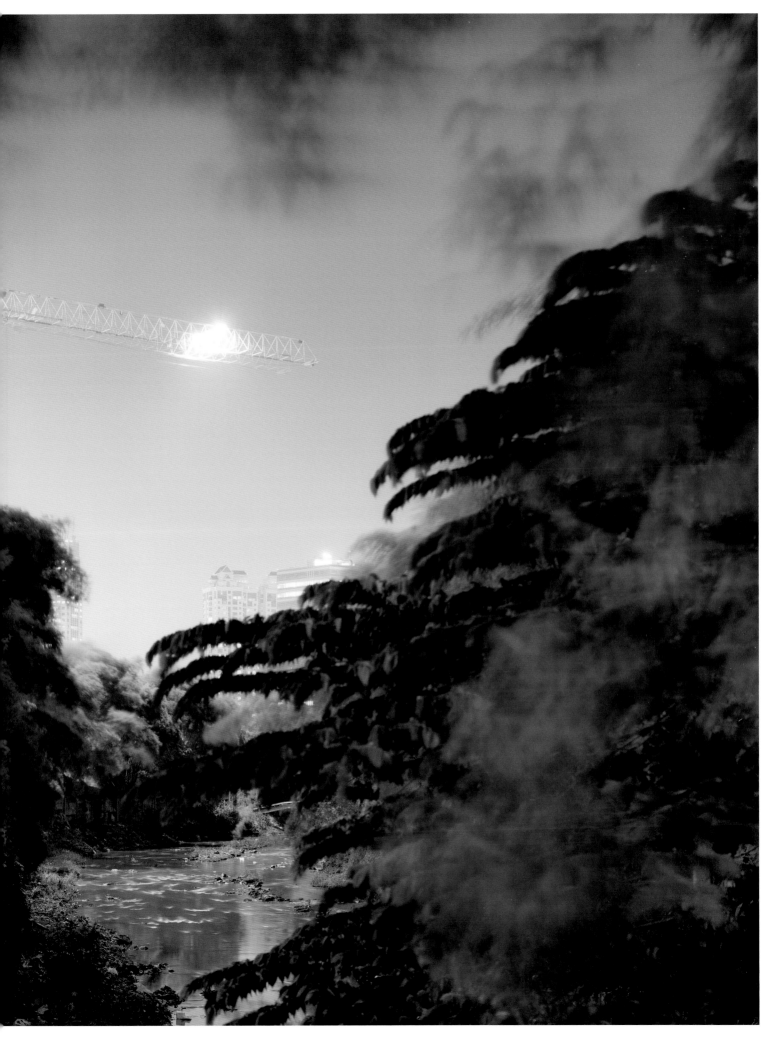

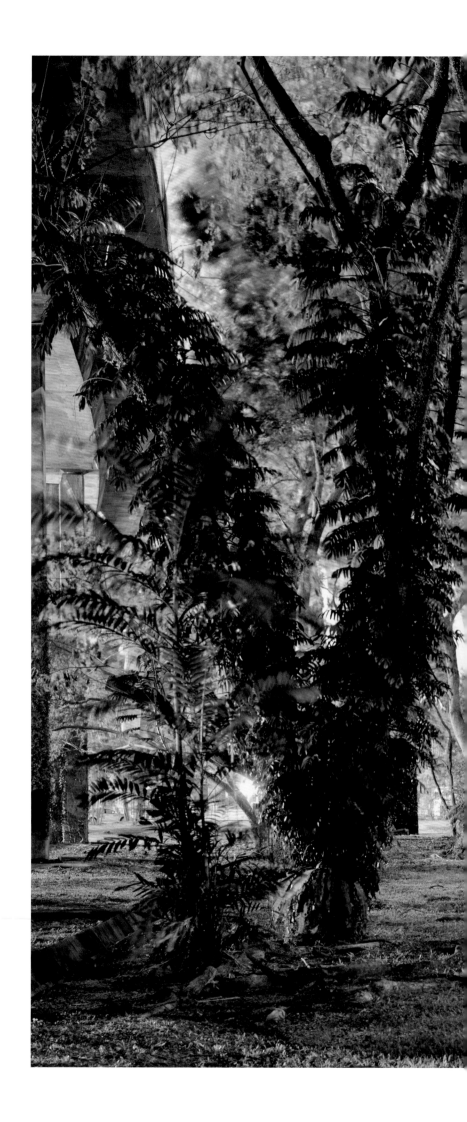

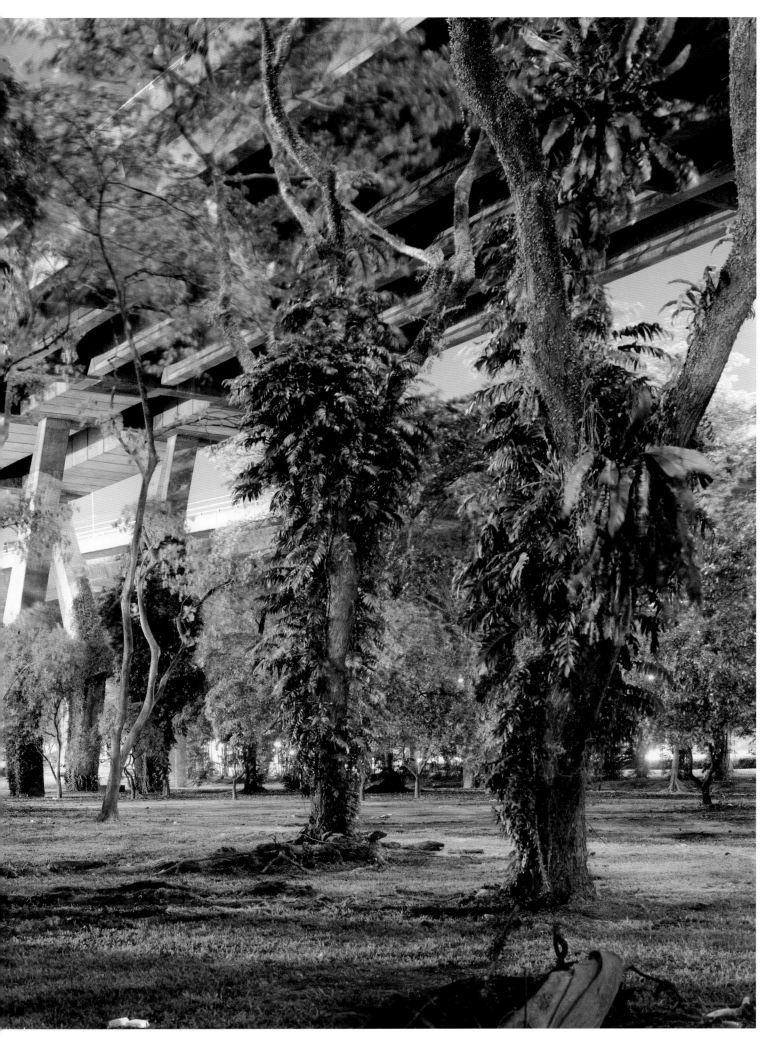

Portraits

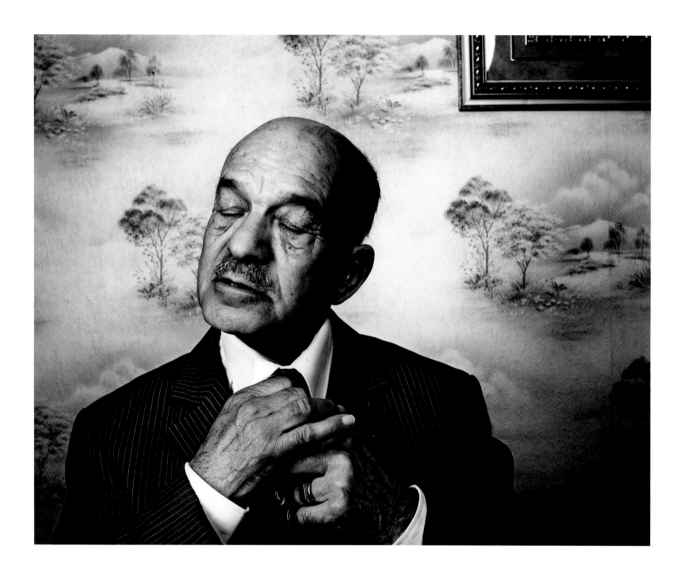

Mohand Dendoune was born in 1928 in Algeria, at the time a French colony, but has lived in France since the 1950s. He worked first as a manual laborer, later with Renault and then as a gardener at a hospital. Together with his wife and first children, he lived for some time in a small room in the suburbs, later moving to a larger apartment and raising a family of nine. He has never taken out French nationality.

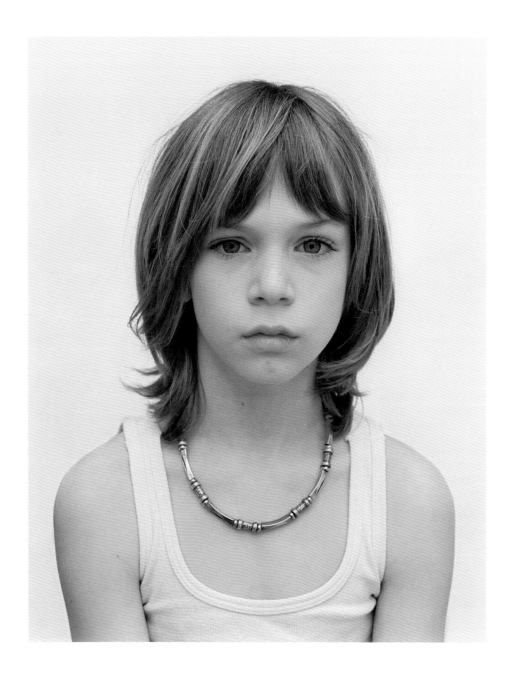

Before they reach puberty, some boys and girls can appear androgynous. The photographer took portraits of young people between the ages of six and 18 over a period of five years, with the aim of challenging viewers' perceptions of gender definitions.

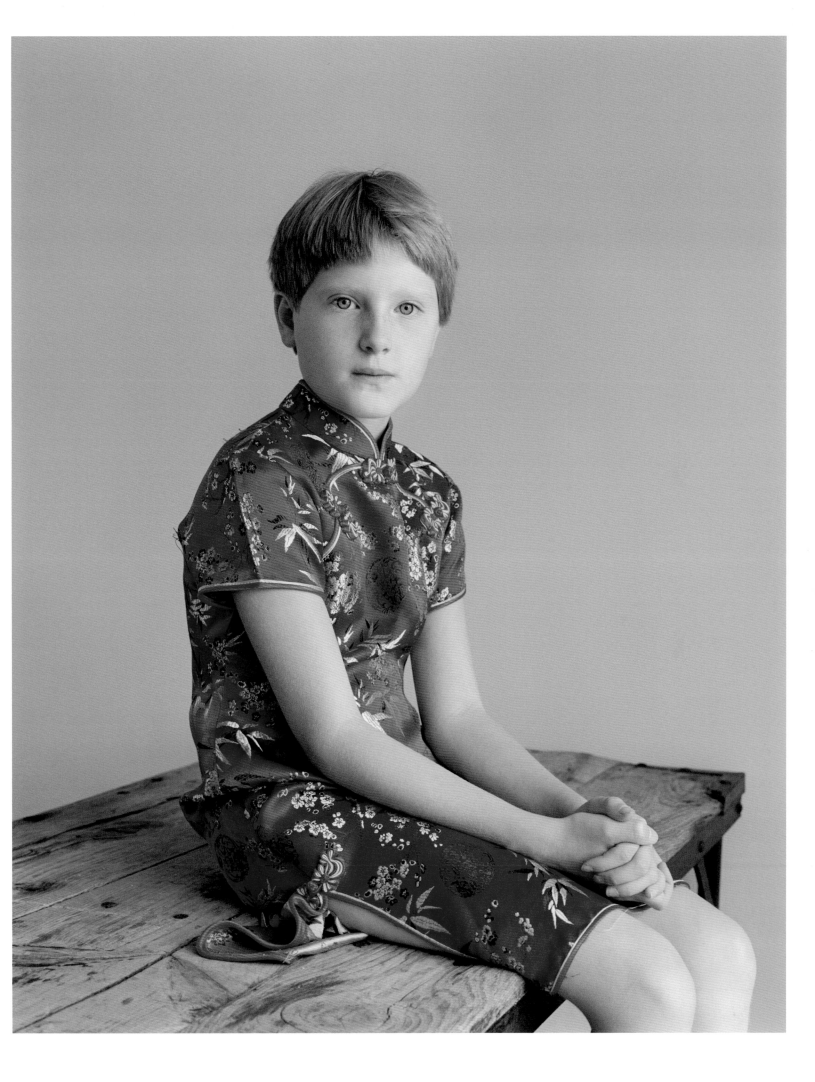

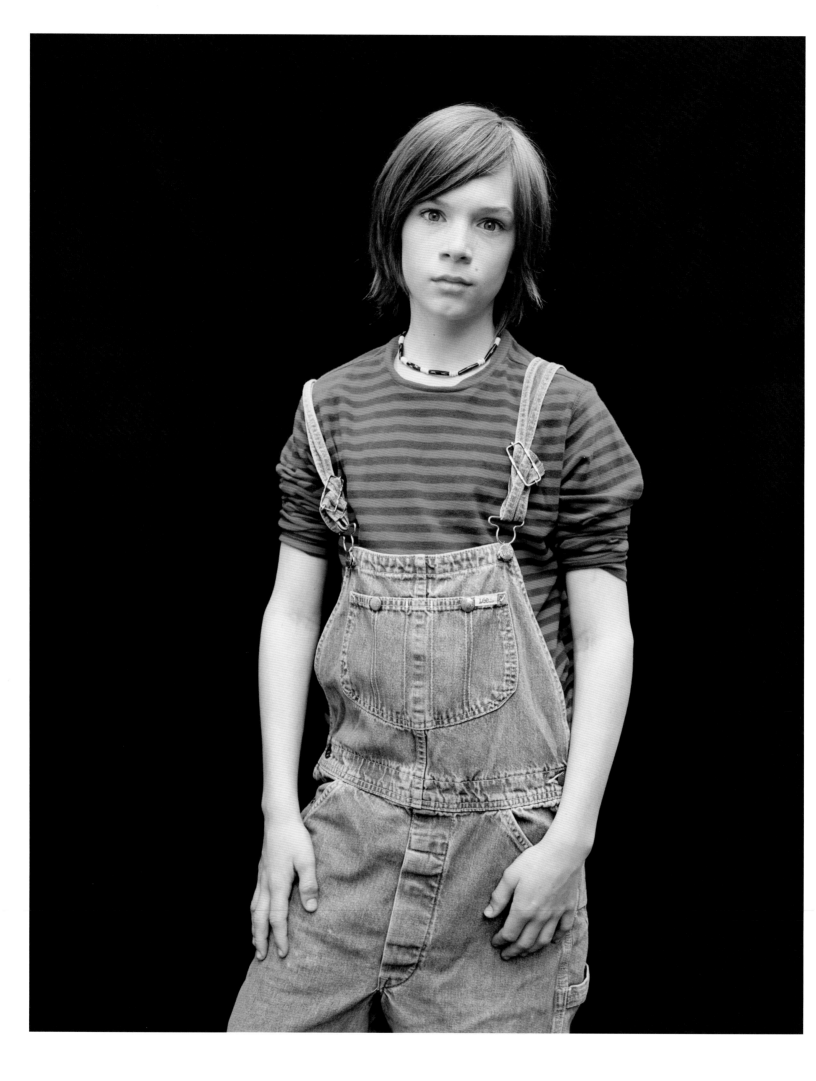

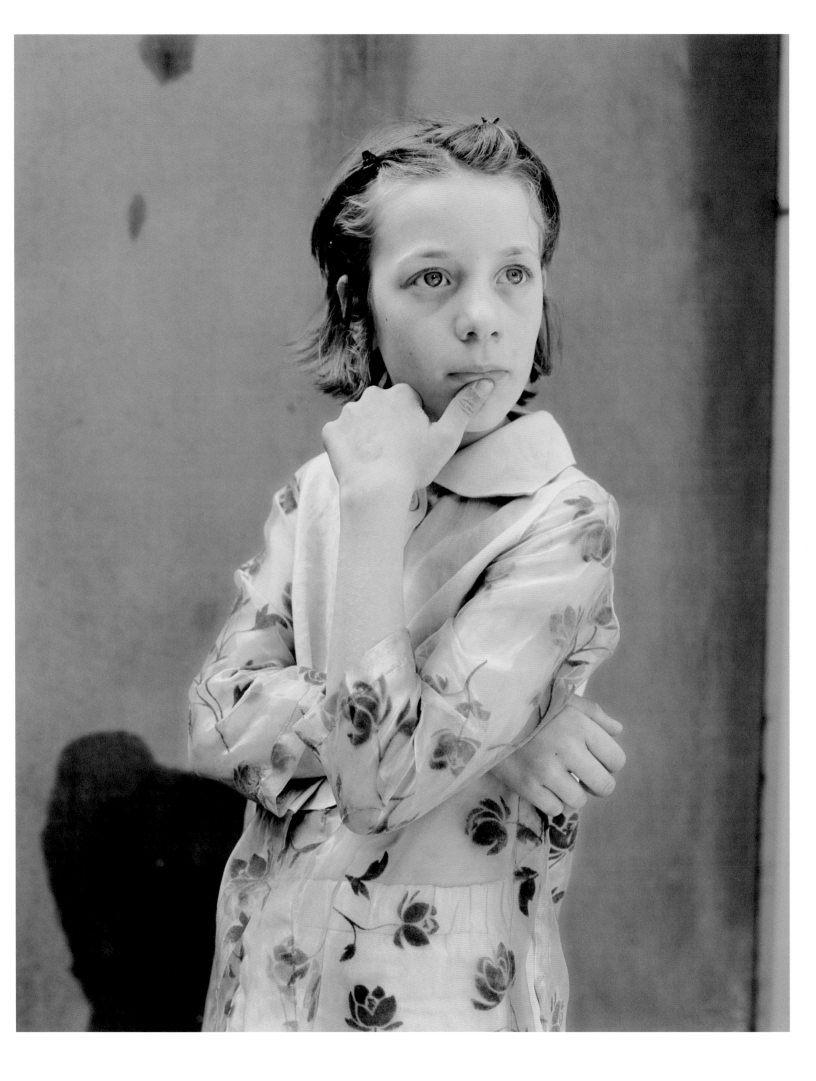

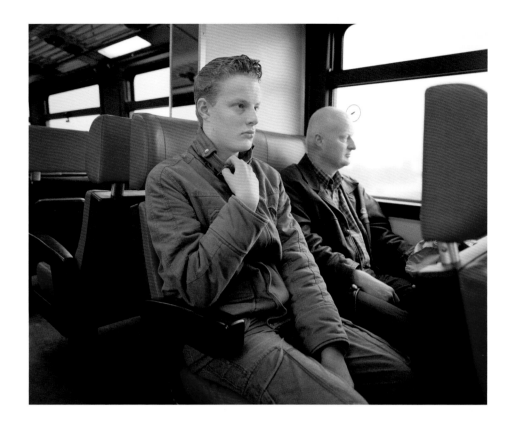

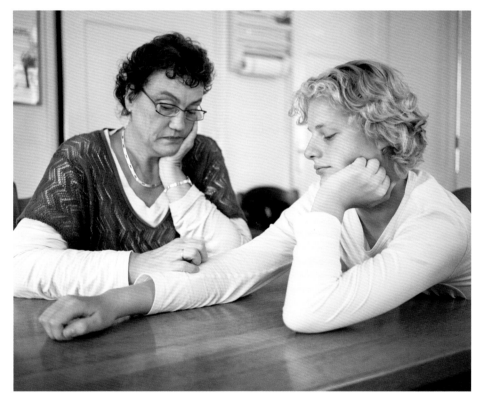

Eva is a teenager with Gender Identity Disorder (GID), receiving treatment which may in time lead to
sex-reassignment surgery. Born a boy (and called Koos), Eva always behaved like a girl and felt an
intense desire to be one. At the age of 13, Koos saw a TV documentary about GID and realized what
was amiss. Together with his mother, Koos visited the VU Medical Centre in Amsterdam, which has a
GID team for children. At the hospital, extensive interviews are conducted over a number of months

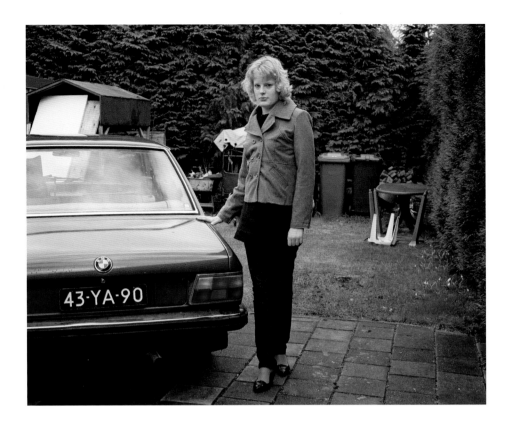

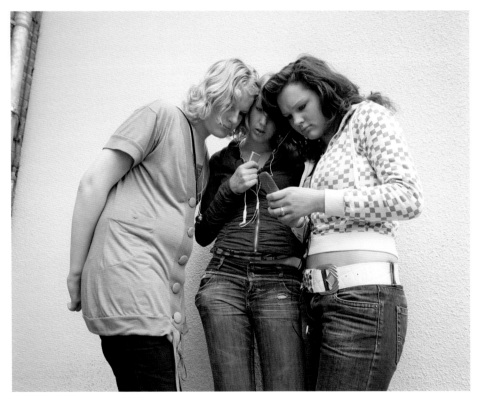

with both parent and child, before psychological tests and a psychiatric investigation are carried out. After the age of 12, young adolescents may be given drugs to delay the onset of puberty, in order to give them time to think about their identity without any sense of urgency. Psychiatric support continues, and only after the age of 16 can cross-sex hormonal treatment be introduced. If the person chooses to continue the process, sex-reassignment surgery occurs after the age of 18.

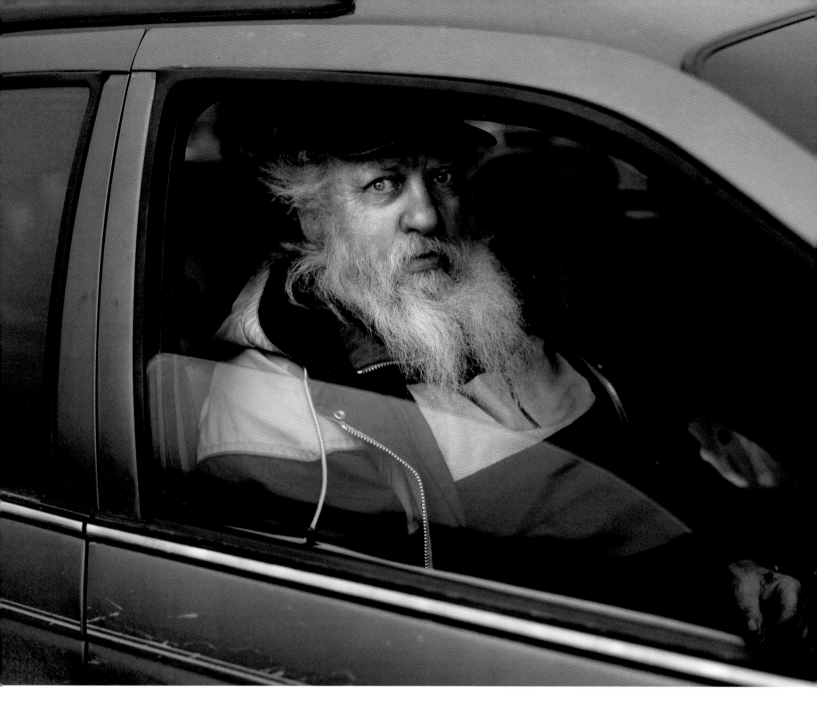

Time spent in an isolated part of British Columbia in Canada drew the photographer's attention to the long hours people spend in their vehicles, suspended in a space between the point of departure and their destination. Above: Williams Lake, British Columbia, Canada. Facing page: Vancouver, Canada. Following pages: Williams Lake, British Columbia, Canada.

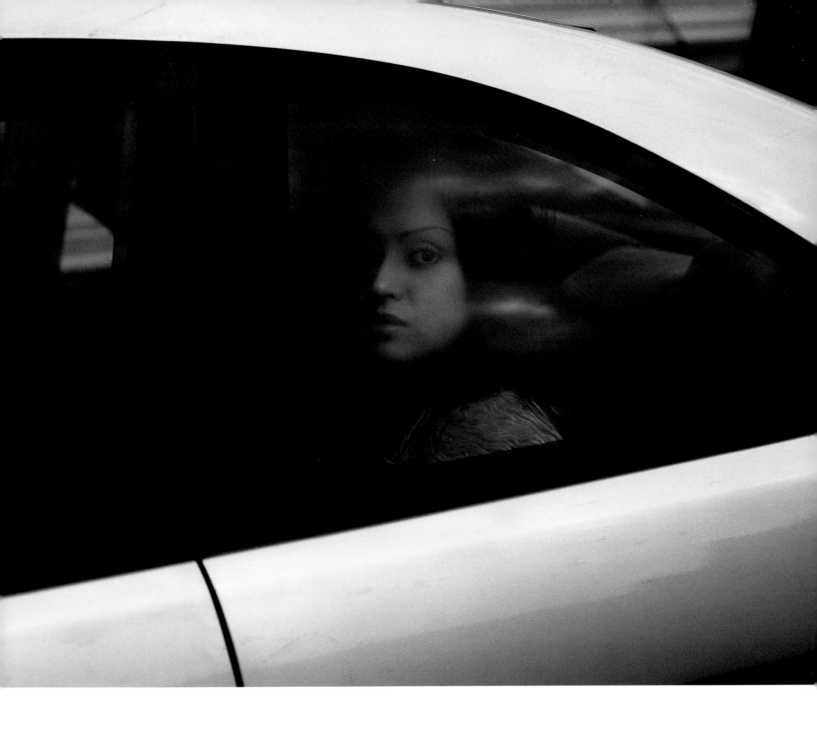

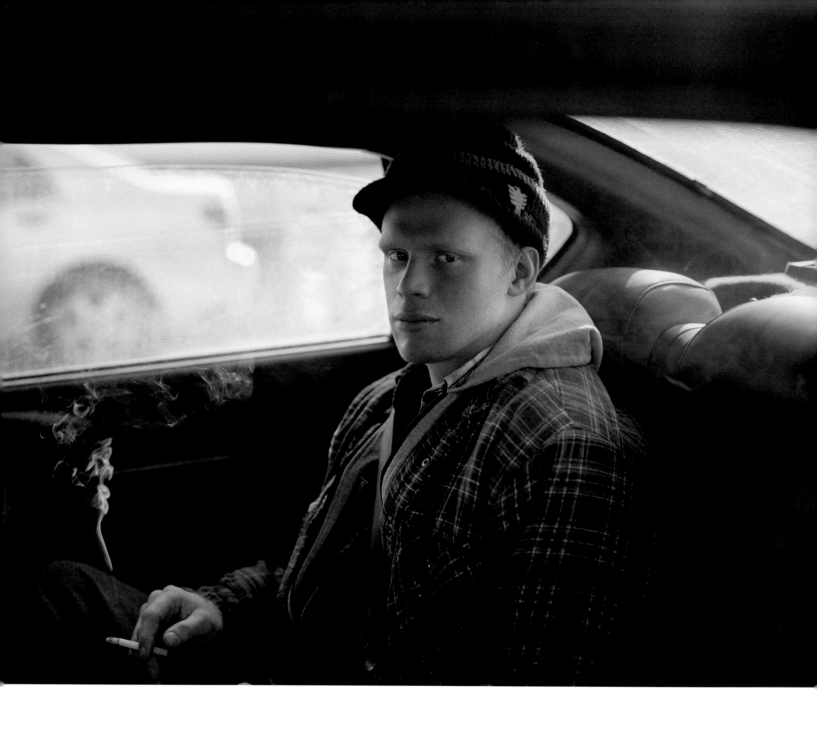

Graham has suffered from anorexia nervosa since he was 14. Initially a chubby child, he developed the condition after becoming infatuated with a girl in his class, trying to lose weight to attract her. As the disorder took hold, Graham became so preoccupied with being thin that he ceased to care about the girl. By the time he was 15 he weighed just over 30 kg, but after retraining himself to eat, he managed to double that weight over the next six years. Now 24 and working as an actor, he sees himself as still recovering from anorexia, and suffers the occasional relapse. Incidence of anorexia is far less common among men than among women. The UK National Health Service estimates that around one in 250 women and one in 2,000 men will experience the eating disorder at some point in their lives, but an exact assessment is difficult as it is suspected that male sufferers are less likely to seek help than women.

Katie, a resident of Hungry Horse, Montana, USA, a town with a population of just 900 people in the Rocky Mountains.

Arts and Entertainment

SINGLES
1st Prize
Malick Sidibé
2nd Prize
JR
3rd Prize
Kees van de Veen
STORIES
1st Prize
Kitra Cahana
2nd Prize
Francesco Giusti
3rd Prize
Karla Gachet

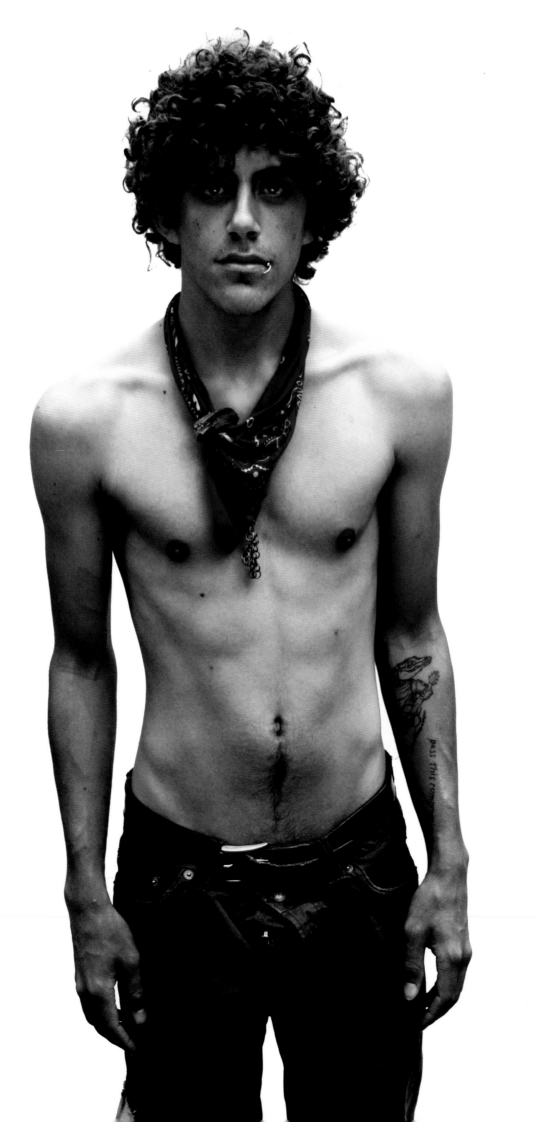

The Rainbow Gathering is an annual festival that takes place around the Fourth of July holiday weekend, in a different American national park each year. Part of the point of the gathering is to celebrate inclusiveness and love for the Earth, and to pray for world peace. The annual festival attracts hundreds of teenage runaways and travelers, who are nicknamed 'The Dirty Kids'. This page: Jeffrey Martin (18). Facing page, top: A traveler sorts through the contents of her bus. Below: Amber (18) soaks up music and mud during a personal spiritual fast. (continues)

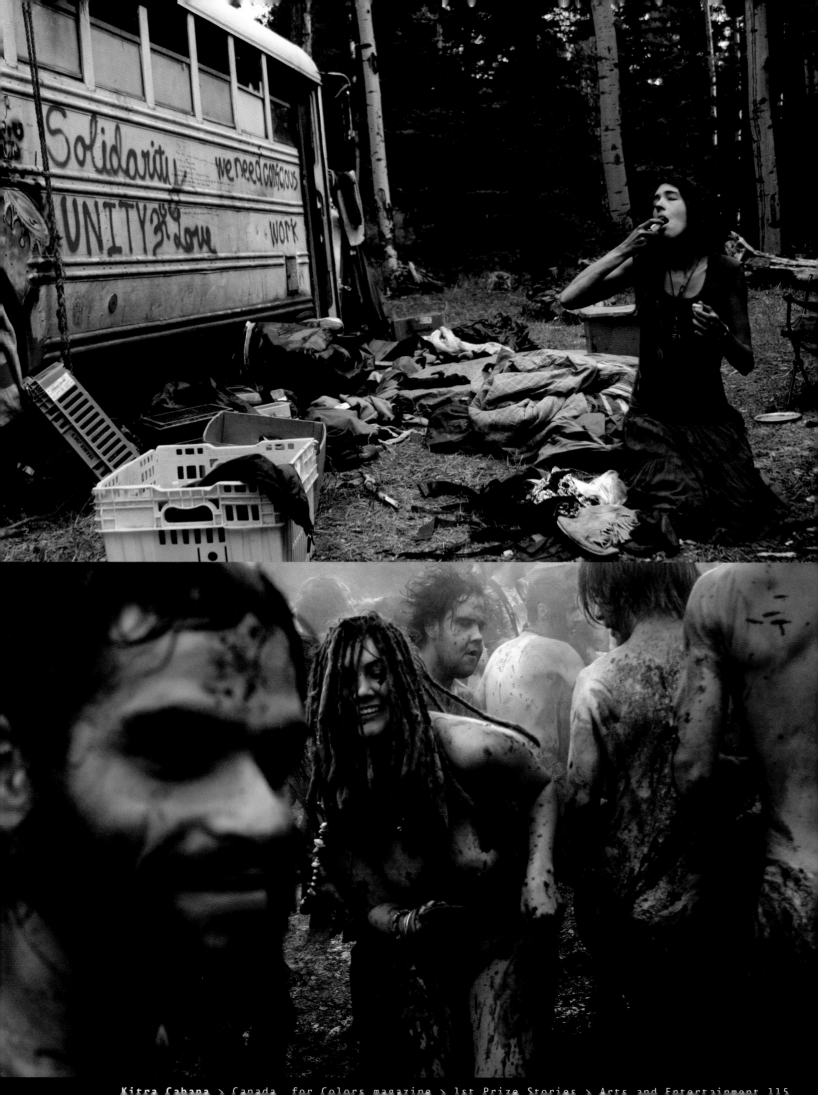

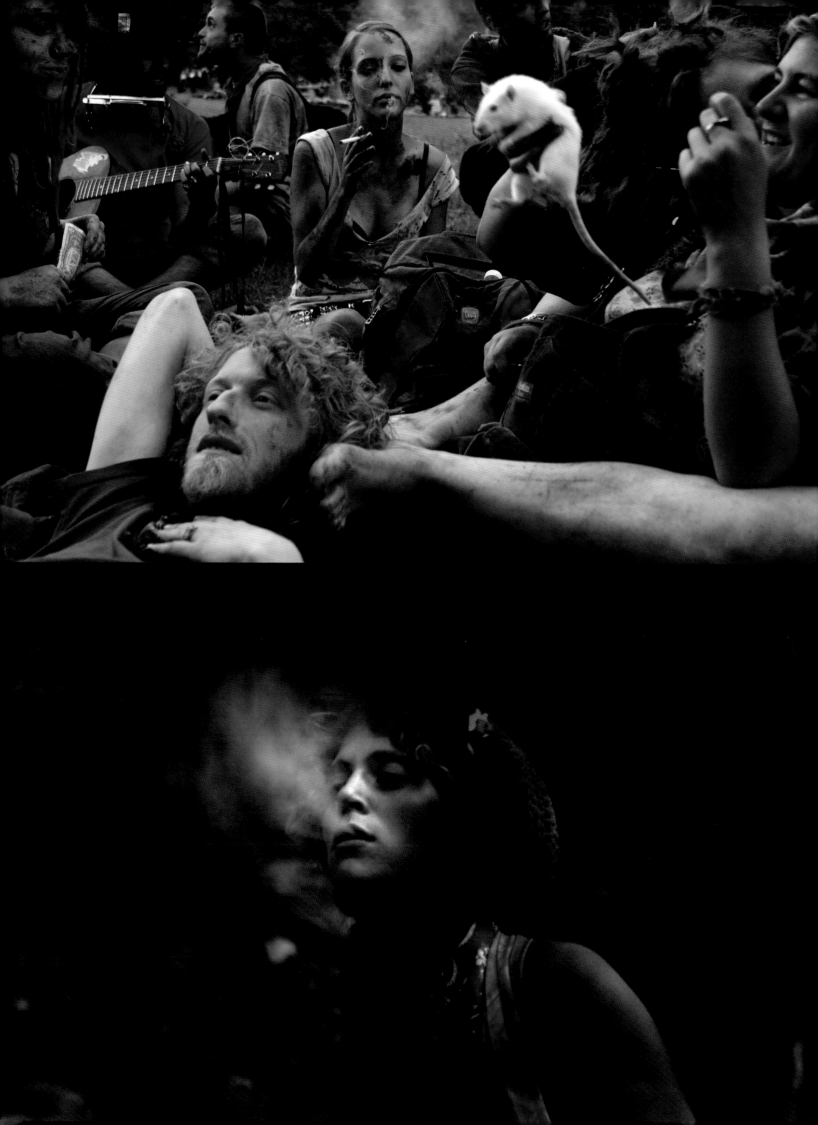

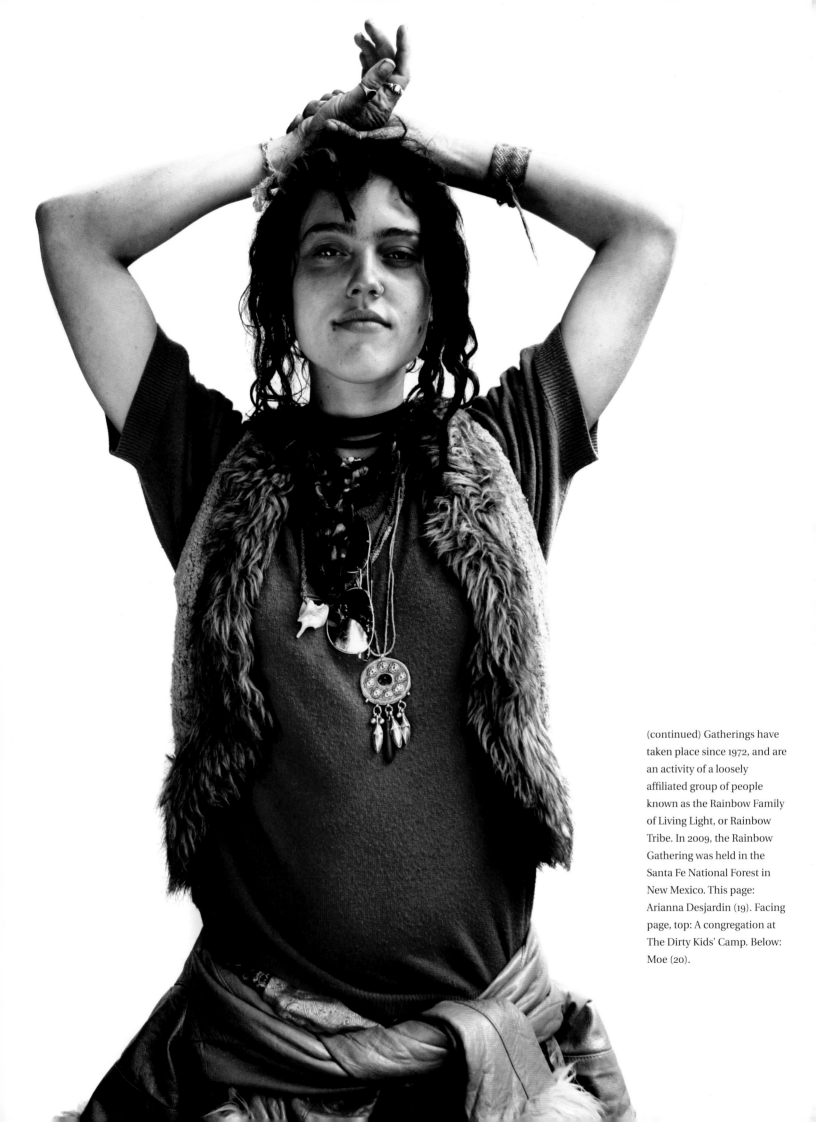

(continued) Gatherings have taken place since 1972, and are an activity of a loosely affiliated group of people known as the Rainbow Family of Living Light, or Rainbow Tribe. In 2009, the Rainbow Gathering was held in the Santa Fe National Forest in New Mexico. This page: Arianna Desjardin (19). Facing page, top: A congregation at The Dirty Kids' Camp. Below: Moe (20).

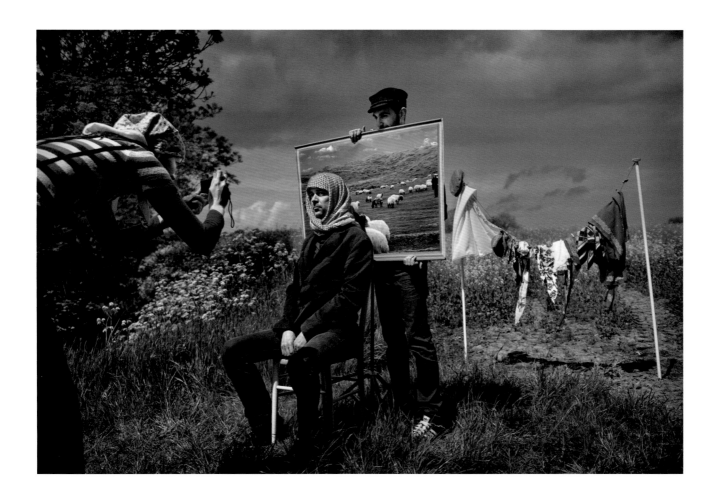

Artists Janna Bathoorn and Onur Kilinçci, together known as Güler Lacht, take photographs of people dressed in Middle Eastern clothing against different backdrops, in order to challenge preconceptions. At KunstSpoor, a three-day art event held at the end of May in the northern Dutch town of Stedum, Güler Lacht were to be found at the end of a kilometer-long route of different art and artists.

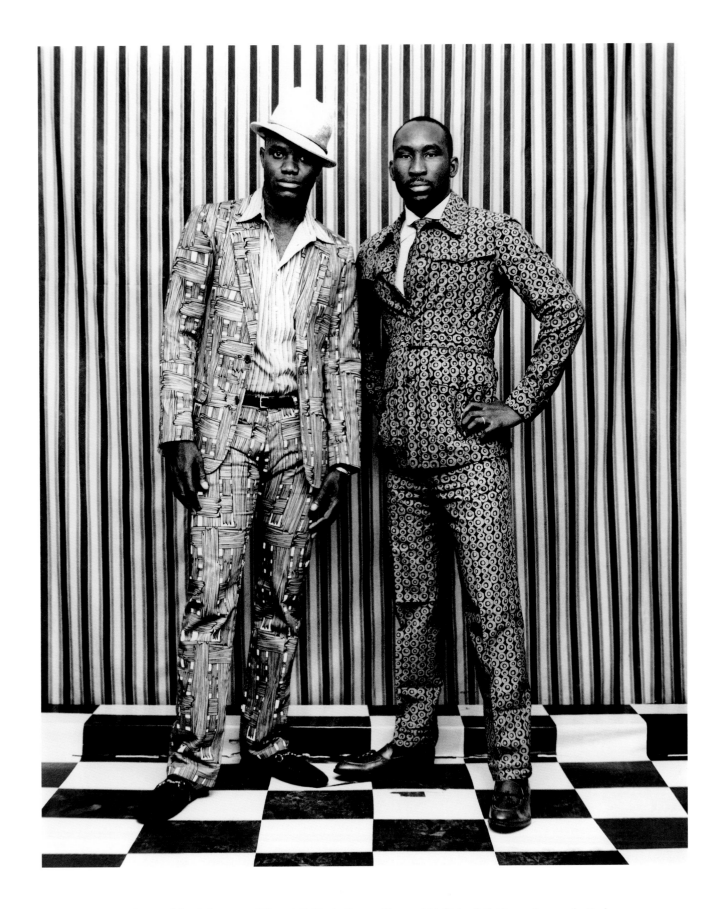

Abdoulaye Diakibe (left) wears a Viktor & Rolf suit, Bottega Veneta shirt, Dolce & Gabbana shoes and a Burberry hat. Mamoutou Kone wears a Dries Van Noten suit and shirt, an Etro tie and Paul Smith shoes.

Ceci, 20, is a tango dancer. She has been dancing since the age of 11, when she was taught tango by her grandparents. During the day she performs for tourists in restaurants and on the streets of the El Caminito quarter of Buenos Aires. Mostly she dances with the same partner, Meme. At night Ceci and Meme head to *milongas*, neighborhood dance parties throughout the city. Ceci is also a student and tries to balance her work with commitments at university. Top row: Ceci's feet suffer from hours of dancing in high heels. Meme knows her routines and style. Second row: Ceci sometimes has to take a taxi to class after work, if she is too late for the bus. Tips are split among dancers after performing. Third row: Ceci has a disagreement with her boss at one of the restaurants where she dances, because she was late after class. Ceci was fired. Ceci and Meme dance outside one of the restaurants in El Caminito. Bottom row: Ceci and Meme get changed after work.

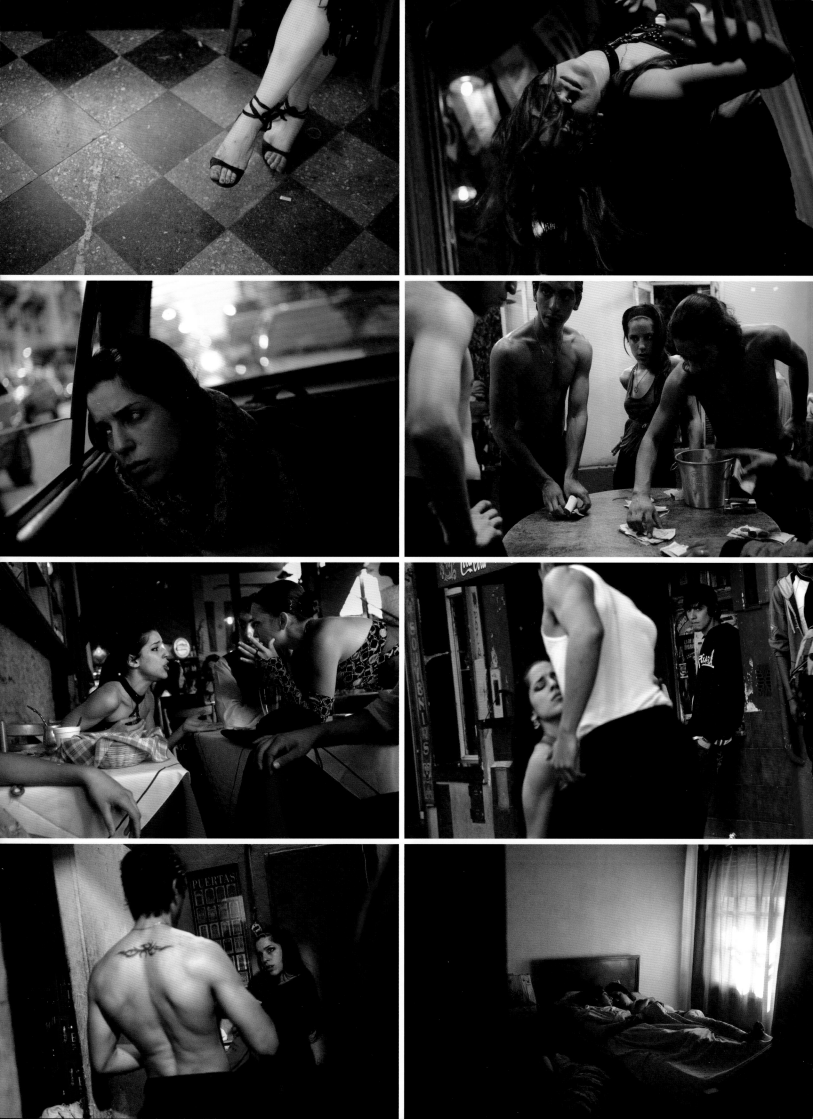

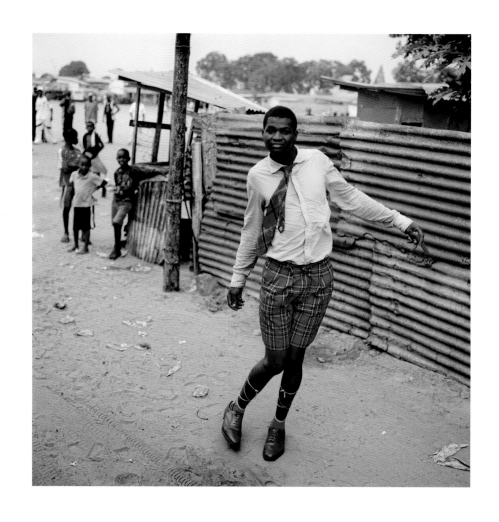

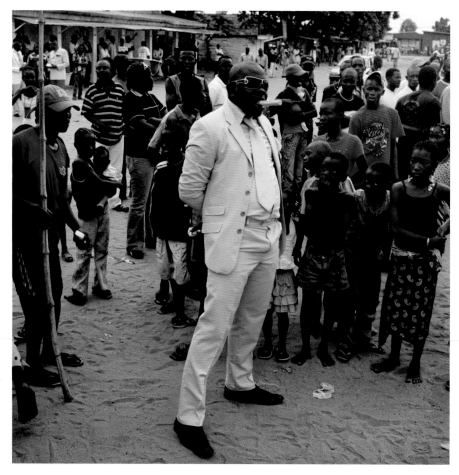

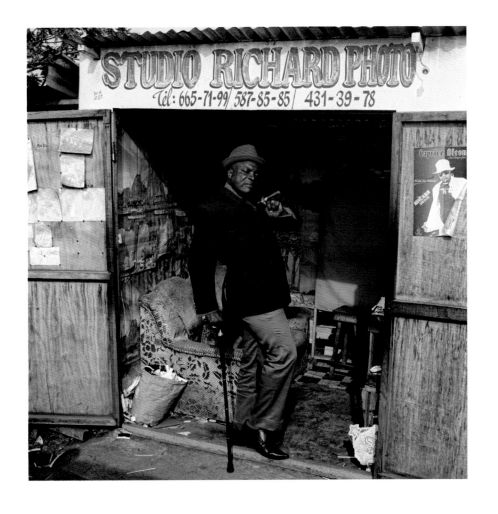

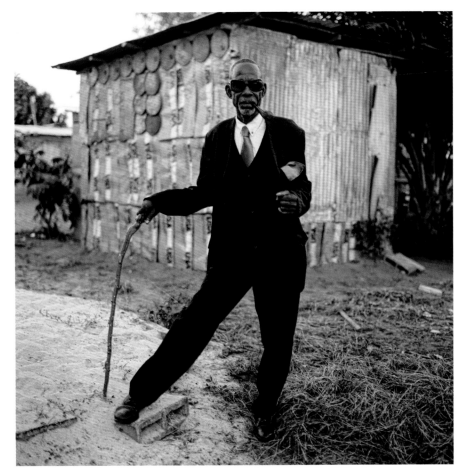

The Société des Ambianceurs et des Personnes Élégantes (Society of Entertainers and Elegant People, SAPE), in Congo-Brazzaville, dates back to the 1920s and 1930s, when privileged Congolese returned stylishly dressed from visits to Paris. Today, this subculture of high fashion takes place against a backdrop of poverty. Many save for years to afford outfits, but originality in matching clothes and choosing the right accessories is respected more than the money spent. Some members of the SAPE, known as Sapeurs, have celebrity status, and make appearances at weddings and funerals. Each has a repertory of gestures, to distinguish him from the others, and many take on amusing nicknames. This page, top: Mabios De M'Paka', in Pointe-Noire, Congo's second city. Below: Vieux Kiboba', of Pointe-Noire. Facing page, top: Pariny Demi Poutou, Pointe-Noire. Below: Blaise 'le Guerrier', Pointe-Noire.

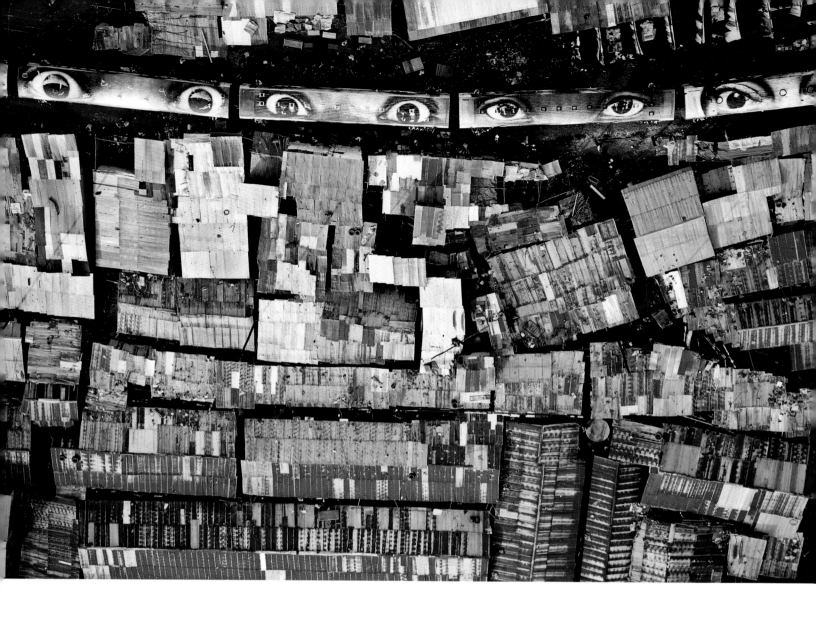

Close-ups of women's eyes adorn the roof of a train passing through Kibera, on the outskirts of Nairobi, Kenya. Between 700,000 and 1.2 million people live in poverty in the two square kilometers of shanties in Kibera. Men who have jobs catch the train to work, the women stay at home. The eyes on the train roof are part of the photographer's 'Women are Heroes' project, aimed at highlighting women's pivotal role in society.

Sports Features

SINGLES
1st Prize
Robert Gauthier
2nd Prize
Mark Holtzman
3rd Prize
Robert Beck
STORIES
1st Prize
Elizabeth Kreutz
2nd Prize
Denis Rouvre

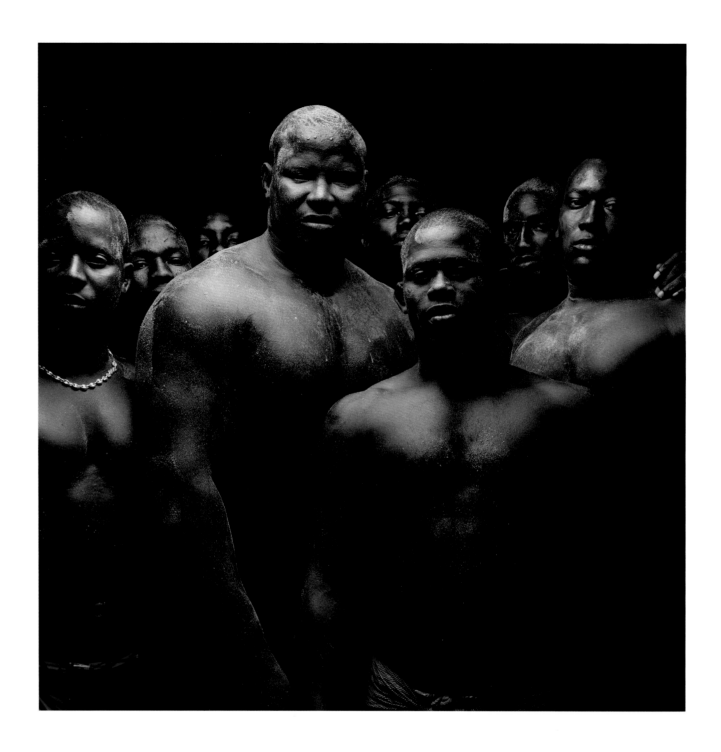

Senegalese wrestling, or *laamb* in the Wolof language, is a mix of conventional wrestling and bare-fist boxing. Contests are televised across the country, and important matches can fill a 60,000-seat stadium. Champions become national heroes, and can earn considerable sums of money. Top-rankers make upwards of €85,000 a fight, and even in the provinces good wrestlers may earn up to €300 a match — but cash prizes have been an incentive only since the 1960s. Traditionally, *laamb* was a demonstration of a young man's skill and strength in order to attract a marriage partner. The pageantry and ritual surrounding the centuries-old sport is almost as important as the wrestling itself. *Marabouts*, leaders of mystical Muslim brotherhoods, fashion amulets and talismans for the fighters for good luck, and coat their bodies with potions and milk to drive away evil.

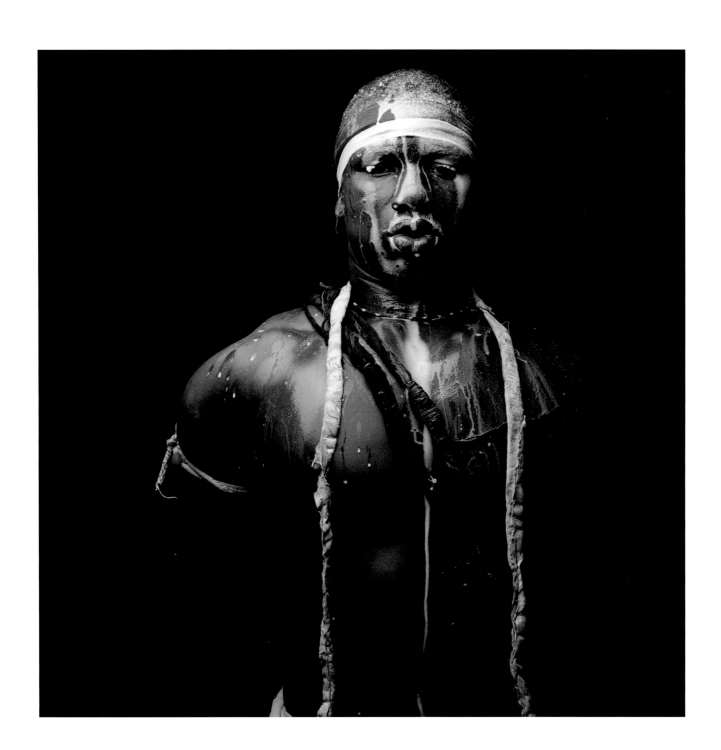

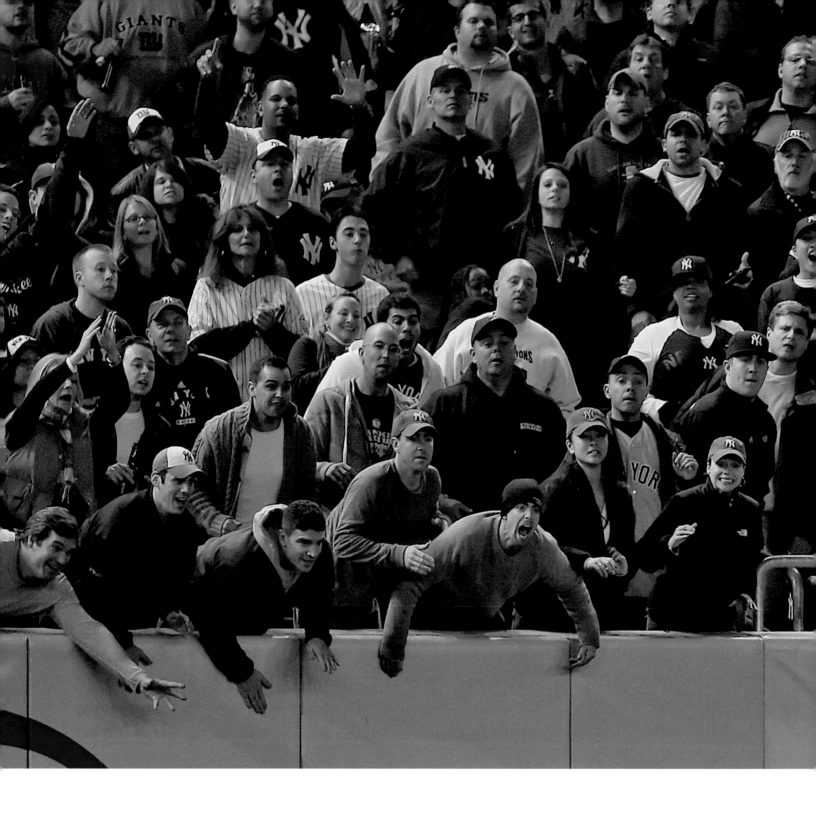

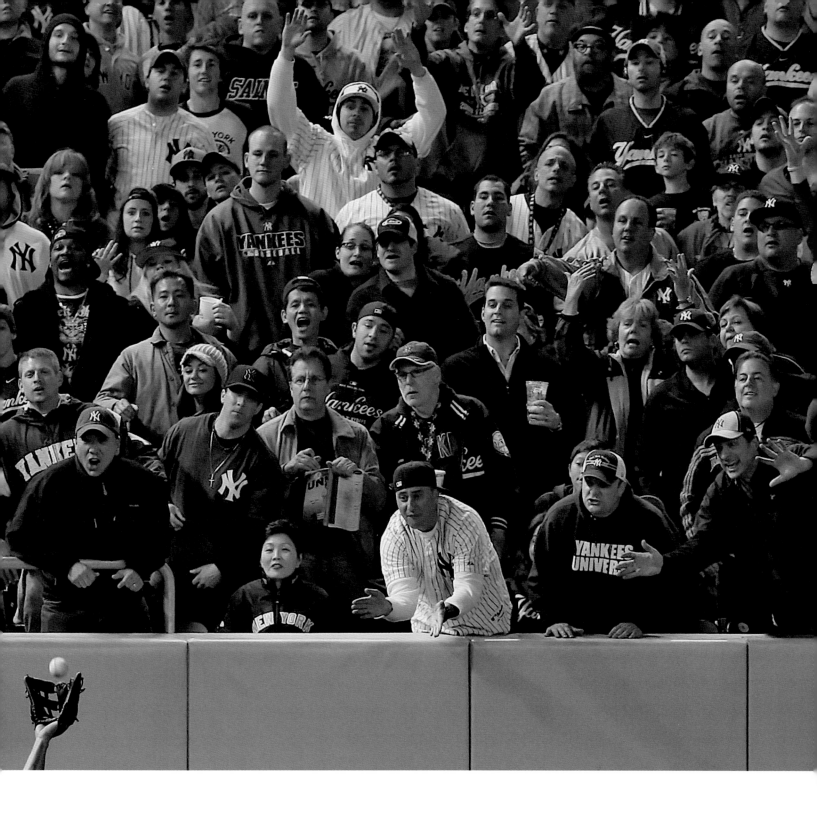

Yankees fans try to distract an Angels left fielder at the Yankee Stadium on 25 October. The day saw victory for the Yankees, propelling the baseball team to the top of its division and on to the World Series. The Yankees went on to win the World Series, their 27th title.

American Lance Armstrong, 37, made his second comeback to professional cycling with the express intent of participating in the 2009 Tour de France. Armstrong won the world's most famous cycle race for a record-breaking seven consecutive years, from 1999 to 2005. He took part in the 2009 event, coming third overall. Top row, left: Armstrong recuperates at home in Austin, Texas, after breaking a collar bone in a crash during the Castilla y León cycling race in Spain on 23 March. Right: Watched by a team doctor and drug administrator, Armstrong urinates during a drug test. He was tested 52 times during the 2008-2009 season, more than any other athlete in any sport. Second row, left: Armstrong is examined in hospital after breaking his collar bone. Right: The cyclist works out in his home gym in preparation for his comeback. Third row, left: Armstrong climbs Mont Ventoux in Vaucluse, during stage 20 of the Tour de France, on 25 July. Right: He waves to media after coming fifth in stage 20, which is acknowledged as the most difficult. Bottom row, left: Armstrong waits before the start of the Tour de France, in Monaco on 3 July. Right: He cycles through the snow, during a training ride in Aspen, Colorado, on 18 April.

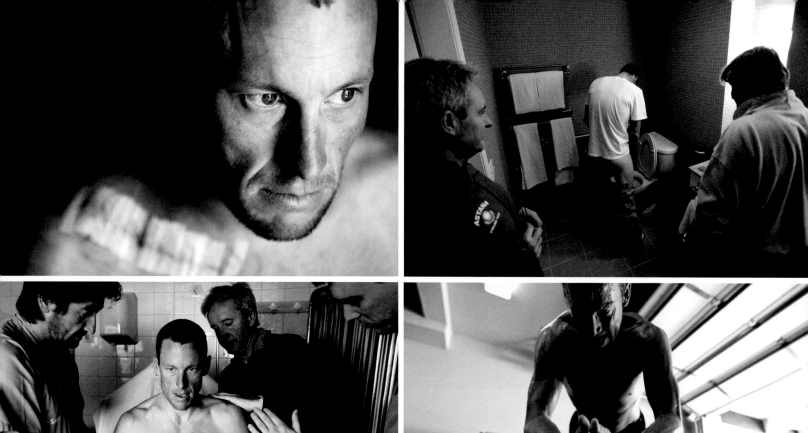
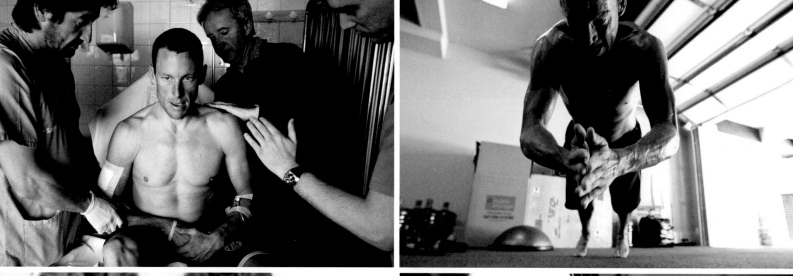
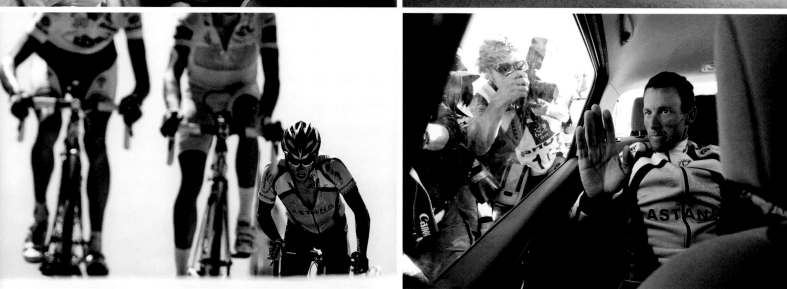
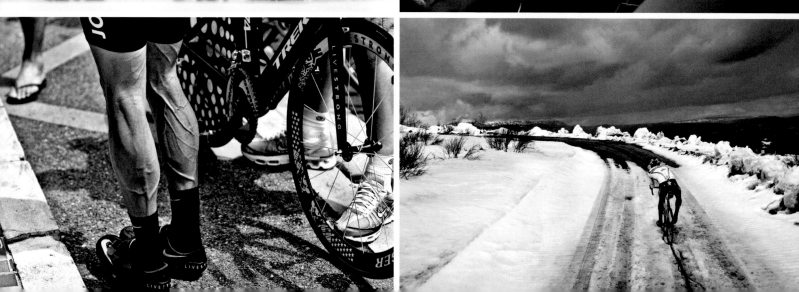

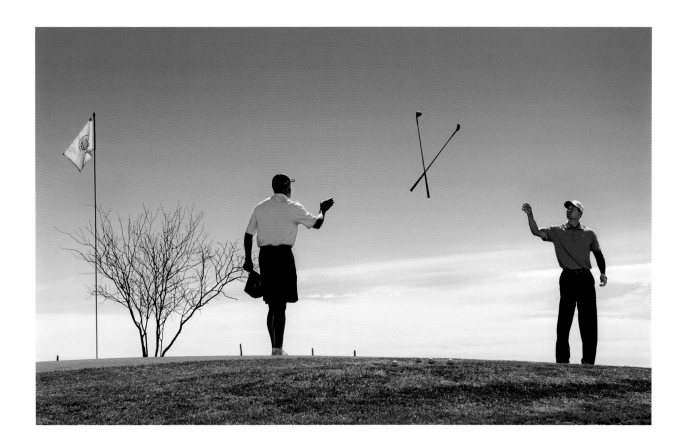

Tiger Woods flips clubs with his caddie Steve Williams, during practice at the Accenture Match Play Championship, at the Ritz-Carlton Golf Club in Marana, Arizona. It was Woods' first tournament after reconstructive surgery to his left knee.

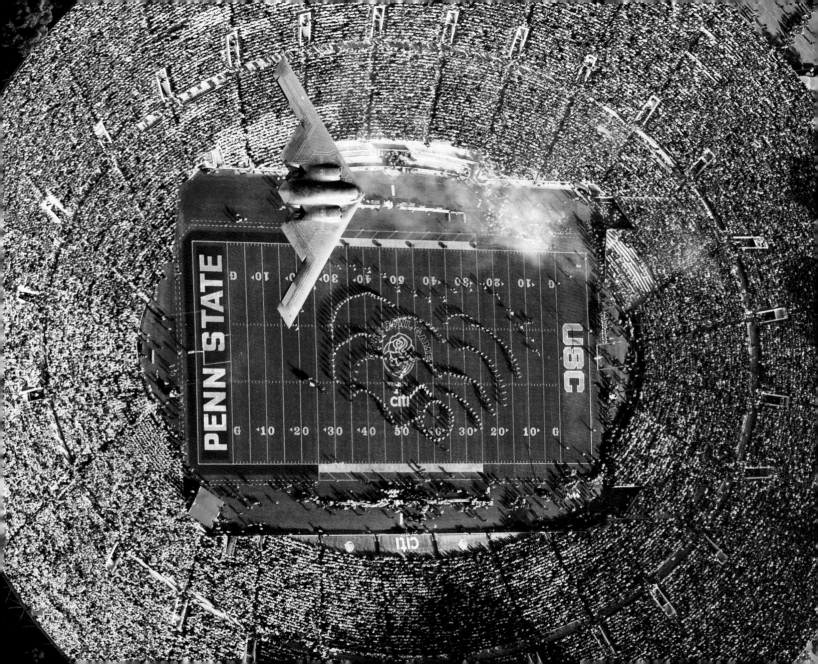

Sports Action

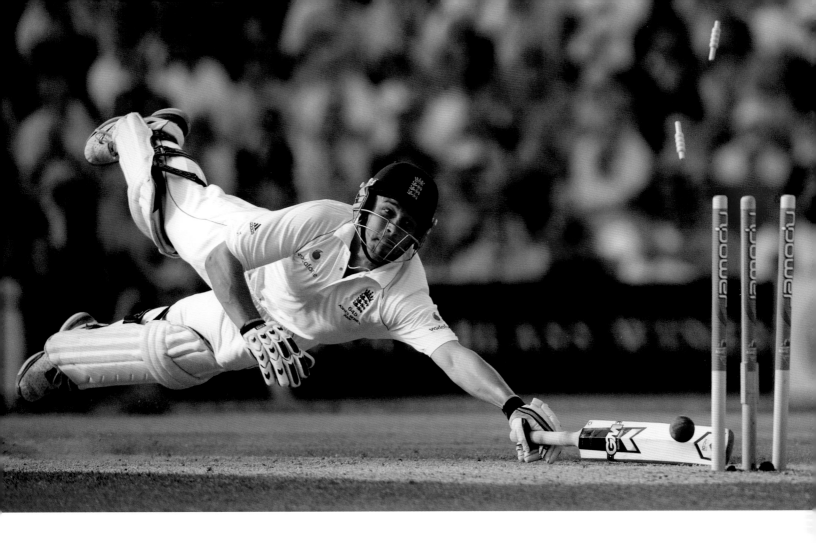

A ball thrown by Australian Simon Katich sends the bails flying, dismissing England batsman Jonathan Trott during the fifth Ashes cricket test match, at The Oval cricket ground in London. The Ashes, played every two years between England and Australia, is one of cricket's most celebrated rivalries, and dates back to 1882. Ashes series are generally played over five test matches, each of which lasts for a number of days. Over the years, 64 series have been played, with Australia winning 31 and England 28. The remaining series have been drawn. The 2009 series was won by England.

136 Sports Action > **Donald Miralle, Jr.** > USA > 1st Prize Stories

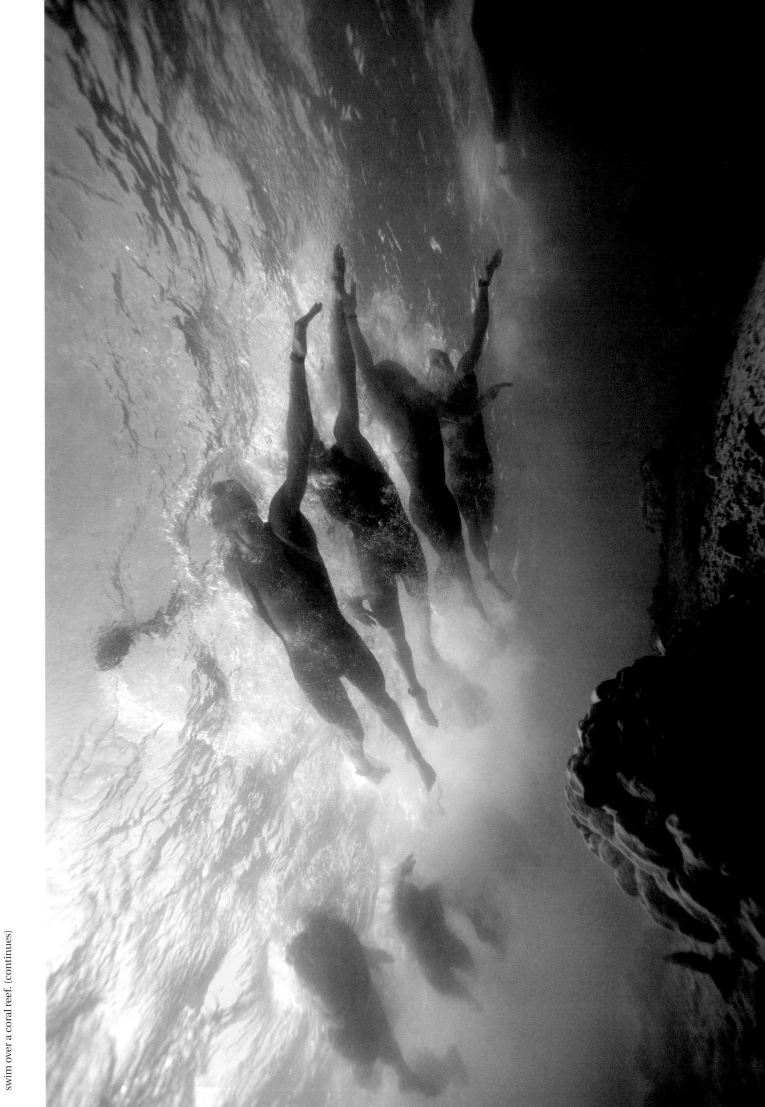

The Hawaiian Ironman World Championships is a grueling annual triathlon comprising a 3.86 km swim, a 180.25 km bicycle race and a 42.195 km marathon, with a strict 17-hour time limit. Above: Nearly 2,000 competitors enter Kailua Bay at sunrise to start the swim. Below: Competitors swim over a coral reef. (continues)

(continued) Competitors must endure scorching temperatures and crosswinds of up to 70 kph. Below: A competitor cycles past a dinosaur lava sculpture on the Queen Ka'ahumanu Highway, western Hawaii. (continues)

(continued) A competitor pours water on his head to cool down during the marathon leg of the triathlon.

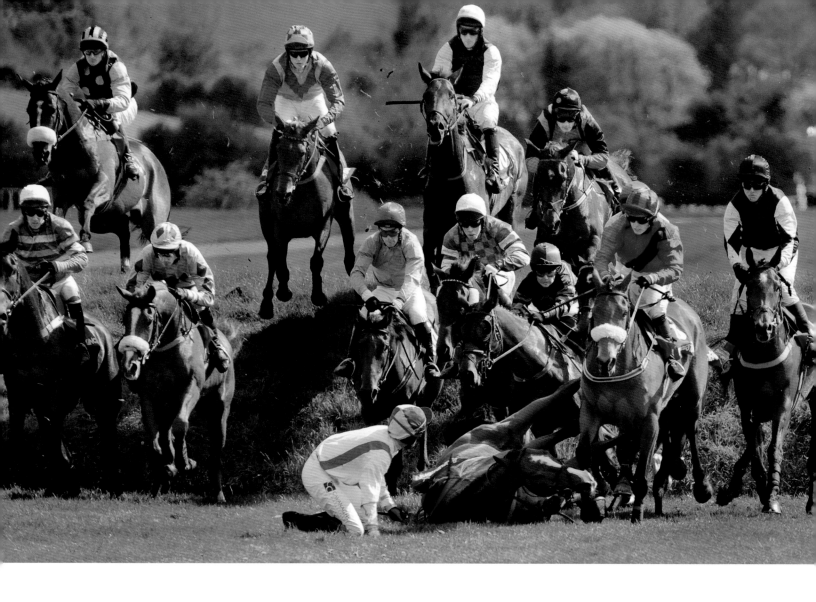

Jockey James Carroll looks
back at the rest of the field,
after his horse Lord Time took
a tumble, during the opening
race of the Punchestown Irish
National Hunt Festival, in
County Kildare, Ireland. The
race is a particularly difficult
steeplechase. Neither horse
nor rider was injured.

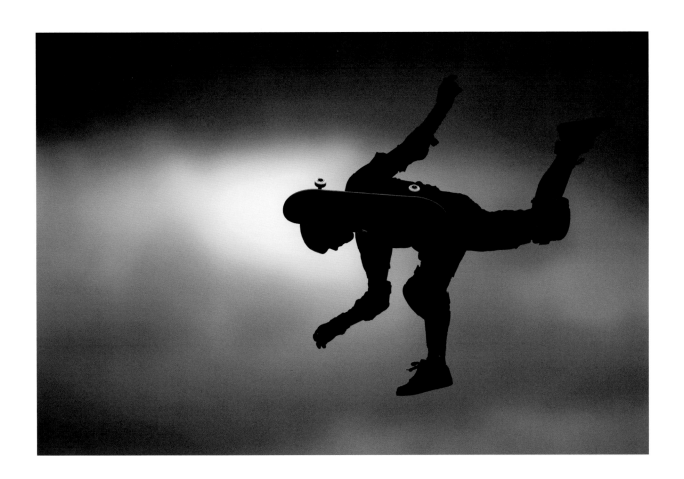

Skateboarder Bob Burnquist attempts a maneuver during free practice for the MegaRamp event, at Anhembi Park in São Paulo, Brazil. The MegaRamp was developed in the USA, and has twice been brought to São Paulo by Burnquist, who is also champion of the event. Measuring 27 meters high, the ramp represents an extreme form of skateboarding, tackled by very few athletes.

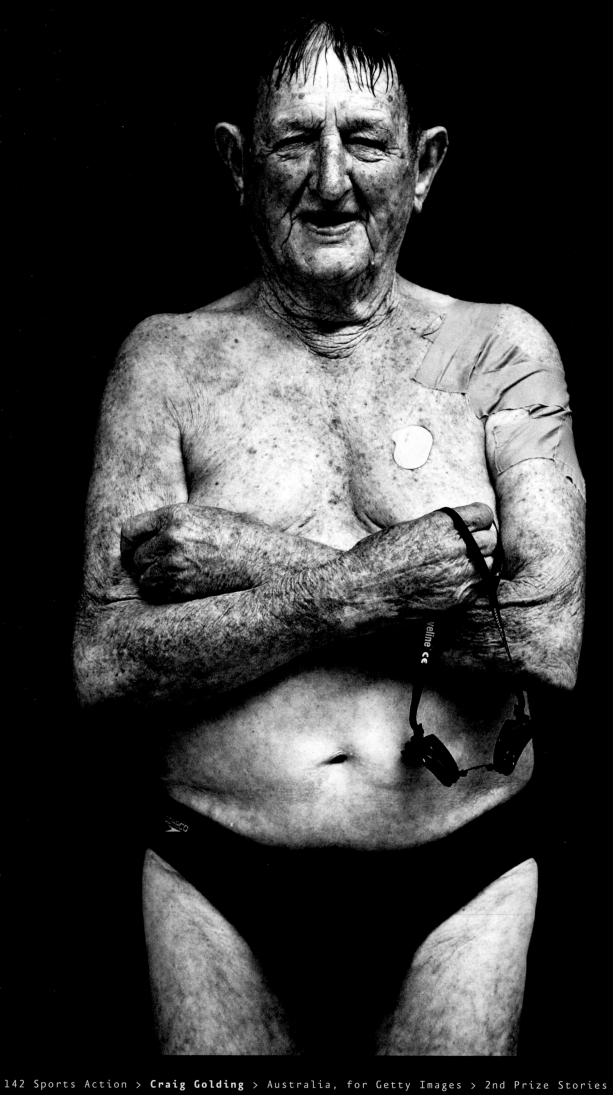

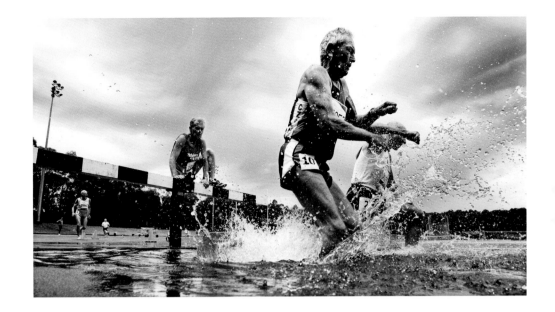

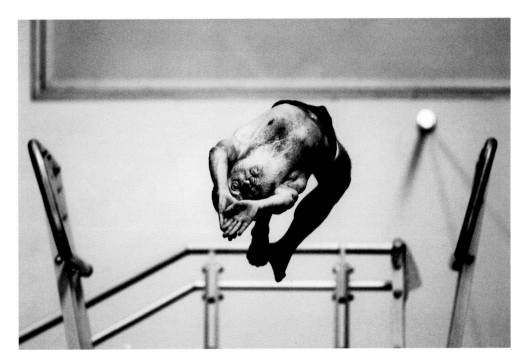

The World Masters Games, held every four years, is the world's largest multi-sport event, with mature competitors from across the globe taking part in 28 different sports. The 2009 games in Sydney attracted 28,292 participants, two of them over 100 years old. This page, top: Athletes compete in the 2,000 meters steeplechase final. Middle: An 80-year-old competitor dives from the one-meter springboard during a training session. Below: Bruce Gallagher, at 75 the oldest rugby union competitor, is clapped off at full time after a match. Facing page: Australian Jack Mathieson, aged 91, shortly after swimming the 800 meters freestyle.

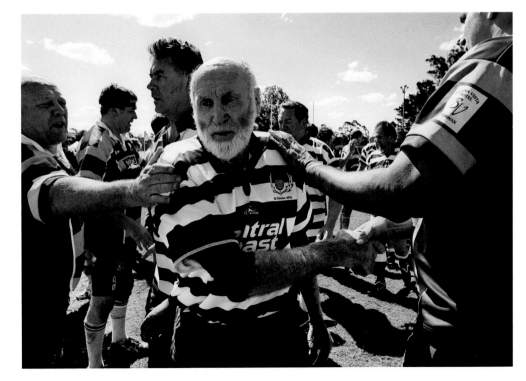

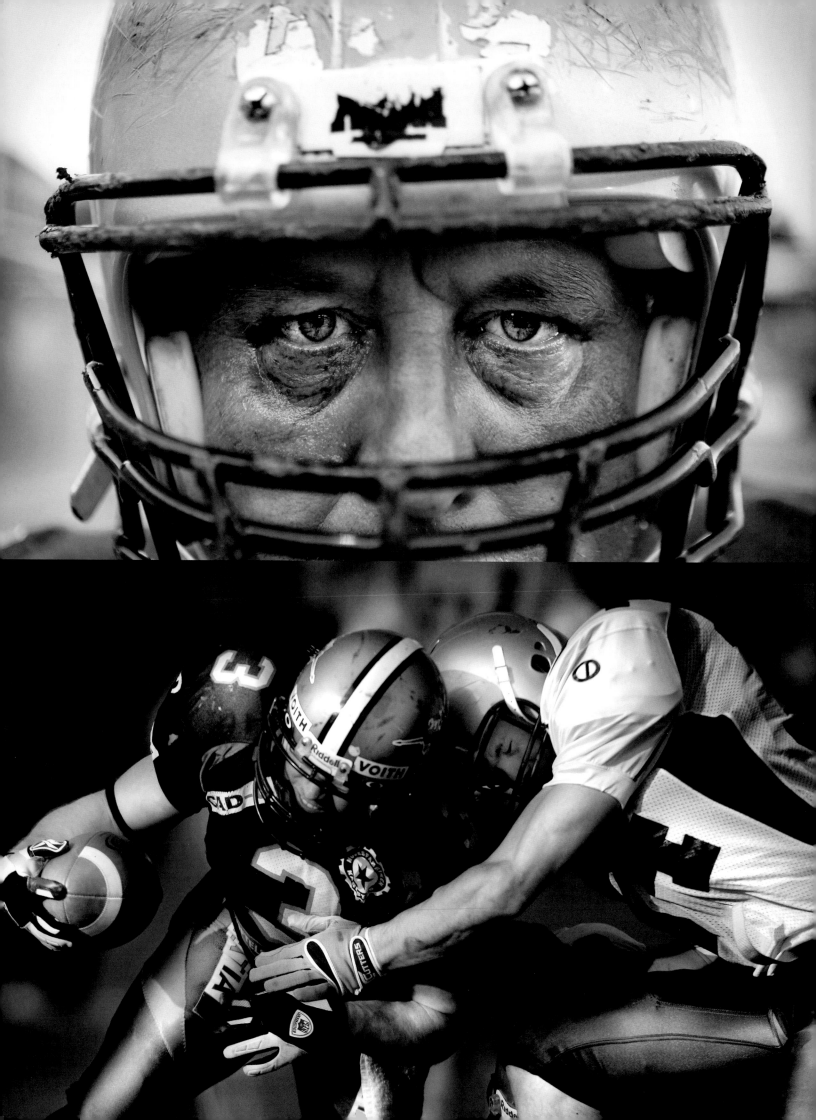

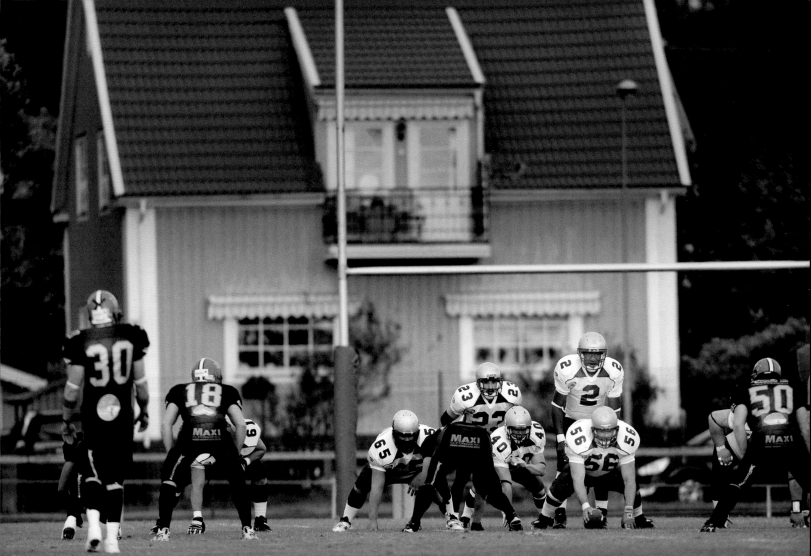

The 2010 jury

Photos: Co de Kruijf / Hollandse Hoogte

Chair:
Ayperi Karabuda Ecer, Sweden / Turkey,
vice president pictures Reuters

Bill Frakes, USA,
photographer *Sports Illustrated*

Volker Lensch, Germany,
head of photo department *Stern*

Harry Borden, UK,
photographer

David Griffin, USA,
director of photography *National Geographic* magazine

Adam Pretty, Australia,
photographer Getty Images

Giovanna Calvenzi, Italy,
picture editor *SportWeek / La Gazzetta dello Sport*

Magdalena Herrera, France / Cuba,
director of photography *Geo*, France

Laura Serani, Italy,
freelance curator

Charlotte Cotton, UK,
creative director National Media Museum, London

Hideko Kataoka, Japan,
director of photography *Newsweek*, Japan

Guy Tillim, South Africa,
photographer

Special Mention

Following the judging of the World Press Photo contest, the jury decided to give Special Mention to a frame grab from a video posted on YouTube in June 2009, during the post-election uprising in Iran. It depicts a woman identified as Neda Agha-Soltan lying on the ground after being shot in the chest.

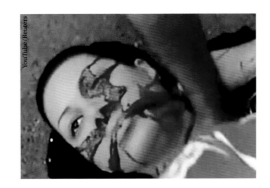

The cameraphone footage was viewed by millions online and discussed on social media networks and in major news media worldwide. In the days following Neda's death, memorials were held around the world and in Iran. Her name and image became a symbol of resistance to the Iranian regime.

The jury considers an image for Special Mention when it has a made an exceptional impact on news reporting worldwide during the preceding year, and could not have been made by a professional photographer. The commendation recognizes a photograph or a sequence of photographs of exceptional news value, without which a visual overview of the year's most important news would not be complete.

Many within the profession recognize that eyewitnesses who capture unfolding events with their cameras have added a new dimension to photography in the media. A precedent for the recognition of a non-professional image was set in 1969, when a photograph of the man on the moon was given a special mention by the World Press Photo jury. Since 2007, juries have had the opportunity — in a separate discussion from the judging of work submitted for the World Press Photo contest — to grant a Special Mention, but this is the first year that such recognition has been made.

Jury member David Griffin of *National Geographic* commented: "I am pleased that World Press Photo has provided an avenue for non-professional images that have a significant impact on the historical visual record."

Participants 2010 Contest

In 2010, 5,847 photographers from 128 countries submitted 101,960 entries. The participants are listed here according to nationality as stated on the contest entry form. In unclear cases the photographers are listed under the country of postal address.

Afghanistan
Barat Ali Batoor
Rahmut Gul
Massoud Hossaini
Marai Shah
Ahmad Masood
Jalil Rezayee
S. Sabawoon
Omar Sobhani
Fardin Waezi

Albania
Arben Bici
Enri Canaj
Edvin Celo
Bevis Fusha
Petrit Kotepano

Argentina
Marcelo F. Aballay
Enrique Manuel Abbate
Rodrigo Miguel Abd
Luis Carlos Abregú
Martin Acosta
Humberto Lucas Alascio
Pablo Añeli
Manuel Arce Molino
Walter Astrada
Soledad Aznarez
Diego Azubel
Pablo Barrera
Carlos Barria
Verónica Bellomo
Santiago Berioli
Nicolás Bravo
Marcos Brindicci
Patricio Cabral
Victoria Cabral
Marcos Carrizo
Pablo Enrique Cerolini
Tomas Cochello
Juan Carlos Corral
Pablo Cuarterolo
Daniel Dapari
Alejandro Del Bosco
Charly Diaz Azcue
Eduardo Dlapa
NKO Galuya
Daniel Garcia
Nestor García
Juan Martin Garcia
Dafne Gentinetta
Bernardo Giménez
Marcos Guillermo Gómez
Pablo Gómez
Ileana A. Gómez Gavinoser
Jeremias Gonzalez
Sergio Gabriel Goya
Leonardo Di Gregorio
Patrick Haar
Juan Hein
Javier Heinzmann
Claudio Herdener
Axel Indik
Gustavo Jononovich
Silvina von Lapcevic
Ezequiel Lazarte
Diego Levy
Diego Lima
Maximiliano Luna
Sebastian Marjanov
Blas Martinez
Fabián Mattiazzi
Lucia Merle
Luis Micou
Emiliana Miguelez
Juan Obregon
Atilio Orellana
Santiago Pandolfi
Julio Pantoja
Javier Orlando Pelichotti
Rodolfo Pezzoni Carbo
Natacha Pisarenko
Nicolás Pousthomis
Mario Quiroga

Paula Ribas
Héctor Rio
Sebastián Hacher
José Romero
Sebastián Salguero
Juan Sandoval
Ricardo J Santellan de Leon
Matias Sarlo
Sebastian Scheiner
Nicolas Silberfaden
Eduardo Soteras
Jose Enrique Sternberg
Juano Tesone
Omar Torres
Tony Valdez
Maximiliano Vernazza
Horacio Villalobos
Leonardo Vincenti
Juan Vittori
Gisela Volá
Irina Werning
Martin Zabala
Hernan Zenteno

Armenia
Nazik Armenakyan
Eric Grigorian
Anahit Hayrapetyan
mirzOyan
Inna Mkhitaryan
Steve Ruark
Laura Samvelyan
Hasmik Smbatyan
Vahan Stepanyan

Australia
James Alcock
Stephen Antonopoulos
Joe Armao
Nicolas Axelrod
Ben Baker
Lincoln Baker
Kelly Barnes
Andrew Bell
Daniel Berehulak
Rowan Bestmann
Paul Blackmore
Philip Blenkinsop
Marty Blumen
Michael Bowers
Penny Bradfield
James Brickwood
Patrick Brown
Andrew Brownbill
Jeff Camden
Glenn Campbell
Robert Carew
David Cartier
Aletheia Casey
Brian Cassey
Steve Christo
Robert Cianflone
Warren Clarke
Lisa Clarke
Tim Clayton
Trevor Collens
Brett Costello
Michael Coyne
Graham Crouch
Lachlan Cunningham
Mark Dadswell
Sean Davey
Tamara Dean
Kristian J. Dowling
Andy Drewitt
Stephen Dupont
Alex Ellinghausen
Brendan Esposito
Mark Evans
Jenny Evans
Adam Ferguson
Brad Fleet
Andrea Francolini
Kate Geraghty
Ashley Gilbertson
Ed Giles
Kirk Gilmour
Michael Goldberg
Craig Golding
Steve Gosch
David Gray
Robert Gray
Toni Greaves
Natalie Grono
Lannon J. Harley
Bronwen Healy
Phil Hillyard
Ian Hitchcock

Lisa Hogben
Glenn Hunt
Bradley Hunter
Christopher Hyde
Anthony Johnson
David L. Kelly
Dirk Arthur Klynsmith
Adam Knott
Paul Lakatos
Dean Lewins
Jon Lister
Brendan McCarthy
Marc McCormack
Chris McGrath
Justin McManus
Paul Miller
Frances Mocnik
Palani Mohan
Nick Moir
Sam Mooy
Dean Mouhtaropoulos
Jake Nowakowski
Jason O'Brien
Warrick Page
Dan Peled
Thomas Pickard
Jack Picone
Ryan Pierse
Gregg Porteous
Andrew Quilty
Mark Ralston
Quinn Rooney
Dean Saffron
Dean Sewell
Russell Shakespeare
Ellen Smith
Marko Sommer
Cameron J Spencer
Marc Sinclair Stapelberg
Dave Tacon
Tasso Taraboulsi
Adam Taylor
Mark Tipple
Mick Tsikas
Tamara Voninski
Paul Wager
Barbara Walton
Nicholas Welsh
Clifford White
Iain D. Williams
Annette Willis
Michael Willson
Craig Wilson
Michael Wilson
Krystle Wright

Austria
Heimo Aga
Harald Arnold
Heinz-Peter Bader
Martin Fuchs
Daniel Gebhart de Koekkoek
Alexandra Grill
Georg Hochmuth
Kurt Hoerbst
René Huemer
Robert Jaeger
Karl Joch
Miro Kuzmanovic
Lois Lammerhuber
Florian Lems
Udo Mittelberger
Arnold Morascher
Lisi Niesner
David Payr
Herwig Prammer
Holger R. Weimann
Michael Marthmayr
Erwin Scheriau
Eva Schimmer
David Schreyer
Lilli Strauss
Aram Voves

Azerbaijan
Majid Aliyev
Sanan Aliyev
Vugar Amrullaev
Agdes Baghirzade
Rafiq Gambarov
Nonna Varley de Gubek
Irada Humbatova
Osman Karimov
Ismayil Kerim
Emil Khalilov
Mammad Rahimov

Bangladesh
Abir Abdullah
Maruf Hasan
Avik
A.M. Ahad
Mohiuddin Ahmed
G.M.B. Akash
J.A. Akash
Shahidul Alam
Monirul Alam
K.M. Jahangir Alam
Shafiqul Alam
Rashed
Md. Golam Mortuza Ali
Amin
K. M. Asad
Soumitra
Wahid Adnan
Saikat Bhadra
Andrew Biraj
Rabi Sankar
M.N.I Chowdhury
Choudhury Luthfe Elahi
Emdadul Islam Bitu
Shoeb Faruquee
Gazi Nafis Ahmed
Indrajit Ghosh
Khaled Hasan
Mohammad Rakibul Hasan
Abu Ala Russel
Ekramul Hoque Manik
Kabir Hossain
Saber Hossen
Ibrahim
Nazrul Islam
Ezazul Islam
Imshiat Sharif
Shafiq Islam
Momena Jalil
S.M. Kakon
Zahidul Karim Salim
Enayet
Naymuzzaman Prince
Tanvir Murad Topu
Abu Taher Khokon
Saiful Huq Omi
Lailunnahar
Masud Alam Liton
Saikat Mojumder
Indranil Kishor
Wasif Munem
Fateheen
Md. Rashed Kibria Palash
Himu
Kazi Md. Golam Quddus
Md. Zillur Rahman Khan
Masud Rana
Probal Rashid
Chandan Robert Rebeiro
Jashim Salam
Jewel Samad
Khaled Sattar
Shaikh Mohir Uddin
M. Yousuf Tushar
Akhlas Uddin
Shehab Uddin
Sumon Yusuf
Qamruzzaman

Belarus
Yuliya Ruzhechka
Victor Drachev
Vasily Fedosenko
Uladz Hrydzin
Mikhail Larchanka
Dmitrij Leltschuk
Andrei Liankevich
Eugene Reshetov
Dmitry Rusak
Alexander Sayenko
Alexander Vasukovich
Aliaksandr Vasmerykou
Sasha Veledzimovich
Tsuranau Viachaslau
Tanja Zenkovich

Belgium
Malek Azoug
Pauline Beugnies
Nicolas Bouvy
Michael Chia
Jean-Michel Clajot
Gert Cools
Guido Van Damme
Jasmine Debels
Delfosse
Raphael Demaret
Jorge Dirkx

Tim Dirven
Sarah van den Elsken
Bruno Fahy
Thomas Freteur
Cédric Gerbehaye
Nick Hannes
Gregory Heirman
Tomas van Houtryve
Nicol' Andrea
Didier Jouret
Eddy Kellens
Christophe Ketels
Jimmy Kets
Koen de Langhe
Frédéric Lecloux
virgnie lefour
David Legrève
Francois Lenoir
Clémence de Limburg
Philippe Luc
Wendy Marijnissen
Virginia Mayo
Mashid Mohadjerin
Christian Overdeput
Tom Palmaers
Olivier Papegnies
Fred Pauwels
Eddy Petroons
Evy Raes
Joost De Raeymaeker
Filip Van Roe
Patrick De Roo
Gaetan Rousselet
Alice Smeets
Lieve Snellings
Dieter Telemans
Wanda Tuerlinckx
Gaël Turine
Wouter van Vaerenbergh
Davy Vanham
Alex Vanhee
Jacques Vekemans
Eva Vermandel
Carol Verstraete
Peter de Voecht
Dirk Waem
Warnand Julien
Thierry Wieleman

Bolivia
Jorge Bernal
Sergio Bretel
Daniel Caballero M.
Gonzalo Contreras
Patricio Crooker
Fernando Cuellar Otero
Diezde
Pedro Laguna
David Mercado
Marcelo Pérez del Carpio
Martin H. Siles Flores

Bosnia-Herzegovina
Dejan Bozic
Haris Calkic
Ziyah Gafic
Sljivo Husein
Almir Panjeta
Damir Sagolj
Nedzad Ugljesa
Dejan Vekic

Brazil
Alinne Rezende
Alex de Almeida
João Alvarez
Paulo Amorim
Rafael Andrade
Keiny Andrade
Eduardo Anizelli
Rodrigo Cavalheiro
Alberto César Araújo
Maria Elisa Franco
Rogério Assis
Diego Redel
Juan Barbosa
Nário Barbosa
Anderson Barbosa
Paulo Barreto
Paulo Batalha
Itaci Batista
Alexandre Belém
Marlene Bergamo
Thiago Bernardes
Ailton Cruz
Julio Bittencourt
Mario Bourges
Fabio Braga

Ana Branco
Reinaldo Canato
Rubens Cardia
Daniel Caron
Ernesto Carriço
Weimer Carvalho
Gabriel Castaldini
Rubens Cavallari
Antonio Cazzali
Ricardo Chaves
Adalmir Chíxaro
André Coelho
Sergio Quissak
Luiz Santos
Jose Luis da Conceição
Renato Conde
Beto Barata
Antonio Costa
Marcos Michael
Cristiano Borges
Felipe Dana
Fernando Dantas
Edilson Dantas
Daniel Ramalho
Daryan Dornelles
Edmar Melo
Euler Paixao
AC Junior
Marcelo Sayão
Alcione Ferreira
Márcia Foletto
Bruno Fraiha
Adriana Franciosi
Eduardo Nicolau
André François
Ricardo Teles
Nilton Fukuda
Dado Galdieri
Pedro Ivo Prates Gomes
Apu Gomes
Rivaldo Gomes
Cristiano Estrela
Jonne Roriz
Luiz Guarnieri
Alexandre Guzanshe
Joyce Cury
Jonas Oliveira
Genaro Antonio Joner
Daniel Kfouri
Antonio Lacerda
Leonardo Lara
Odair Leal
Claus Lehmann
Marcelo Leite de Oliveira
Paulo Liebert
Mauricio Lima
Helvio Romero
Rodrigo Coca
Davi Ribeiro
Cezar Magalhaes
Gustavo Magnusson
Bruno Magalhaes
Marcelo Pereira
Ricardo Nogueira
Daniel Marenco
Kardec Epifânio
Ricardo Matsukawa
Leonardo Melgarejo
Michell Mello
Luiz Fernando Menezes
Márcio Mercante
Marcelo Min
Daniel Mobilia
Ricardo Moraes
Sebastião Moreira
Fabio Motta Lins
Sergio Neves
Malabi
Michael Patrick O'Neill
Sergio Ricardo de Oliveira
Eduardo Lima
Isabela Pacini
Diego Padgurschi
Paulo Pampolin
Lunaé Parracho
Hamilton Pavam
Emilio C. S. Pedrosa
Andre Penner
Marcos Piffer
Paulo Pinto
André Porto
Tiago Queiroz Luciano
Thiago Leon
Marcos Ramos
Sergio Ranalli
Genesio
Marcelo Franco
Carlos Roberto

Evelson de Freitas
Célio Jr
Rogério Marques
Joao Marcos Rosa
Felipe Russo
Evaristo Sa
Gilvan Barreto
Dida Sampaio
Werther Santana
Daniela Souza
Juliano Gouveia
Rodrigo Albert
Anderson Schneider
Jean Schwarz
Fabio Seixo
Nirley Sena
Alexandre Severo
José Patricio da Silva
Albari Rosa
Olga Leiria
Ricardo Rafael
Andre Silva
Daniela Xu
Charles Silva Duarte
Francisco De Souza
Bruno Fernandes
Alexandre Souza Fonseca
Jean Lopes
Rogério Stella
Renato Stockler
Toninho Cury
Robson Ventura
Luciano Vicioni
Mauro Vieira
Cláudio Vieira
André Vieira
Tadeu Vilani
Paulo Brandao Whitaker
Ricardo Yamamoto
Adriana Zehbrauskas

Bulgaria
Iosif Astrukov
Mehmed Aziz
Svetlana Bahchevanova
Ventseslav Danev
Dimitar Dilkoff
Dimitar Dobrev
Nellie Doneva
Vassil Donev
Nikolay Doychinov
Yanne Golev
Hristo Dimitrov Hristov
Marin Krastev
Dimitar Kyosemarliev
Julia Lazarova
Eugenia Maximova
Aydan Metev
Nikola Mihov
Stoyan Nenov
Oleg Popov
Ognyan Stefanov
Ivaylo Velev
Georgy Velichkov
Boris Voynarovitch

Burkina Faso
Yempabou Ouoba

Cambodia
Philon Sovan
Tang Chhin Sothy

Cameroon
Orock Emmanuel Eta
Happi Raphaël Mbiele

Canada
Tyler Anderson
Benoît Aquin
Anthony Shiu Hung Au
Cheol Joon Baek
Anne Bayin
Mike Berube
Paul Bettings
Mark Blinch
Bernard Brault
Jan Brouwer
David Buzzard
Kitra Cahana
Mike Cassese
Alexandre Chabot
David Champagne
Noel Chenier
Philip Cheung
Andy Clark
Mark Coatsworth
Nick Czernkovich

Nathalie Daoust
Barbara Davidson
Don Denton
Mike Drew
Darryl Dyck
Bruce Edwards
Candace Elliott
Elliot Ferguson
Colleen Flanagan
Joel Ford
Brent Foster
Jason Franson
Kevin Frayer
Blair Gable
Benoit Gariépy
Cole Garside
Ryan Gauvin
Brian J.Gavriloff
Rafal Gerszak
Greg Girard
Dina Goldstein
Christopher Grabowski
Robert van Waarden
John Hasyn
Jenna Hauck
James Helmer
Gary Hershorn
Megan Hirons
Ryan Enn Hughes
Michel Huneault
Emiliano Joanes
Ed Kaiser
Saeyun Koh
Todd Korol
Esmond Lee
Roger Lemoyne
Jean Levac
Brent Lewin
Lorne Liesenfeld
Lung S Liu
Norman Y. Lono
Larry Louie
John Lucas
Douglas MacLellan
Rick Madonik
Jude Mak
Sheri Manson
Jeff McIntosh
Enrique Miranda
Ligumsky
Sarah Moffat
Kamal
Stephen Morrison
Mandel Ngan
Paul Nicklen
Farah Nosh
Gary Nylander
Finbarr O'Reilly
George Omorean
Ed Ou
Kieran Oudshoorn
Charles-F. Ouellet
Louie Palu
Wendell Phillips
André Pichette
Ryan Pyle
Andrew Querner
Ryan Remiorz
Alain Roberge
Jim Ross
Liz Rubincam
Cpl Jasper Schwartz
Dan Shugar
Jack Simpson
Sami Siva
Rob Skeoch
Timothy Smith
Lyle Stafford
Steve Tran
Michel Tremblay
Stephen Uhraney
Andrew Vaughan
Aaron Vincent Elkaim
Steve Wadden
Andrew Wallace
George Webber
Donald Weber
Iva Zimova

Chile
Cocho
Francisco Bermejo
Robert Coyote
Roberto Candia
Cristián Carvallo Foix
Christian Demarco Vásquez
Fernando Gallardo Sanz
Edgard Garrido

Miguel Ángel Larrea
Camila Lassalle Ramírez
Tomás Munita
Waldo Nilo
Ale Olivares
Pamela Pasten
Sebastian Sepulveda
Elisa Verdejo Sinsay
Pedro Ugarte
Eduardo Verdugo
Carlos Villalon
Nicolas Wormull

China
Bai Gang
Zhoufeng Bai
Shuzhen Bai
Baofan
Yongbin Feng
Wang Bing
Chenbinrong
Bu Ensa
Cai Minqjang
Yang Cai
Cai Tongyu
Kingson
Xueqincao
Chang Liang
ZhongZhengChang
Cheliang
Chen Qiang
Chen Qinggang
Chen Jie
Chennan
Chen Zhuo
Chen Hui
Chen Xiaoyue
Chen Fan
Chen Jian
Chenliang
Mingzhe Chen
Chen Youxin
Jianyu Chen
Yongping Chen
Chen Xiaodong
Chen Hui
Shaohua Chen
Jianyong Chen
Chen Wencai
Chendong
Chen Yao
Qituo Chen
Chengeng Sheng
Leo Chen
Chen Haitong
Cheng Gong
Cheng Qiling
Cheng Xuliang
Wenjun Cheng
Yong-Qiang Cheng
Chengxu
Chenglong Yang
Jin Chien
Cancan Chu
Yongzhi Chu
Lu Tingchuan
Zhang Chunhai
Hucong
Cui Heping
Yue Yong Cui
Jun Dai
Jia Daitengfei
Cai Daizheng
Lidan
Deng Bo
Deng Xiaowei
Denghuosheng
Deng Jianbin
Deng Dongfeng
Wudi
Yin Di
Ding QingLin
Zhang Dong
Don Yanjun
Dongjianling
Du ZongJun
Du Hai
Dunzhu wang
Fan RenLi
Li Fan
Fan Fangbin
Fan Liyong
Fang Qianhua
Wang Fang
Tian Fei
Fei Maohua
FSJX
Victor Fraile
Fu Yongjun
Fu Xinghua
Turbo

GuangZhou Fu
Li Ga
Yin Gang
Chang Gang
Zhu Gang
Gao Baoyan
Gaofei
Gao Yong
Gao Hetao
Lu Gao
Gao Xiao
Gaoshanyue
Zhanxu Gu
GU Hongfei
Guan Xin
Guang Niu
Guangxia Zhao
Tieliu Guo
Guo Jianliang
Guo Jijiang
Jin Guo
Guo Yong
Jianzheng Guo
Liliang Guo
Long Hai
Guo Hai
Han Wei
Yan Han
Han Meng
Han Tao
Liming Han
Han shiqi
Han Yun Min
HanXin LU
Tony Wang Hanzong
He Jianrong
Jian He
Dingsanlang
He Ben
Yi He
He Haiyang
Pin He Wu
HongPing Wang
Zhang Hongwei
Jun Hou
Shaoqing Hou
Hu Guoqing
Hu Lingyun
Hu Yongqiang
Jianbin Huo
Ji Dong
Ji Xiang
Jia Guorong
Jia YuChuan
Zhujianguo
Chenjian&Niexin
Jiang Dong
Jiang Sheng Lian
Jiang Hao
Jiang Hongjing
Jiangyue
Shengli Jiang
Jiang Jianhua
Jiangsheng
Jiangwei Ren
Yang Jianmin
Jin Siliu
Guo Jing
Li Jinhe
Edward Ju
Wang Zhong Ju
WangKai
Ma EnKai
Kaida Liu
KangZhen
Kang Jinbao
Yin Kang
Xu Kangping
Yang Kejia
Keqiang Fu
Kong Linjian
Hongguang Lan
Yezuo Lan
Lan Jun
Lan Fei
Lang Shuchen
Lang Lang
Jason Lee
Li Xiaoguo
Jianggang Li
Zhen Yu Li
Li Qizheng
Li Jiuhong
Li Yue
Feng Li
Yonggang Li
Li Guang Cheng
Liweiguang
Li Wei
Qiang Li
Feng Li

Li Fei
Li Xin
Downker
LiBin
LI Shuangqi
Li Jianming
Li Li
Liwei
LI Guohua
Frank Li Qibin
Zhanjun Li
Hui Li
Lidongsheng
Gang Li
Lihao
Cheng Li
Li Jiejun
Zhao Li Jun
Li Ming Yang
Dong Li Xin
Lian Ming
Wen Xiang Liang
Liang Meng
Liangliang
Zhen Liang
ZhangLiang
Liuliang
Liang Tie Zhang
Dian Yang Liang
Liang Daming
Liao Yujie
Liao Pan
LinYunlong
LinGuoRui
Liu Jin
Liu Jiangfeng
Liu Tao
Liu Hang
Liu Tao
ZhengLiu
Guoxing Liu
LiuSong
Liutong
Chenping Liu
LiuLei
Liu Lihang
Zheng Yi Liu
Liu Yang
Jack Liu
Liu Xiaofeng
Jerry Liu
Bingsheng Liu
Tianxing Liu
Fuguoliu
Liu Ping
Liu Yuan
Zhou Lixin
Lu Guang
Guozhong Lu
Mingjie Lu
Lu Gang
Lu Jinbo
Xin Lu
Luan Zheng Xi
Lui Siu Wai
Chang Wei Luo
Luo Chuan
Ma Hongjie
Mao Feng
Mark Joe
Yemaolin
Mengge
Miaobo
Miao Jian
Mars
Mingjia Zhou
Mrke Jiang
Huachu Ni
Ni Na
Ni Li Xiang
Ni Yuxing
Ning Feng
Ning Zhouhao
Niu GuoZheng
Niu Shiyun
Pandeng
Xiping Bridge
Xiao Panpan
panjinglin
Pei Jingde
Peng Hui
Pinger
Feng Pu
Qi JieShuang
Xiao Qi
Qi Heng
Han Qian
Qian Zhengsheng
Qianbo
Qiang Zheng Guo
Wang Yiqiang

Qiao Jianguo
Qin Bin
Zhou Q
Haiqing Ying
Wei Qing
Qiu Yan
Qiu Weirong
HonghuoQiu
Qiu Jianhua
Jun Qu
Ran Wen
Yin Ran
Ren Shi Chen
Ren Zhenglai
Renzhong
Yuming Ren
Luay Sababa
Xiaohui Shan
Shang Huage
Bai Shanshan
Li Shaowen
Shen Zhicheng
Shen Yi
Shen Hong
Hongxu Sheng
Sheng Jia Peng
ChangShenggang
Shengkun Yang
Yi Shi
Shi Tao
Shiwei
Guangzhi Shi
Shi Peng
Shi Lifei
Zhao Shichen
Mao Shuo
You Sihang
Song Jianhao
ZhenTao Song
Song Wei
Songlu
Simon Song
Yuefeng Song
Aly Song
Pan Songgang
Songqing
Shiri Su
Sun MingHong
Sun Hai
Ning Dong Sun
Sun Hai Bo
Debo Sun
Sunxin
Sun Xiaodong
Sheng Sun
Suren Li
Tan Qingju
Tan Weishan
Tang Xiaoyi
Tian Weitao
Tian Feng
Joseph Tu
Tuanjie Chen
Wang Da Bin
Xinke Wang
Wang Xinyi
Wang Ye
Wang Mianli
Wang Jing
Wang Jianhua
Wang Juliang
Wang Pan
Liang Wang
Hui Wang
Xiaoming Wang
Wang Yan
Wangyi
Wang Haixin
JinWang
Shen Wang
Wang Jianing
Wang Yi
Wang Qingqin
Wang Lei
Wang Pingsheng
Wang Guibin
Wang Yuanling
Wang Yuheng
Wei Wang
Yong Wang
Shijun Wang
zhou wang
Hongjun Wang
Flyinthewind
LiLi Wang
Wang Fan
Wang Jing
Wang Shibo
Wang Xiaoming
Guoxing Wang
Sheng Wang Hui

Wang Wen Yang
Wang Zhao-hang
Wei Zheng
Li Wei
Wei Fengzheng
Xuweichun
Hu Weimin
Cao Weisong
Wen Qing
Wen Qingqiang
Qiyu Weng
Wenson Chen
Wu Chuan Ming
Fang Wu
Wu Jun Song
Wu Qiang
Wu Changqing
Guofang Wu
WU Jie-ming
Jiaxiang Wu
Xiaorong Wu
Wu Yuan Feng
Wu JianGuo
Wu Wei
Wu Zhangjie
Wujianmin
Haibo Xi
Xi Zhinong
Tanxi
Xia Yong
Xia Shiyan
Xiaohao
Li Xiaogang
Wu Xiaoling
Zhang Xiaoyu
Xie Youding
Xin Yi
Cheng Xin
Lu Xin
HUang Xingneng
Wangxinmei
Xi Fang
Xu Jian Hua
Xu Jingxing
Xu Qi
Xu Zhuoheng
Shaofeng Xu
Xuqing
Xu Junwen
Xu Yanxing
Xu Hai Feng
Xuan Hui
Gangqiang Xuan
Huake Xue
Zhao Fengguo
Li Yalong
Bailiang Yan
Jing Yan
Yan Ming
ShanliangYan
Yan Guang Xu
Ri Yue
Bo Yang
Xi Yang
Ningyang
Yangtao
Yang Huiquan
Yang Fawei
Yang Xiao Xuan
Yang Chang
Shuhuai Yang
Yang Huan
Yanglei
Yang Shen
Yao Zhuang
Yewei
Zhang Yi
Yi Jin
Duanyigang
Yin Bogu
Wang Ying
Yong Shi
Chen Yong
Cai Yong
Lin Yong Hui
Zhan You Bing
Haibo Yu
Yu Wenguo
Wenhao Yu
TongYu
Yu Ping
Tian Yu
Wang Jia Yu
Han Yu Hong
Alexander F. Yuan
Yuan Zheng
Yue yuewei
TianYue
Zeng Yufeng
Yun Hongbo
Leiyundong

Yuzhou Chen
Jihui Zang
Zeng Yi-Cheng
Qiang Zeng
Zeng Junshang
Yu Zheng
Zeng Yi
Guang Sheng
Zhan Yu
Zhang Feng
Zhang Wang
Zhang Zihong
Zhang Min
Zhang Wei
Wei Zhang
Paul Zhang
Lijie Zhang
Nicky Zhang
Zhang Xiaodong
Xiaoli Zhang
Cuncheng
Zhang Jinqi
Zhang Yan
Yasser Zhang
Zhang Jian
Zhang Chengbin
Zhang Yongqiang
Zhang Yonghui
Zhang GuoTong
Jack Jie Zhang
Xiangyang Zhang
Kexin Zhang
Zhangjianwei
Zhang Zi Liang
Zhenzhen
Yue Zhang
Zhang Guofang
Zhang Yanhua
Wei liang zhang
Zhang Mo
Wengliang Zhang
Zhang Mingshu
Zhang Cheng
Zhang Changjiang
Zhang Chuanqi
Zhang Lide
Zhang Wei Qing
Zhao Jingdong
Zhao Hang
Zhao Qing
ZhaoBin
Zhaojingwei
Yong Feng Zhao
Zhao Guanshen
Zhao Chongyi
Yongsheng zhao
Rongsheng Zhao
Zhao Qin
Zhen Hongge
Pang Zheng
Zheng Xiaoyun
Zhenglindong
Cai Xiao Zhi
Ye Yuzhi
Ou Zhihang
Sun Zhijun
Fu Zhiyong
Ming Zhong
Zhong Guilin
Zhong Min
He Zhong
Wu Zhonglin
Zhou Guoqiang
Zhou Qingxian
Cunyun Zhou
Zhou Yuanqing
Zhou Chao
Xin Zhou
Min Zhou
Gukai Zhou
Zhou Lei
Zhou Haisheng
Zhou Ren
Zhou ShaoHua
Dashan
Guoxian Zhou
Lingxiang zhou
Zhou Wei
Zhou Can
Yuanbin Zhu
Danyang Zhu
Xiyong Zhu
M Yu
Zhao Zhurong
Zou Hong
Zousen
ZUO qing

Colombia
Luis Acosta
Gabriel Aponte Salcedo

Raul Arboleda
Fernando Ariza Romero
Juan D Arredondo
Juan Manuel Barrero Bueno
Alvaro Barrientos
Fabián Bernal
Kena Betancur
Daniel Bustamante
Felipe Caicedo Chacón
Juan Carlos Calderón
Henry Agudelo
Nelson Cárdenas
Abel E. Cardenas O.
Andres F. Castaño Jimenez
Christian Castillo M.
Gerardo Chaves
Jhon Yara
Milton Diaz
Yohanna Diaz
Carlos Duran Araujo
Escobart
Christian Escobar Mora
Javier Galeano
Jose Miguel Gomez
Juan Pablo Gomez
Negro
Guillermo Gonzalez
Rodolfo González
Juan Pablo Gutierrez
Camilo Henao
Iván Darío Herrera
Daniel Iannini
Julian Lineros
Luis Lizarazo
Marcelo Londoño
Albeiro Lopera Hoyos
William Fernando Martinez
Carlos J. Martinez Tamara
Andrea Moreno
Mauricio Moreno
Eduardo Munoz
Jaiver Nieto Álvarez
Federico Orozco
Carlos Ortega
Leon Dario Pelaez Sanchez
Jaime Pérez
Luis Ramirez
Alfonso Reina Leon
Leo Queen
Federico Rios Escobar
Luis Robayo
Henry Romero
Camilo Rozo
Manuel Saldarriaga
Jaime Saldarriaga
Diana Sanchez Muñoz
Juan A. Sanchez Ocampo
Diego Santacruz
Nelson A. Sierra Gutierrez
Andrés Torres
Guillermo Torres
Andres Valenzuela
Ricardo Vejarano
John W. Vizcaino
Zamora

Costa Rica
Gloria Calderon Bejarano
Teresa Chavarria
Jose Diaz
Marco Monge Rodriguez
Alexander Otarola
Rafael Pacheco Granados
Mónica Quesada C.
Gabriela Téllez
Alexander Arias Valverde

Croatia
Bernard Covic
Marina Filipovic
Romeo Ibrisevic
Davor Javorovic
Miroslav Kis
Vlado Kos
Igor Kralj
Zvonimir Krstulovic
Zeljko Lukunic
Stipe Marinovic
Dragan Matic
Marijan Murat
Josip Šeri
Sanjin Strukic
Sinisa Sunara
Mario Topic
Ivo Vucetic

Cuba
Daniel Anaya
Juan Pablo Carreras
Arien Chang Castan

Ginle
Gonzo González
Cristóbal Herrera
Angel Yu
Noel Miranda
Alejandro Ernesto
Randy Rodriguez Pagés
Rebeca Román Capdevila
Adalberto Roque

Cyprus
Nicolas Iordanou
Petros Karadjias
Yannis Yapanis

Czech Republic
Lukas Biba
Tomas Bican
Michal Bîlek
Radek Burda
Jan Cága
Roman Cerný
Michal Cizek
Michaela Danelova
Jiri Dolezel
Alena Dvorakova
Viktor Fischer
Michael Fokt
Lukas Houdek
Otakar Hürka
Hana Jaklrová
Milan Jaros
Jakub Joachim
Petr Josek
Tom Junek
Kaifer Daniel
Svatopluk Klesnil
Lenka Klicperová
Antonin Kratochvil
Standa Krupar
Veronika Lukasova
Michaela Mokrosova
Martin Mraz
Jan H. Ponert
Jiri Rezac
Slavek Ruta
Jan Sibik
Filip Singer
Jan Sochor
Tomas Tesar
Jiri Urban
Dan Vojtech
Jan Zatorsky

Denmark
Steven Achiam
Niels Ahlmann
Christian Als
Carsten Bundgaard
Nicolas Asfouri
Soren Bidstrup
Anders Birch
Jonathan Bjerg Møller
Michael Barrett Boesen
Bo Bolther
Laerke Posselt
Michael Bothager
Andreas Hagemann Bro
Jan Cavling
Klavs Bo Christensen
Mathias Christensen
Jan Dago
Casper Dalhoff
Jakob Dall
Miriam K. S. Dalsgaard
Jacob Ehrbahn
Peter Elmholt
Frederik Fensbo
Jørgen Flemming
Mette Frandsen
Jan Grarup
Bjorn Stig Hansen
Anders Debel Hansen
Mari Bastashevski
Tine Harden
Christian Holst
David Høgsholt
Michael Jensen
Simon Jeppesen
Kim Rune
Martin N. Johansen
Jakob Jorgensen
Lars Krabbe
Nanna Kreutzmann
Claus Bjørn Larsen
Nikolai Linares
Thomas Lekfeldt
Bax Lindhardt
Tobias Selnæs Markussen
Lea Meilandt
Lars Moeller

149

Morsi
Mads Nissen
Miklas Njor
Panduro
Ulrik Pedersen
Rasmus Flindt Pedersen
Kristoffer Juel Poulsen
Lisa Pram
Kim R
Pelle Rink
Thomas Sjoerup
Betina Skovbro
Carsten Snejbjerg
Morten Stricker
André Thorup
Klaus Thymann
Mario Travaini
Gregers Tycho
Jens Tønnesen
Robert Wengler

Dominican Republic
Jorge Cruz
Pedro Farias-Nardi
Pedro Jaime Fernandez
Miguel Gomez
Adriano Rosario

Ecuador
Buendia Rodrigo
Karla Gachet
Alfredo Ernesto Lagla
Marcos Pin
Carlos Pozo Alban
Alejandro Reinoso
Paul Rivas
Fernando Sandoval Jr
Santiago Serrano

Egypt
Myriam Abdelaziz
Farid Abdulwahab
Mohamed Abdou
Nour El Refai
Laura El-Tantawy
Bassam El-Zoghby
Dalia Elakkad
Ahmed Hayman
Mohamed Hossam El-Din
Amr Nabil
Ahmed Ona
Heba Rabie
Alia Refaat
Asmaa Waguih

El Salvador
Mario Amaya
Mauro Arias
Erick S. Barahona Salinas
José Cabezas
Mauricio Cáceres
Omar Carbonero
Douglas Alberto Urquilla
Ericka Chávez
Yuri Cortez
Giovanni Cuadra
Jorge Reyes
Lissette Lemus
Luis Alonso López
Borman Mármol
Victor Peña
Frederick Meza
Oscar Mira
Juan Carlos
Nubia Rivas
Roberto Escobar
Manolo Rivera
Luis Angel Umaña
Arely Umanzor
Salomón Vásquez

Estonia
Kaido Haagen
Erik Prozes

Ethiopia
Befekadu Beyene Tefera

Faroe Islands
Benjamin Rasmussen

Finland
Tommi Anttonen
Jukka Gröndahl
Sari Gustafsson
Hannes Heikura
Markus Jokela
Petteri Kokkonen
Rami Lappalainen
Tatu Lertola
Henrik Malmström

Timo Marttila
Juhani Niiranen
Tatu Paulaharju
Jari Peltomäki
Heidi Piiroinen
Aleksi Poutanen
Timo Pyykkö
Kimmo Räisänen
Johan Sandberg
Heikki Saukkomaa
Eetu Sillanpää
Ilkka Uimonen
Tuomas Uusheimo
Petri Mikael Uutela
Mikko Vähäniitty

France
Olivier Adam
Pierre Adenis
Farid Allouache
Christian Alminana
Thierry Ardouin
Patrick Artinian
Capucine Bailly
Joan Bardeletti
Martin Barzilai
Pascal Bastien
Sébastien Baverel
Patrick Baz
Vladimir Bazan
Benjamin Béchet
Arnaud Beinat
Christian Bellavia
Besse
Guillaume Binet
Bernard Bisson
Romain Blanquart
Olivier Boëls
Christophe Boete
Vincent Boisot
Francis Bompard
Régis Bonnero
Jérôme Bonnet
Marc Bonneville
Jean-Christian Bourcart
Denis Bourges
Loic Bouteruche
Pierre Boutier
Eric Bouvet
Gabriel Bouys
Jacques Bravo
Fabien Breuil
Patrick Bruchet
Axelle de Russé
Christophe Calais
Anne-Laure Camilleri
Federico Campanale
Herman Campos
Francesco Carella
Francois Carlet-Soulages
Sarah Caron
Fabrice Catérini
Héléne Caux
Gabriel de la Chapelle
Lionel Charrier
Thomas Chasaing
Julien Chatelin
Marc Chaumeil
Mehdi Chebil
Sylvain Cherkaoui
Jean-Pierre Clatot
Sébastien Le Clézio
Thomas Coex
Stephane Compoint
Jerome Eagland-Conquy
Olivier Coret
Yannick Cormier
Magali Corouge
Olivier Corsan
Philippe Cottin
Jean-Christophe Couet
Olivier Coulange
Gilles Coulon
Eve Coulon
Mathieu Cugnot
Olivier Culmann
Denis Dailleux
Viviane Dalles
Khanh Dang-Tran
Julien Daniel
William Daniels
Gautier Deblonde
J.Debru
Magali Delporte
Francis Demange
Michel Denis-Huot
Mathias Depardon
Lionel Derimais
Pierre-Olivier Deschamps
Benedicte Desrus
Jean Jérôme Destouches

Dewever Plana
Agnes Dherbeys
Olivier Digoit
Joel Douillet
Oliver Douliery
Claudine Doury
Alain Ernoult
Jean-Eric Fabre
Hubert Fanthomme
Franck Faugère
Bruno Fert
Corentin Fohlen
Daniel Fouray
Jean François Fourmond
Emmanuel Fradin
Dorian Francois
Eric Gaillard
Nicolas Gallon
Eric Garault
Beatrice De Gea
Laurent Geslin
Christophe Gin
Baptiste Giroudon
Georges Gobet
Julien Goldstein
Mondoloni
Mathieu Grandjean
Olivier Grunewald
Bertrand Guay
Damien Guerchois
Jack Guez
Ivan Guilbert
François Guillot
Jean-Paul Guilloteau
Guionie
Pascal Guyot
Valery Hache
Eitan Haddok
Lea Hamoignon
Laurent Hazgui
Gerald Holubowicz
Boris Horvat
Philippe Huguen
Pierre Hybre
JR
Laurent Julliand
Guilad Kahn
Christophe Karaba
Alain Kauffmann
Vincent Kessler
Stephane Klein
Pascal Kobeh
Christian Koeler
Gregoire Korganow
Patrick Kovarik
Benedicte Kurzen
Olivier Laban-Mattei
Stephane Lagoutte
Bertrand Langlois
Sébastien Lapeyrère
Herve Lavigne
Stéphane Lavoué
Ulrich Lebeuf
Eric Lefranc
Benjamin Lemaire
Herve Lequeux
Lewkowicz
Philippe Lissac
Christian Lombardi
Philippe Lopparelli
John MacDougall
Pascal Maître
Stephane Mantey
Christophe Maout
Catalina Martin-Chico
Pierre-Yves Marzin
Georges Merillon
Isabelle Merminod
Bertrand Meunier
C Mikael
Marcel Mochet
Bruno Morandi
Vincent Mouchel
Roberto Neumiller
Sebastien Nogier
Alain Noguès
Stephan Norsic
Frederic Noy
Hector Olguin
Olivier Robin
Georges Pacheco
Jef Pachoud
Olivier Panier des Touches
Julien Pannetier
Panseri
Philippe Parent
Claude Pauquet
Pascal Pavani
Jean-Baptiste Pellerin
Vincent Perraud

Eric Perriard
Franck Perrogon
Christophe Petit-Tesson
Dominique Pichard
Poiron
Frédéric Mery Poplimont
Anne-Christine Poujoulat
Philippe de Poulpiquet
Philip Poupin
Christian Poveda
Eric Prinvault
Noël Quidu
Rijasolo
Eric Rechsteiner
Stéphane Remael
Guillaume Ribot
Franck Robichon
Olivier Roller
Denis Rouvre
Frédéric Sautereau
Pierrick Sauvage
Antonio Scorza
Franck Seguin
Roland Seitre
Thierry Seray
Jérôme Sessini
Jean-Manuel Simoes
Christophe Simon
Catherine Steenkeste
Benoit Stichelbaut
Frédéric Stucin
Flore-Aël Surun
Thierry Suzan
Boris Svartzman
Patrick Swirc
Myriam Tangi
Fred Tanneau
Pierre Terdjman
Ambroise Tézenas
Laurent Theillet
Pierre Torset
Patrick Tourneboeuf
Eric Travers
Bruno Valentin
Eric Vandeville
Loic Venance
Jean-Christophe Verhaegen
Véronique de Viguerie
Franck Vogel
Marc Wattrelot
Stephan Zaubitzer
Zuili Guillaume
Michael Zumstein

Georgia
Mariam Amurvelashvili
Temo Bardzimashvili
Fridon Gegeshidze
Natela Grigalashvili
Khatia Jijeishvili
Levan Kherkheulidze
Marika Kochiashvili
David Mdzinarishvili
Ketevan Mgebrishvili
Dato Rostomashvili
Mzia Saganelidze
Niko Tarielashvili
Beso Uznadze

Germany
Valeska Achenbach
Emil Alfter
André Lützen
Ingo Arndt
Bernd Arnold
Kathryn Baingo
David Baltzer
Christoph Bangert
Lars Baron
Theodor Barth
Patrick Barth
Dirk Bauer
David Bebber
Siegfried Becker
Marion Beckhäuser
Marc Beckmann
Gregor Beltzig
Fabrizio Bensch
Jutta Benzenberg
Guido Bergmann
Peter Bialobrzeski
Henning Bode
Anja Bohnhof
Sebastian Bolesch
Stefan Boness
Maik Bönisch
Wolfgang Borm
Wolf Böwig
Verena Brandt
Hermann Bredehorst
Gero Breloer

Hansjürgen Britsch
Sabine Bungert
Hans-Jürgen Burkard
Christian Burkert
Christoph Busse
Dominik Butzmann
Sven Creutzmann
Michael Dalder
Peter Dammann
Ansgar Dlugos
Sven Döring
Frank Domahs
Martin von den Driesch
Birgit-Cathrin Duval
Winfried Eberhardt
Thomas Ebert
E. Ehmke
Jörg-Florian Eisele
Andreas Ellinger
Stefan Enders
Stephan Engler
Daniel Etter
Simon Eymann
Stefan Falke
Rüdiger Fessel
Anke Fleig
Mareike Foecking
Kai Peter Försterling
Samantha Franson
Horst Friedrichs
Sascha Fromm
Maurizio Gambarini
Christian Gatniejewski
Frank Gehrmann
Uwe Gerig
Christoph Gerigk
José Giribás
Jörg Gläscher
Christoph Goedan
Oliver Görnandt
Jens Grossmann
Waltraud Grubitzsch
Hanno Gutmann
Robert Haaß
Haertelpress
Jürgen Haffa
Michael R. Hagedorn
Matthias Hangst
Verena Hanschke
Alfred Harder
Barbara Hartmann
Alexander Hassenstein
Julie Hau
Silvia Hauptmann
Roswitha Hecke
Gerhard Heidorn
Marc Heiligenstein
Axel Heimken
Meiko Herrmann
Katharina Hesse
Benjamin Hiller
Monika Hoefler
Torben Hoeke
Marc Hofer
Helge Holz
Sandra Hoyn
Wolfgang Huppertz
Malte Jäger
P. Jahn
Angelika Jakob
Judith Jockel
Patrick Jöst
Kati Jurischka
Rasmus Kaessmann
Eduard
Paul Kalkbrenner
Enno Kapitza
Christiane Kappes
Lutz P. Kayser
Claus Kiefer
Dagmar Kielhorn
David Klammer
Christian Klein
Brigitta Klotz
Jens Knappe
Herbert Knosowski
Heidi Koch
Hans-Jürgen Koch
Willem Konrad
Marcus Koppen
Christof Köpsel
Reinhard Krause
Gert Krautbauer
Andrea Künzig
Karl Lang
Oliver Lang
Ralph Larmann
Bernd Lauter
Matthias Ley
Ralf Lienert

Gerd Ludwig
Maximilian Ludwig
Jochen Manz
Henrik Martinschledde
Noel Tovia Matoff
Matthias Jung
Fabian Matzerath
Oliver Meckes
Verena Meier
Jörg Meier
Martin Meissner
Günther Menn
Andreas Meyer
Robert Michael
Katharina Mouratidi
Cathrin Mueller
Andreas Mühe
Bodo Müller
Tim Müller
Lene Münch
Merlin Nadj-Torma
Anja Neidringhaus
Klaus Nigge
Nicole Ottawa
Christoph Otto
Ingo Otto
Jens Palme
Michael Penner
Laci Perenyi
Carsten Peter
Kai Pfaffenbach
Helge Prang
Stephan Rabold
Thomas Rabsch
Britta Radike
Baz Ratner
Markus Georg Reintgen
Pascal Amos Rest
Sascha Rheker
Stefan Richter
Astrid Riecken
Julian Roeder
Daniel Rosenthal
Martin Sasse
Henning Schacht
Helena Schaetzle
Susanna Schaffry
Rüdiger Schall
Peter Schatz
Detlev Scheerbarth
Tomas Schelp
Detlev Schilke
Goetz Schleser
Roberto Schmidt
Mika Schmidt
Wolfgang Schmidt
Thomas Schmidt
Oliver Schmieg
Marcus Schmigelski
Harald Schmitt
Michael Schnabel
Uwe Schober
Harald Schrader
Thomas Schreyer
Annette Schreyer
Frank Schultze
Claudius Schulze
Stephan Schütze
Michael Schwartz
Jens Schwarz
Oliver Sehorsch
Yvonne Seidel
Philip Seidel
Bernd Seydel
Frank Siemers
Marcus Simaitis
Johannes Simon
Agata Skowronek
Armin Smailovic
Stefan Sobotta
Ute Sonnenberg
Heiko Specht
Martin Specht
Kathrin Spirk
Andy Spyra
Martin Steffen
Matthias Steinbach
Marc Steinmetz
Björn Steinz
Peter Steudtner
Angelika von Stocki
Gottfried Stoppel
Carsten Stormer
Volker Strohmaier
Jakob Studnar
Selim Sudheimer
Jens Sundheim
Stefan Syrowatka
Holger Talinski
Andreas Teichmann
Tuna Tekeli

Micha Theiner
Marc-Steffen Unger
Thomas Victor
Heinrich Voelkel
Stefan Volk
Alexander Volkmann
Helmuth Vossgraff
Lucas Wahl
Richard Walch
Harry Weber
Frank Wechsel
Oliver Weiken
Sandra Weller
Ludwig Welnicki
Johanna
Gordon Welters
Philipp Wente
Falk Wenzel
Silke Wernet
Sebastian Widmann
Kai Wiedenhöfer
Claudia Yvonne Wiens
Carsten Windhorst
Rainer Windhorst
Ann-Christine Woehrl
Michael Wolf
Oliver Wolff
Solvin Zankl
Frank Zauritz
Christian Ziegler
Marco Zitzow
Marcus Zumbansen

Ghana
Emmanuel Quaye

Greece
Yannis Behrakis
Alexandros Beltes
Evangelos Bougiotis
Androniki Christodoulou
Vassilis Constantineas
Jonnek Jonneksson
Apostolis Domalis
Pavlos Fysakis
Ioannis Galanopoulos
Vangelis
Petros Giannakouris
Harris Gikas
Angelos Giotopoulos
Louisa Gouliamaki
Thanasis Kalliaras
Yiorgos Karahalis
Nikos Kokkas
Yannis Kolesidis
Dionysis Kouris
Savvas Lazaridis
John Lefakis
Tzekas Leonidas
Marios Lolos
Georgios Makkas
Kostas Mantziaris
Vasilis Maroukas
Aris Messinis
Dimitris Michalakis
Sakis Mitrolidis
Stefania Mizara
Konstantinos Paschalis
Nikos Pilos
Lefteris Pitarakis
Vladimir Rys
Fanny Sarri
Thanassis Stavrakis
John Stratoudakis
Elias Staris
Vassilis Triantafyllidis
Sofia Tsampara
Tzamaros Panayiotis
Angelos Tzortzinis
Aris Vafiadakis
Stratis Vogiatzis

Guam
Ed Crisostomo

Guatemala
Jesús Alfonso
Rodrigo Arias
Edwin Benavente
Moisés Castillo
Erlie Castillo Nufio
Ana Cecilia Cobar Falla
Carlos Duarte
Luis Echeverria
Esteban Biba
Stanley Herrarte
Doriam Morales
Andrea Pennington
Morena Joachin
Danilo Ramírez
Toni Rodriguez

Luis Soto
Beatriz Veliz Argueta
Alvaro Yool

Honduras
Martinez Elmer
Orlando Sierra

Hong Kong
Chan Wai Hing
Chau Wing Yiu Vivian
Wang Chen
Xiye
Chun Wai
Chan Chun Kei
Fu Chun Wai
Ho Ming Lau
Thomas Lee
Ted Lee
Hiuwing Lee
Leung Cho Yi
Robert Ng
ShiZhong OuYang
jackypoon83
Huang Songhe
Sun Lanshan
Sunhuajin
Yiulun Wong
Wong Ho Hang
Paul
Jia-lian Yuan
Gene Chow Yanlo

Hungary
Jozsef Agocs
Bacsi Robert Laszlo
Attila Balázs
Zoltán Balogh
Béli Balázs
Judit Berekai
Krisztián Bócsi
Balázs Czagány
Gyula Czimbal
Katalin Darnay
Dobos Ferenc
Bela Doka
Tivadar Domaniczky
Gabor Dvornik
Krisztina Erdei
Imre Foldi
Gabor Garamvari
Balazs Gardi
András Gati
Glázer Attila
András Hajdú D.
Hernad Geza
Akos Horvath
Tibor Illyés
Ferenc Isza
Bea Kallos
Levente Kádár
György Károlyi
Kerekes M. István
Peter Kollanyi
Szilard Koszticsak
Attila Kovács
Mti/Tamas Kovacs
Daniel Kovalovszky
Janos Kummer
Arpad Kurucz
Attila Manek
Bence Máté
Simon Móricz
Lazslo Novak
Paczai Tamas
Balint Porneczi
Tamas Revesz
Zsolt Reviczky
Gaspar Risko
Zoltan Ritzel
Zsuzsanna Rózsa
Sánta István Csaba
Balázs Simonyi
Lajos Soos
Gábor Steiner
Akos Stiller
Sandor H. Szabo
Szabo Bernadett
Peter Szalmas
Bela Szandelszky
Robert Szaniszlo
Lilla Szász
Jason Szenes
Joe Petersburger
Zsolt Szigetváry
Laszlo Szirtesi
Zoltan Tombor
Adam Urban
László Varga
Attila Volgyi
Péter Zádor

Iceland

Vilhelm Gunnarsson
Heiða Helgadóttir
Thorvaldur Kristmundsson
Kristinn Magnússon
Rakel Ósk Sigurðardóttir
Pall Stefansson
Arni Torfason

India

S. N. Acharya
Sanjay Ahlawat
irshad alam
A. Sarath Kumar
A. Prathap
Channi Anand
Bindu Arora
Anand Bakshi
Pritam Bandyopadhyay
Tarapada Banerjee
Jaswant Singh Bassan
Subhashis Basu
Salil Bera
Sayantan Bera
Kamalendu Bhadra
Rouf Bhat
Mukesh Kamal
Subhamoy Bhattacharjee
Anup Bhattacharya
Biju Boro
A.K. Bijuraj
Kishor Kumar Bolar
Ranjan Basu
Anamitra Chakladar
Rana Chakraborty
Amit Chakravarty
Ch. Vijaya Bhaskar
Puneet Chandhok
Jagadeesh
Anindya Chattopadhyay
Chirodeep Chaudhuri
Manoj Chhabra
C Suresh Kumar
K.K. Choudhary
Ch. Narayana Rao
Arul Horizon
Dar Yasin
Bikas Das
Sucheta Das
Sanjit Das
Sudipto Das
Subhabrata Das
Vrindavan Lila Dasi
Arko Datta
Sumit Dayal
Rajib De
Mukunda De
Samba
Dasarath Deka
Mandar Deodhar
Uday Deolekar
Ranjit Deshmukh
Ashok Dhamija
YC Dhardhowa
Purushottam Diwakar
Sima Dubey
Dudhalkar Gajanan
Nilayan Dutta
Subir Kumar Dutta
Bishwarup Dutta
Pattabiraman
Uttam Ghosh
Sanjoy Ghosh
Sayatan Ghosh
Ronjoy Gogoi
Alok B. Guha
Prodip Guha
Ashish Shankar
Mukesh Gupta
Sanjeev Gupta
Sanjay Hadkar
Subir Halder
Krishnendu Halder
Adeel Halim
Sachin Haralkar
G.K. Hegde
Vikas Hotwani
Sohrab Hura
Yasir Iqbal
Ritika Jain
Puduvai J. Murugan
Vibi Job
Rajesh Joshi
Shaifali Joshi
Fayaz Kabli
Yawar Nazir Kabli
Rajanish Kakade
Aditya Kapoor
Sankha Kar
Soumik Kar
Vinod Karimatt

Harikrishna Katragadda
Ruhani Kaur
Bijumon Kavalloor
Mukhtar Khan
Praveen Khanna
Kamal Kishor
Kamal Kishore
Venkat Kolluru
Ritu Raj Konwar
Pawan Kumar
Vipin Kumar
Selvan Shiv Kumar
Naleen Kumar
Nalgonda Shiva Kumar
Manoj Chemancheri
Rajesh Kumar Singh
Selvaprakash Lakshmanan
Ajilal
Zishaan Akbar Latif
Ryan Lobo
Manvender Love
Amit Madheshiya
Sudhanshu Malhotra
Rafiq Maqbool
Kailash Mittal
Indranil Mukherjee
Paroma Mukherjee
Arindam Mukherjee
Babu Murali Krishnan
Rajtilak Naik
Suresh Nampoothiri
Anupam Nath
Ashok Nath Dey
Nathan G
VT Navas
Gagan Nayar
Pitamber Newar
Pabitra Das
Hemant Padalkar Ravindra
Raminder Pal Singh
P.V. Sunder Rao
Josekutty Panackal
Shailendra Pandey
Sandeep Pangerkar
Manas Paran
Ganesh Parida
Shriya Patil
Kunal Pradeep Patil
Prajakt P. Patil.
Indranil Paul
Partha Paul
Vijayan.P
Peethambaran Payyeri
Sivakumar P.V.
Ravi Posavanike
Chhandak Pradhan
Jitendra Prakash
Pranjal Baruah
Altaf Qadri
Appampalli Radhakrishna
Ashish Raje
R. Senthil Kumaran
Rama Madhu Gopal Rao
K. Ramesh Babu
Amit Rameshchandra
Nishant Ratnakar
R. Raveendran
Nilanjan Ray
Sandesh Rokade
Manpreet Romana
Sambit Priya Saha
Abdul Sajid
Apoorva Salkade
M. Joy Samuel
Sajeesh Sankar
Suman Sarkar
Sarkar
Kayyur Sasi
Satheesh Nair
Pankaj Sekhsaria
Arijit Sen
Bijoy Sengupta
Partha Sarathi Sengupta
KVS Giri
Russell Shahul
Anil Shakya
L.R.Shankar
Subhash Sharma
Tushar Sharma
Ashish Sharma
Jayanta Shaw
Anand Shinde
Abid Saleem Siddiqi
Bharat Sikka
Prakash Singh
Dhiraj Singh
Sujan Singh
Jaipal Singh
Sanat Kumar Sinha
Ashok Sinha
Anshuman Poyrekar

Ajit Solanki
Nitin Sonawane
Shekhar Soni
SreeKumar EV
Vemula Amara Srinivasarao
Subhendu Ghosh
Anantha Subramanyam.K.
Pradeep Kumar Surya
Manish Swarup
Syed Fasdiuddin
Gitika Talukdar
T. Srinivasa Reddy
Rajesh Tandon
Ishan Tankha
Deepak Turbhekar
Harish Tyagi
Ritesh R. Uttamchandani
Mathimaran
Vijay Verma
Ajay Verma
Robert Vinod
Vishal Srivastava
Prashanth Vishwanathan
Keshav Vitla
Danish Ismail
N. Jaisingh
Atul Yadav
Dar Yasin
Mohd Zakir

Indonesia

Yuyung Abdi
Ricky Adrian
Afriadi Hikmal
Yuniadhi Agung
Dita Alangkara
M. Anshar
Andi Anshari
Hasbi Azhar
Binsar Bakkara
Tantyo Bangun
Agung Kuncahya B.
Beawiharta
Sumaryanto Bronto
Ramdani
Johannes P. Christo
Andi Cristop
Oka Daud
Dedy Sinuhaji
Budi N.D. Dharmawan
Irwin Fedriansyah
Muhammad Fitrah
Iwan
Md. Mishbahul Fuad
Junaidi Gandy
AkbarGumay
Guslan Gumilang
Jongki Handianto
Y.T. Haryono
Raditya Helabumi
Wihdan
Ulet Ifansasti
Fauzan Ijazah
Akbar Insani
Mast Irham
Bay Ismoyo
Mamuk Ismuntoro
Hubert Januar
Heri Juanda
Kemal Jufri
Nungki Kartikasari
Feri Latief
P.J. Leo
Mahatma Putra
Yudhi Mahatma
Chaideer
Safir Makki
Zarqoni
Doni Maulistya
Yusuf Ahmad Muhammad
Wahyu Heru
Irsan Mulyadi
Ronny D. Musyhiar
Mike Eng Naftali
Karolus Naga
Made Nagi
Chalid Nasution
Fanny Octavianus
Crack Palinggi
Sigit Pamungkas
Pang Hway Sheng
Rosa Panggabean
Ivan N. Patmadiwiria
Ismar Patrizki
Danang Ambar Prabowo
Lucky Pransiska
Arief Bagus
Peksi Cahyo
Boby Matanesia
Danu Primanto
Rommy Pujianto

Edy Purnomo
Agung Rahmadiansyah
Agung Rajasa
Thoriq Ramadani
Ardiles Rante
Aman Rochman
Andrea
Bedu Saini
Toto Santiko Budi
Susanto Santo
Willy Saputra
Sandi Jaya Saputra
Yuli Seperi
Antonius Riva S.
Iwan Setiyawan
Oscar Siagian
Ferdy Siregar
Poriaman Sitanggang
Sihol Sitanggang
Boy Slamet
Sinartus Sosrodjojo
Jurnasyanto Sukarno
Agus Susanto
Ichwan Susanto
Arief Suhardiman
Donang Wahyu
Petra Wangsadihardja
Agustinus Wibowo
Andreas Satryo Wibowo
Wisnu Widiantoro
Danny Widjaja
Andika Wahyu
Taufan Wijaya
Yudhi sukma wijaya
Totok Wijayanto
Rony Zakaria

Iran

Anonymous
Hossein Alizadeh
Aslon Arfa
S N Azad
Mohammad Babaei
H. Langrodi
Kaveh Baghdadchi
Roxane B.
Mohsen Bayramnejad
Adel Bonakdarpour
Danial Bouzarjomehri
Reza
Parastoo Ebneali
J.E. Aalimanesh
Amir Reza Fakhri
Saeed Faraji
Caren Firouz
Mohammad Ghadamali
Ali Ghalamsiah
Ghasedak
Babak Ghoorchian
Mohammad Golchin Kohi
Reza Golestani
Seyed Hossien Hadeaghi
Ziba Hajheydari
Mehri Jamshidi
Saeed Jodat
Arash
Mohammad Kheirkhah
Mohammed Reza Kowsari
Ghazal Mafakheri
Katayoun Massoudi
Behrouz Mehri
Soroosh Milanizadeh
Behnam Moazen
Md. Mahdi Moazen
Ahmad Moenijam
Mansoreh Motamedi
Sara Ahmadi Najaf Abadi
Mohammad Namazi
M. Nikoubazl-e Motlagh
Morteza Noormohammadi
Amir Masoud Oskouilar
Morteza Pournejat
Aydin
Maryam Rahmanian
Farhad Ranjbaran
Golrokh Ravesh
Saeed Rezvanian
Kaveh
Payam Rouhani
Amir Sadeghi
Majid
Sajjad Safari
Vahid Salemi
Nousha Salimi
Ali Samei
Niloofar Sanandajizadeh
Mohsen Sanei Yarandi
Babak Sedighi
Shaded
Shahrouz Sharifi Nasab
Mahmoudi Soleyman

Mamrez
Alireza Sotakbar
Saba Taherian
Abedin Taherkenareh
Mohamad Tajik
Newsha Tavakolian
Shahrnaz Zarkesh
Raheleh Zomorrodinia

Iraq

Ghaith Abdul-Ahad
Julie Adnan
Yahya Ahmed
Ahmed Al-Rubaye
Hassan Ammar
Muhannad Fala'ah
Karim Kadim
Khalid Mohammed
Jamal Penjweny
Dhikra Sarsam

Ireland

Julien Behal
Laurence Boland
Deirdre Brennan
Matthew Browne
Mark Condren
Aidan Crawley
David Creedon
Barry Cronin
Kieran Doherty
Colman Doyle
Mark Duffy
Arthur Ellis
Brenda Fitzsimons
David O'Flynn
Kieran Galvin
David Gannon
Noel Gavin
Brian Gavin
Diarmuid Greene
Keith Heneghan
Steve Humphreys
Cillian Kelly
John C Kelly
Graham Keogh
Brian Lawless
Dan Linehan
Eric Luke
David Maher
Andrew McConnell
Ross McDonnell
Cathal McNaughton
Charles McQuillan
Oliver McVeigh
Frank Miller
Denis Minihane
Paul Mohan
Declan Monaghan
Brendan Moran
Seamus Murphy
Pat Murphy
Mick O'Neill
Cathal Noonan
Bryan O'Brien
Douglas O'Connor
Kenneth O'Halloran
Stalingrad O'Neill
Finbarr O'Rourke
Joe O'Shaughnessy
Fergal Phillips
Dave Ruffles
Ray Ryan
Lorraine O'Sullivan
Valerie O'Sullivan
Domnick Walsh
Eamon Ward
Gwen Wilkinson
Henry Wills
Omar Yashruti

Israel

Tomer Appelbaum
Oded Balilty
Dan Balilty
Rafael Ben-Ari
Jonathan Bloom
Rina Castelnuovo
Amir Cohen
Gil Cohen Magen
Yori Costa
Natan Dvir
Nir Elias
Ido Erez
Michal Fattal
Boaz G.
Eddie Gerald
Kobi Gideon
Amnon Gutman
Nitzan Hafner
Asher Havivi

Nir Kafri
Menahem Kahana
Nadav Kander
Julia Komissaroff
Ziv Koren
Eyal Landesman
Shay Mehalel
Amir Meiri
Omer Messinger
Moti Milrod
Lior Mizrahi
Nadav Neuhaus
Jorge Novominsky
Eldad Rafaeli
Rose Inbal
Atef Safadi
Ariel Schalit
Shaul Schwarz
Ahikam Seri
Nati Shohat
David Silverman
Uriel Sinai
Michael Steindel
Abir Sultan
Dafna Tal
Matanya Tausig
Daniel Tchetchik
Yuval Tebol
Gali Tibbon
Miriam Tsachi
David Vaaknin
Guy Wasserman
Yonathan Weitzman
Pavel Wolberg
Kobi Wolf
Ilia Yefimovich
Yehoshua Yosef
Oren Ziv
Ronen Zvulun

Italy

Francesco Acerbis
Edoardo Agresti
Fabio Amadei
Vito Amodio
Roberto Armocida
Giampiero Assumma
Giovanni Attalmi
Michele Audisio
Tommaso Ausili
Daniele Badolato
Silvia Baglioni
Diana Bagnoli
Antonio Baiano
Alessandro Belgiojoso
Marco Barbon
Andrea Erdna Barletta
Marco Baroncini
Tommaso Barsali
Massimo Bassano
Matteo Bastianelli
Nino Bartuccio
Paola Zofrea Battipede
Francesca Bellini
Cristiano Bendinelli
Massimo Berruti
Leonello Bertolucci
Carlo Bevilacqua
Alessandro Bianchi
Alfredo Bini
Marco Biondi
Valerio Bispuri
Silvia Boarini
Roberto Boccaccino
Paolo Bona
Tommaso Bonaventura
Marcello Bonfanti
Ugo Lucio Borga
Alberto Bortoluzzi
Michele Borzoni
Susetta Bozzi
Massimo Brega
Maurizio Bricola
Daniele Brunetti
Talos Buccellati
Fabio Bucciarelli
Mario Bucolo
Monika Bulaj
Giulio Bulfoni
Marco Bulgarelli
Alberto Buzzola
Roberto Caccuri
Jean-Marc Caimi
Guy Calaf
Simona Caleo
Eleonora Calvelli
Alberto Campi
Maristella Campolunghi
Federico Caponi
Leonardo Caporale

Davide Casella
Samantha Casolari
Eduardo Castaldo
Luciano Del Castillo
Luca Catalano Gonzaga
Gianluca Cecere
Giancarlo Ceraudo
Alessia Cerqua
planetdario
Maurizio Chelucci
János
Francesco Chiorazzi
Donato Chirulli
Cesare A. Cicardini
Alessandro Ciccarelli
A. Cicchini
Manolo Cinti
Pier Paolo Cito
Massimiliano Clausi
Ignacio Maria Coccia
Francesco Cocco
Giovanni Cocco
Maurizio Cogliandro
Nadia Shira Cohen
Emanuela Colombo
Luna Coppola
Luigi Corda
Mauro Corinti
Matt Corner
Marilisa Cosello
Marzia Cosenza
Alessio Coser
Alessandro Cosmelli
Lidia Costantini
Mirko Cottone
Alfredo Covino
Claudio Cricca
Christian Cristoforetti
Marco Cristofori
Pietro Cuccia
Fabio Cuttica
Alfredo D'Amato
Marco D'Antonio
Albertina d' Urso
Alessandra d'Urso
Enrico Dagnino
Daniele Dainelli
Francesco Dal Sacco
Daniel Dal Zennaro
Chiara Dazi
Abramo De Licio
Nicolò Degiorgis
Luca Desienna
Pietro Di Giambattista
Marco Di Lauro
Armando Di Loreto
Alessandro Di Meo
Giulio Di Sturco
Giovanni Diffidenti
Alessandro Digaetano
Dario de Dominicis
Simone Donati
Patrizia Dottori
Davide Elias
Salvatore Esposito
Alfredo Falvo
Flavia Fasano
Gughi Fassino
Luca Ferrari
Ettore Ferrari
Linda Ferrari
Marzia Ferrone
Marco Ficili
Gaialight
Fabio Fiorani
Giorgia Fiorio
Simone Florena
Nanni Fontana
Ventura Formicone
Luca Forno
Ermanno Foroni
Marco Fracassa
Adolfo Franzò
Eva Frapiccini
Andrea Frazzetta
Nicola "Okin" Frioli
Gabriele Galimberti
Alessandro Gandolfi
Enrico Gaoni
Luigi Gariglio
Marco Garofalo
Massimo Gatti
Guido Gazzill
Giorgio Gelmetti
Michele de Gennaro
Genovese Alessio
Enrico Genovesi
Simona Ghizzoni
Carlo Gianferro
Lorenzo Giglio
Pierluigi Giorgi

Gianni Giosue
Fabrizio Giraldi
Pino Rampolla
Francesco Giusti
Elena Givone
Chiara Goia
Stefano De Grandis
Alessandro Grassani
Paola de Grenet
Marco Iacobucci
Luca Lo Iacono
Alessandro Imbriaco
Marina Imperi
Mattia Insolera
Roberto Isotti
Giuliano Koren
Licio La Rocca
Oskar Landi
Franco Lannino
Larizza Emiliano
Francesco Lastrucci
Laudanna Saba
Alessandro Lazzarin
Francesca Leonardi
Letaz
Martino Lombezzi
Peppino Longobardo
Ciro de Luca
Stefano De Luigi
Guillermo Luna
Lorenzo Maccotta
Sirio Magnabosco
Alessandro Majoli
Ettore Malanca
Livio Mancini
Beatrice Mancini
Francesca H. Mancini
Francesca Romana Mancini
Emiliano Mancuso
Marco Manfredini
Fabio Mantovani
Manuel Marano
Paolo Marchetti
Claudio Marcozzi
Giovanni Marino
Fabio Marras
Giovanni Marrozzini
Simone Martinetto
Cesare Marzucci
Enrico Mascheroni
Bob Masi
Alex Masi
Massimo Mastrorillo
Pietro Masturzo
Daniele Mattioli
Antonio Mazzarella
Antonello Mazzei
Edoardo Melchiori
Giovanni Mereghetti
Francesco Millefiori
Matteo Minnella
Mauro Minozzi
Pierpaolo Mittica
Mimi Mollica
Laura Montanari
F. Filippo Monteforte
Davide Monteleone
Silvia Morara
Morelli Stefano
Claudio Morelli
Alberto Moretti
Lorenzo Moscia
Sara Munari
Filippo Mutani
Giulio Napolitano
Luca Nizzoli Toetti
Massimo Di Nonno
Francesco Nonnoi
Michele Nucci
Francesca Oggiano
Nino Oliveri
Oliviero Olivieri
Claudio Onorati
Gianluca Oppo
Dario Orlandi
Diego Orlando
Agostino Pacciani
Franco Pagetti
Giancarlo Pagliara
Luca Pagliari
Andrea Pagliarulo
Joao Paglione
Michele Palazzi
Stefano Paltera
Graziano Panfili
Pietro Paolini
Paolo Patrizi
Stefano G. Pavesi
Alice Pavesi
Alice Pedroletti
Samuele Pellecchia

151

Paolo Pellegrin
Paolo Pellizzari
Alessandro Penso
Viviana Peretti
Simone Perolari
Barbara Perotti Casagrande Perz
Lorenzo Pesce
Carlo Pettinelli
Giuseppe Piazza
Dario Picardi
Emiliano Pinnizzotto
Vincenzo Pinto
Filippo Podestà
Duilio Polidori
Antonio Politano
Paola Pollio
Paolo Porto
Giovanni Presutti
Fabio Proverbio
Rino Pucci
Maike Pullo
Jacopo Querci
Valentina Quintano
Sergio Ramazzotti
Simone Raso
Diego Ravier
Pierpaolo Redondo
Marco Rigamonti
Giada Ripa di Meana
Renata Romagnoli
Filippo Romano
Alessio Romenzi
Claudia Romiti
Rocco Rorandelli
Max Rossi
Patrick Russo
Andrea Sabbadini
Giovanni Sacchetti
Alessandro Sala
Roberto Salomone
Marco Salustro
Luca Santese
Marta Sarlo
Gastone Scarabello
Andrea Scaringella
Claudio Schiacca
Stefano Schirato
Serra Stefano
Luca Sgamellotti
Tonino Sgrò
Claudio Sica
Gianluca Simoni
Massimo Siragusa
Stefano Snaidero
Luca Sola
Andreas Solaro
Pasquale Sorrentino
Luca Spano
Mauro Spanu
Stefano Spaziani
Gabriele Stabile
Simone Stefanelli
Alessandro Stellari
Roberto Strano
Giorgio Sturlese Tosi
Mario Taddeo
Michela Taeggi
Ms Larsen
Daniele Tamagni
Bruno Tamiozzo
Delfina Todisco
Naoki Tomasini
Dario Tommaseo
Luca Tommasini
Stefano Torrione
Alessandro Tosatto
Christian Tragni
Gianfranco Tripodo
Francesco Troina
Luca Tronci
Cristian Umili
Giuseppe Ungari
Stefano Unterthiner
Marco Vacca
Nicoletta Valdisteno
Giuseppe Valente
Roberta Valerio
Davide Vannini
Cristina Vatielli
Riccardo Venturi
Marco Vernaschi
Paolo Verzone
Francesco Vicenzi
Roberto Vignoli
Fabrizio Villa
Laura Villani
Alessandro Vincenzi
Valerio Vincenzo
Massimo Vitali
Antonio Zambardino

Barbara Zanon
Zast
Fabio Zayed
Antonia Zennaro
Massimo Cesare Zinagrdi
Francesco Zizola
Nicola Zolin
Vittorio Zunino Celotto

Jamaica
Jermaine Barnaby
Norman Grindley
Makyn
Andrew P. Smith

Japan
Noriyuki Aida
Tetsuya Akiyama
Everett Kennedy Brown
Yasuyoshi Chiba
Shiho Fukada
Robert Gilhooly
Masaru Goto
Toru Hanai
Yusuke Harada
Hiroyuki Ito
Daisuke Ito
Takaaki Iwabu
Tomonori Iwanami
Taichi Kaizuka
Shizou Kambayashi
Keisuke Kato
Chiaki Kawajiri
Naoko Kawamura
Tetsuya Kikumasa
A.K. Kimoto
Thoshifumi Kitamura
Shigetaka Kodama
Koide Yohei
Toyokazu Kosugi
Yasuhiro Kunimori
Dai Kurokawa
Ikuru Kuwajima
Naoki Maeda
Masato Sawada
Hiroko Masuike
Kazuhiko Matsumura
Fumiko Matsuyama
Kimimasa Mayama
Shigeki Miyajima
Miyazaki Makoto
Takashi Morita
Junji Naito
Takuma Nakamura
Ayumi Nakanishi
Shiro Nishihata
Kazuhiro Nogi
Yasuhiro Ogawa
Kosuke Okahara
Yasuo Ota
Takashi Ozaki
Masashi Saito
Q. Sakamaki
Sato Toshikazu
Kazushige Shirahata
Akira Suemori
Dai Sugano
Ryuzo Suzuki
Okubo Tadashi
Takagi Tadatomo
Kuni Takahashi
Satoshi Takahashi
Tomonari Takao
Atsushi Taketazu
Piko
Terazawa Masayuki
Takeshi Tokitsu
Umemura Naotsune
Kenichi Unaki
Gen Yamaguchi
Kazuhiko Yamashita
Kazuhiro Yokozeki

Jordan
Adeeb Atwan
Ahmed Gharabli
Mohammad abu Ghosh
Nasser Nasser
Mohamed A.A. Salamah
Burhan Salameh

Kazakhstan
Grigoriy Bedenko
Aziz Mamirov
Vladimir Tretyakov
Vera Tropynina
Vladimir Zaikin

Kenya
Thomas Mukoya
Eric Bosire

Antony Kaminju
Caroline W Kaminju
Tony Karumba
Stephen Mudiari
Mbugua Kibera
Charles Kimani
Evans Habil
Thomas Mukoya
James Njuguna Mwaura
Thomas Omondi
Jennifer Muiruri

Kosovo
Laura Boushnak

Latvia
Valdis Brauns
Roman Drits
Reinis Hofmanis
Wilhelm Mikhailovsky
Andrei Shapran
Zigismunds Zalmanis
Ieva Zemite

Lebanon
Ramzi Haidar
Wael Hamzeh
Bilal Jawich
Marwan Naamani
Marwan Tahtah

Lithuania
Mindaugas Azusilis
Romas Cekanavicius
Tomas Cernisevas
Ramunas Danisevicius
Ricardas Grigas
Petras Katauskis
Mindaugas Kavaliauskas
Kazimieras Linkevicius
Gintaras Lukosevicius
Berta Upe Tilmantaite
Romualdas Vaitkus
Saulius Ziura

Luxembourg
Jean-Claude Ernst

Macedonia
Ivan Blazhev
Milan Dzingo
Dzingo Leon
Tomislav Georgiev
Aleksandar Kovacheski

Madagascar
Randrianarisoa Riana R.

Malawi
Amos Gumulira
Bonex Julius
Emmanuel Simpokolwe

Malaysia
Azman Ghani
Jaafar Abdullah
Supian Ahmad
Sawlihim Bakar
Tim Chong
Sim Eng Hooi
Azman Firdaus
Goh Chai Hin
Glenn Guan
Heng Yin Yin
Bob Lee Keng Siang
Kerk
Lai Seng Sin
Lee Chee Keong
Leong Chun Keong
Lawrence Looi
Azhar Mahfof
Adli Ghazali
Ahmad Yusni Mohd Said
Bazuki Muhammad
Mohd Naim Aziz
Samsul Said
Kamal Sellehuddin
Tan Ee Long
Ian Teh
Teoh Jit Khiam
Vincent Thian
FL Wong
Marcus Yam
Yau Choon Hiam

Maldives
Mode

Mali
Malick Sidibe

Malta
Stephen Busuttil
Michael Ellul
Matthew Mirabelli
Johanna Mifsud
Darrin Zammit Lupi

Mauritius
George Michel
Bouck Pillay
Ally Soobye

Mexico
Jesus Ballesteros
David Oziel
Jesus Alcazar
J.C. Alvarez
Lizeth Arauz Velasco
Guillermo Arias
Jerónimo Arteaga-Silva
Miguel Borzelli Arenas
Alejandro Bringas
Fernando Brito
José Luis Camacho
Luis Castillo
Carlos Cazalis
Rafael del Rio
Alfredo Coria
Rodrigo Cruz
José Luis Cuevas
Elizabeth Dalziel
Gustavo Duran De Huerta
Bernardo De Niz
Jorge Dueñes
Gerardo Flores
Enrique Villaseñor
Alfredo Pelcastre
Rafael Gaviria Santos
Julio C Hernández
José Carlo González
Claudia Guadarrama
Hector Guerrero Skinfill
Alfredo Guerrero Zorrilla
Pedro Guevara
Eleazar Esacobar
Fernando Gutiérrez-Juárez
Jaime Boites
Héctor García
Jose Manuel Jiménez
Miguel Juarez
Angel Llamas
Eduardo Loza
Luis Cortes
jcmontana
Jose Luis Magana
Luis Gutiérrez
Imelda Medina
Alexandre Meneghini
David de la Paz
Omar Meneses
Gilberto Meza
Alberto Millares
Jesus Montoya
Eugenio
Gonzalo Fuentes
Alan Morgado
Joel Merino
Javier Otaola
Carlos Aranda
Mauricio Châlons
Ernesto Ramirez
Fernando Ramírez Novoa
Arturo Ramos Guerrero
Pepe Avila
Cristopher Rogel
Valente Rosas
Joel Sampayo Climaco
Juan Carlos Sánchez Díaz
Miriam Sánchez Varela
Ronaldo Schemidt
Diego R. Sierra Moreno
Jorge Silva
Octavio Hoyos
Luis Torres Ruiz
Miguel Tovar
Diego Uriarte Quezada
Federico Vargas Somoza
Irving Villegas Sanchez

Moldova
Serghei Donets

Mongolia
Ts. Batbaatar
Rentsendorj

Morocco
Fayssal Zaoui

Mozambique
Mario Macilau

Nepal
Dhruba Ale
Bijay
Bijay Gajmer
Bimal Gautam
Rajesh Gurung
Chandra Shekhar Karki
Bikash Karki
Sailendra Kharel
Rajendra Manandhar
Ravi Manandhar
Pchandra Neupane
Bhaswor Ojha
Bibi Funyal
Sunil Sharma
Naresh Shrestha
Prasant Shrestha
Tapas Thapa
Keshab Thoker

The Netherlands
Erwin van Amstel
Marcel Bakker
Jan Banning
Amit Bar
Amber Beckers
Berber van Beek
Marcel van den Bergh
Hugo Bes
Chris de Bode
Cynthia Boll
Theo Bosboom
Henk Bothof
Morad Bouchakour
Joost van den Broek
Jan-Dirk van der Burg
Gitta van Buuren
Rachel Corner
Roger Cremers
Marc Deurloo
Marten van Dijl
Rogér van Domburg
Willeke Duijvekam
Carina Dumais
Flip Franssen
Annie van Gemert
Brian George
Peter Gerritsen
Aloys Ginjaar
Remon Haazen
Johan G. Hahn
Roderik Henderson
Piet Hermans
Eddy Hilhorst
Ronald de Hommel
Pieter ten Hoopen
Rob Hornstra
Rob de Jong
Martijn de Jonge
Bas jongerius
Jasper Juinen
Karijn Kakebeeke
Rob Keijzer
Geert van Kesteren
Chris Keulen
Arie Kievit
Theo Kingma
Rebke Klokke
Robert Knoth
Ton Koene
Rob Komen
Joris Komen
Peter de Krom
John Lambrichts
Jerry Lampen
Inez van Lamsweerde
Floris Leeuwenberg
Anya van Lit
Kadir van Lohuizen
Cindy Marler
Vinoodh Matadin
Diederik Meijer
Arjen van der Merwe
Willem Mes
Eric de Mildt
Evert van Moort
Bart Mühl
Robert Mulder
Mathilde Mupe
Jeroen Oerlemans
Marco Okhuizen
Masha Osipova
Erik-Jan Ouwerkerk
Mardoe Painter
Willemine Pernette
Mladen Pikulic
Ahmet Polat
Frans Poptie

Pavel Prokopchik
Mischa Rapmund
Pim Ras
Myriam Roesink
Wouter Roosenboom
Roderick Lloyd
Geert Snoeijer
Corné Sparidaens
Hans Stakelbeek
Corné van der Stelt
Jan-Joseph Stok
Larissa Strating
Ruud Taal
Ruben Joachim Terlou
Jeroen Toirkens
Robin Utrecht
Kees van de Veen
Marieke van der Velden
Peter Verdurmen
Yanthe Verhoeven-van Nek
Dirk-Jan Visser
Teun Voeten
Paul Vreeker
Vincent de Vries
Hanneke de Vries
Koen van Weel
Maryatta Wegerif
Klaas Jan van der Weij
Eddy van Wessel
Arthur Wiegman
Emily Wiessner
Sander F de Wilde
Robert van Willigenburg
Paolo Woods
Daimon Xanthopoulos
Peter van Zetten
Mark van der Zouw

New Zealand
Greg Baker
Scott Barbour
Kent Blechynden
John Borren
Greg Bowker
Melanie Burford
Jocelyn Carlin
Bruce Connew
Marion van Dijk
Braden Fastier
Andrew Gorrie
Robin Hammond
Paul Kennedy
Oliver Xin Li
Marty Melville
Mike Millett
Jiongxin Peng
Brett Phibbs
Phil Reid
Richard Robinson
Martin de Ruyter
Craig Simcox
Aaron Smale
The Age
Mark Taylor
Dean Treml
Phil Walter

Nicaragua
Oscar Navarrete
Jorge Cabrera
B. Picado
Esteban Felix
Guillermo Flores Morales
Orlando Valenzuela
Rossana Lacayo
Oswaldo Rivas

Nigeria
Israel Ophori
Sunday Olufemi Adedeji
Immanuel Afolabi
Kunle Ajayi
Ajumobi Adedayo
Akintunde Akinleye
Will
Kingston O. Daniel
Tuoyo Omagba
Ezeokolie Chika Emmanuel
Nnamdi Charles Ijiomah
Sunday Alamba
Sunday Ohwo
Abiodun Omotoso
Tony Afam Onwuemene
Opara Adolphus

Norway
Jarle Aasland
Tor Arne Andreassen
Paal Audestad
Jon-Are Berg-Jacobsen

Stein Jarle Bjorge
Truls Brekke
Pal Christensen
Marte Christensen
Bjorn Steinar Delebekk
Oyvind Elvsborg
Linda Engelberth
Frode Fjellstad
Andrea Gjestvang
Torbjørn Grønning
Johnny Haglund
Pal Christopher Hansen
Alf Ove Hansen
Thomas Haugersveen
Pål Hermansen
Jan Johannessen
Adrian Øhrn Johansen
Anne-Stine Johnsbråten
Sigurd Fandango
Hilde Mesics Kleven
Daniel Sannum Lauten
Tore Meek
Ole Morten Melgard
Otto von Münchow
Peter Mydske
Linda H. Naesfeldt
Eivind H. Natvig
Fredrik Naumann
Johan Arnt Nesgård
Aleksander Nordahl
Kristine Nyborg
Kim Nygård
Christopher Olssøn
Ken Opprann
Espen Rasmussen
Haavard Saeboe
Pia Solberg
Terje Størksen
Jorn Tomter
Lars Idar Waage
Knut Egil Wang
Sveinung Ystad

Pakistan
Ameer Hamza
Bilal Ahmed
Arshad Arbab
Fayaz Aziz
Bahauddin Khan Bangash
KM Chaudary
Hassan Asif
Zahid Hussain
Amna Nasir Jamal
Saeed Khan
K. Parvez
Mohsin Raza
Akhtar Soomro

Palestinian Territories
Mohammed Abed
Ibraheem Abu Mustafa
Eman Mohammed
Fady Adwan
Rajaa Alterri
Ashrof Amra
Mouid Ashqar
Atta Awissat
Hazem Bader
Khalil Hamra
Mahmud Hams
Adel Hana
Ahmed Jadallah
Abid Katib
Abbas Momani
Muhammed Muheisen
Wissam Nassar
Ali Nureldine
Hatem Omar
Haytham Othman
Khaleel Reash
Mohammed Saber
Suhaib Salem
Mohammed Salem
Nasser Shiyoukhi
Rami Swidan
Ismail Zaydah

Panama
Alexander Arosemena
Eustacio Humphrey
Jaime Justiniani
Anselmo Mantovani
Maydee Romero
Essdras M Suarez
Bienvenido Velasco

Paraguay
Jorge Adorno

Peru
Eitan Abramovich
Mariana Bazo
Miguel A. Bellido Almeyda
Ernesto Benavides del Solar
Martin Bernetti
Manuel Berrios
Max Cabello Orcasitas
I Caceres
Ana M. Castañeda
Patricia Castro Obando
Enrique Castro-Mendivil
Marco Del Rio Correa
Andrés Durand
Hector Emanuel
Antonio Escalante
Raquel Esquives
Stefanía Falla Guiulfo
Barbara P. Fernandez
Bruno Gallia
Carlos Garcia Granthon
Marco Garro
Renzo Giraldo
Juanca
Cecilia Herrera
Richard Hirano
Gary Manrique
Miguel Ángel Mejía C.
Melina Mejía
Andrea Montenegro
Karel Keil Navarro Pando
Lenin Nolly
Musuk Nolte
Pilar Pedraza
Dante Piaggio Diaz
José Luís Quintana
Jair Ramirez
Oscar A. Roca Perales
Camila Rodrigo
Yael Rojas Medina
Luis Sergio
Luna Sibadon
Daniel Silva Yoshisato
Alberto Távara
Giancarlo
Manuel Milko
Gihan Tubbeh
Jose Vidal Jordan
Nancy Chappell Voysest

The Philippines
Mark Balmores
Alex Baluyot
Marianne Bermudez
Estan Cabigas
Kin Cheung
Pam Chua
Tammy David
Jay Directo
Linus Guardian Escandor II
Aaron Favila
Romeo Gacad
Oliver Y. Garcia
Jeryc Garcia
Hadrian N. Hernandez
John Javellana
Victor Kintanar
Luis Liwanag
Francis Malasig
Dennis Borja Mallari
Ver S. Noveno
Buck Harold Pago
Buck Pago
Danny Pata
Bj. A. Patiño
Tony Pionilla
Cheryl Ravelo
KJ Rosales
Joaquin Ruste
Dennis Sabangan
Charlie Saceda
Gigie Cruz
Donald C. Tapan
Dondi Tawatao
Rouelle Umali
Aaron R. Vicencio
VJ Villafranca
Rem Zamora
Fernando Gantica Zapata

Poland
Dorota Awiorko-Klimek
Pawel Bachanowski
Ewa Beldowska
Krystian Bielatowicz
Piotr Bieniek
Aleksander Bochenek
Andrzej Bogacz
Robert Boguslawski
Witold Borkowski
Kasjan Borkowski

Jan Brykczynski
Caillot Dubus
Grzegorz Celejewski
Davido Chalimoniuk
Roman Chelmowski
Filip Cwik
Lukasz Cynalewski
Adam Czajka
Dariusz Delmanowicz
Grzegorz Dembinski
Tomasz Desperak
Natalia Dobryszycka
Irek Kowal
Marek Dylewski
Michal Fludra
Wojtek Franus
Pawel Frenczak
Tomasz Gawalkiewicz
Karolina Gembara
Lukasz Giza
Arkadiusz Gola
Tomasz Gotfryd
Michal Grocholski
Wojciech Grzedzinski
Tomasz Gudzowaty
Michal Gwozdzik
Jakub Ismer
Marcin Jamkowski
Piotr Jasiczek
Radek Jaworski
Maciej Jeziorek
Tomasz Jodlowski
Maciej Kaczanowski
Tomasz Kaminski
Jakub Kaminski
Mariusz Kapala
Maciej Kawalski
Maciej Kielbowicz
Marcin Kin
Krzysztof Koch
Grzegorz Komar
Tytus Kondracki
Pawel Kopczynski
Michal Kosc
Kacper Kowalski
Krzysztof Kowalski
Adam Kozak
Andrzej Koziar
Damian Kramski
Witold Krassowski
Bogdan Krezel
Krzysztof Kubasiewicz
Bartlomiej Kudowicz
Maciej Kupiec
Lukasz Kus
Adam Lach
Pawel Laczny
Marek Lapis
J. Wojtek Laski
Arkadiusz Lawrywianiec
Dawid Linkowski
Michal Luczak
Aga Luczakowska
Aleksander Majdanski
Piotr Malecki
Ola Jaachimska
Rafal Malko
Bartosz Matenko
Justyna Mielnikiewicz
Rafal Milach
Katarzyna Mirczak
Pawel Mlodkowski
Wojtek Moskwa
Yarrek
Maciek Nabrdalik
Andrzej Nasciszewski
Mikolaj Nowacki
Rafal Nowakowski
Joanna Nowicka
Jakub Ochnio
Michal Okla
Wojciech Oksztol
Krystyna Okulewicz
Marcin Onufryjuk
Zbigniew Osiowy
Lukasz Ostalski
Paczos
Tmasz Padlo
Katarzyna Paletko
Adam Panczuk
Elzbieta Piekacz
Robert Pipala
Renata Pizanowska
Piotr Placzkowski
Ryszard Poprawski
Aleksander Rabij
Artur Radecki
Lukasz Radziszewski
Agnieszka Rayss
Jarek Romacki
Kuba Rubaj

Olgierd Rudak
Bartek Sadowski
Katarzyna Sagatowska
Marcin Saldat
Mateusz Sarello
Slawomir Seidler
Darek Sepiolo
Andrzej Siwinski
Tobiasz Skwarczynski
Julian Sojka
Lukasz Sokol
Waldemar Sosnowski
Filip Springer
Mieszko Stanislawski
Pawel Stauffer
Mikolaj Suchan
Przemek Swiderski
Maciej Sypniewski
Michal Szlaga
Szwic
Emanuela Tatarkiewicz
Dawid Tatarkiewicz
Maciej Gadek
Tomaszewski
Michal Topa
Kropa-Marta Topa
Lukasz Trzcinski
Piotr Tumidajski
Jacek Wajszczak
Patryk Walkowicz
Grzegorz Welnicki
Tomasz Wiech
Andrzej Wielgus
Wojciech Wilczyk
Rafal Witczak
Piotr Wittman
Bartek Wrzesniowski
Marek Zakrzewski
Filip Itoito
Karol Zienkiewicz
Bartlomiej Zurawski

Portugal
Daniel Aguiar
Paulo Alexandrino
Edgar Alves
Sérgio Azenha
Schwantz
Carlos Barroso
Júlio Barulho
Miguel Lopes
Paulo Duarte
Rodrigo Cabrita
Mário Caldeira
José Carlos Carvalho
Armindo Cerqueira
Bruno Colaço
Luis António Costa Rosário
Rui Miguel Cunha
Paulo Cunha
Nuno André Ferreira
Nuno Ferreira Santos
Nuno Fox
Nelson Garrido
Luís Guerreiro
Pedro Noel da Luz
Paulo Vaz Henriques
Sérgio Lemos
Nuno Lobito
Angelo Lucas
Miguel Barreira
Artur Machado
Ana Brígida
Da Maia Nogueira
Paulo Nunes dos Santos
Armando Ribeiro
Carlos Palma
Bruno Panache
PedroPatrício
Tiago Petinga
João Pina
Jose Manuel M. Ribeiro
Vitor Manuel Ribeiro
Miguel Ribeiro Fernandes
Miguel A. Lopes
Odette Rodrigues
António Luís Campos
Pedro M. R. Teodosio F.
Nuno Sa
Pedro Saraiva
Paulo Cordeiro
Carlos Costa
Paulo Escoto
Renato Silva
Miguel De Sousa Dias
Luís Ramos
Gonçalo Lobo Pinheiro
Nuno Guimaraes
Nuno Veiga

Puerto Rico
Xavier J. Araujo
Teresa Canino Rivera

Romania
Florin Alboiu
Sorin Antonescu
Remus Nicolae Badea
Valentin Bartolomeu
Irina Bartolomeu
Alex Boghian
Horia Calaceanu
Petrut Calinescu
Leonard Chioveanu
Ioana Cirlig
Octavian Cocolos
Tal Cohen
Bogdan Cristel
Bogdan Croitoru
Cosmin Dan
Zsolt Fekete
Florin Gabor
Octav Ganea
Henning Janos
Victor Ionescu
Stefan Jora
Zoltan Kiraly
Kristo Robert
Laurentiu Nica
Dragos Lumpan
Liviu Maftei
Sebastian Marcovici
Nagy Melinda
Andrei Nacu
Dana Popa
Andrei Pungovschi
Mircea Restea
Sandor Manases
Sebastian Sascau
Radu Sigheti
Catalin Soreanu
Raul Stef
Dragos Stoica
Laurentiu Tarcomnicu
Erika Tasnadi
Mihail Vasile
Tudor Vintiloiu

Russia
Lana Abramova
Fail Absatarov
Anatoli Morkovkin
Anna Akelyeva
Vladimir Anosov
Marya Andreeva
Andre Lyzhenkov
Anikina Valeriya
Petr Antonov
Arbuzov Dmitry
Andrey Arkhipov
Armen Asratyan
Alexander Astafiev
Pavel Astrakhov
Dmitry Azarov
Kazbek Basayev
Beliakov Dmitry
Dimytri Beliakov
Alexander Bendyukov
Olga Kartashova-Bigun
Vitalij Bogdanovich
Viacheslav Buharev
Alexey Bushov
Andrei Chepakin
Artem G. Chernov
Sergei Chirikov
Davidyuk Alexander
Alexandra Demenkova
Evgeniya Dudnikova
Viktoriya Dzhaparidze
Ershova Inna
Vladimir Fedorenko
Yuri Feklistov
Vladimir Filimonow
Mikail Fomichev
Dmitriy Fomichev
Mikhail Galustov
Serge Golovach
Pavel Golovkin
Grigory Golyshev
Sergey Gorbachev
Pavel Gorshkov
Sergey Grachev
Yuri Gripas
Alexander Gronsky
Tatiana Grozetskaya
Sergei Guneyev
Solmaz Guseynova
Yelena Ignatieva
Sergei Ilnitsky
Vasily Ilyinsky
Olga Ivanova

Vaga
Pavel Kashaev
Sam Katz
Dinara Khafizova
Gulnara Khamatova
Kirill Kudryavtsev
Victor Kirsanov
Evgeny Kiselev
Sergei Kivrin
Denis Kojevnikov
Sergey A. Kompaniychenko
Alexey Kompaniychenko
Yevgeny Kondratiev
Anna Kondratieva
Eduard Korniyenko
Gleb Kosorukov
Dmitry Kostyukov
Tanya Kotova
Sergey Kozmin
Evgeny Kozyrev
Andrey Kravchuk
Olga Kravets
Ruslan Krivobok
Oleg Lastochkin
Sergei L. Loiko
Dmitry Lovetsky
Lukin Andrey
Marina Makovetskaya
Dmitry Markov
Maxim Marmur
Julia Maslova
Sergey Maximishin
Natalia Maximova
Alexey Mayshev
Vladimir Melnik
Valery Melnikov
Marianna Melnikova
Sayana Mongush
Mikhail Mordasov
Boris Mukhamedzyanov
Anton Mukhametchin
Alexander Nemenov
Arseniy Neskhodimov
Kseniya Nesmelova
Sergey Novikov
Oksana Onipko
Valentinas Pecininas
Alexander Petrov
Sergey Petrov
Svetlana Petrova
Ilya Pitalev
Sergey Plotnikov
Tatiana Plotnikova
Kirill Pochivalov
Vova Pomortzeff
Sergey Ponomarev
Irina Popova
Pronin Andrei
Mikhail Protasevich
Andrey Rudakov
Maria Rudnaya
Salavat Safiullin
Konstantin Salomatin
Vitaly Savelyev
Alexey Sazonov
Malgavko Shakhidzhanyan
Dmitry Shalganov
Ivan Shapovalov
Oleg J Shashkov
Sergei Shchekotov
Shevelyova Anna
Dmitry Shikhin
Maxim Shipenkov
Nikita Shokhov
Vladimir Shootafedov
Alexander Sidorov
Denis Sinyakov
Vlad Sokhin
Alexander Stepanenko
Dmitry Stepanov
Grigory Sysoev
Alexander Taran
Denis Tarasov
Fyodor Telkov
Alexey Tikhonov
Alexey Tsarev
Yuri Tutov
Sergey V. Vasilyev
Vladimir Velengurin
Sergei Vinogradov
Wishnewetz
Anatoly Vorobiev
Yuri Vorontsov
Vladimir Vyatkin
Alexander Yermakov
Sergey Yermokhin
Yufa Natalya
Victor Yuliev
Yulia Dorofeeva
Alexey Yushenkov
Oksana Yushko

Konstantin Zavrazhin
Anton Jdanov

Saudi Arabia
Zaki Sinan

Senegal
Mamadou Touré

Serbia
Nebojsa Brankovic
Jovana Cetkovic
Aleksandar Dimitrijevic
Marko Djokovic
Milos Djuric
Novak Djurovic
Andrija Ilic
Andrej Isakovic
Nemanja Jovanovic
Sanja Knezevic
Lekic Dragan
Tatjana Lucovic
Pedja Milosavljevic
Alen Popov
Nebojsa Raus
Sasa Radovanovic
Marko Risovic
Srdjan Sulejmanovic
Goran Tomasevic
Dusan Vranic

Singapore
Suhaimi
Chan Bin Kan
Chen Wei Li
Alphonsus Chern
Paul Chew
Caroline Chia Su-Min
Chin Fook Chew
Zhuang Wubin
Kelvin Chng
Choo Chwee Hua
Jonathan Choo
Chua Chin Hon
Er Kian Peng
Joyce Fang Hui-Lin
Gavin Foo
Samuel He
Zann Huizhen Huang
Edwin Koo
Kua Chee Siong
Lam Khin Thet
Lim Wui Liang
Desmond Lim
Kevin Lim
Nicky Loh
Joseph Nair
Ng Sor Luan
Leonard Phuah Hong Guan
Vivek Prakash
Mugilan Rajasegeran
Sam Kang Li
Seah Kwang Peng
David Lee Shijian
Sim Chi Yin
Darren Soh
Edgar Su
Terence Tan
Trevor Tan
Ray Tan
Alex Teh
Toh Nan Li
Wong Maye-E
Woo Fook Leong
Stephanie Yeow
How Hwee Young

Slovakia
Vlado Baca
Jozef Barinka
Gabriela Bulisova
Jana Cavojska
Zdenko Hanout
Jozo Jarosik
Joe Klamar
Martin Kollar
Jozef Mytny
Miro Nota
Ol'ga Pohanková
Pavel Maria Smejkal
Daniel Sutka

Slovenia
Jaka Adamic
Luka Cjuha
Luka Dakskobler
Jaka Gasar
Maja Hitij
Manca Juvan
Matjaz Kacicnik
Matjaz Krivic

Simon Plestenjak
Kaja Pogacar
Matej Povse
Klemen Razinger
Matjaz Rust
Igor Skafar
Tadej Znidarcic

Somalia
Feisal Omar
Sunni Said Salah
Farah Abdi Warsameh

South Africa
Jeffrey Abrahams
Tracey Adams
Justin Barlow
Pieter Bauermeister
Michel Bega
Heinrich van den Berg
Werner Beukes
Daniel Born
Rodger Bosch
Nic Botha
Jennifer Bruce
Sam Clark
Pierre Crocquet
Felix Dlangamandla
Otmar Dresel
Thys Dullaart
Alan Eason
Brenton Geach
Ilan Godfrey
Julian Goldswain
Bongiwe Gumede
Michael Hammond
Cornél van Heerden
Brian Hendler
Loanna
Jon Hrusa
George Hugo
Mike Hutchings
Andrew Ingram
Matthew Jordaan
Adrian de Kock
Christiaan Kotze
Sue Kramer
Halden Krog
David Larsen
Leon Lestrade
Masi
Lizane Louw
Kim Ludbrook
Ziphozonke
Cindy
Mxolisi Whitey Madela
Leonie Marinovich
Lebohang Mashiloane
Neil McCartney
Bongiwe
Eric Miller
Jon Minster
Lauren Mulligan
Ayanda Ndamane
Craig Nieuwenhuizen
Oupa Nkosi
Simphiwe Nkwali
James Oatway
Sibonelo Ngcobo
Raymond Preston
Alet Pretorius
Antoine de Ras
Samantha Reinders
Nikki Rixon
John Robinson
Shayne Robinson
Etienne Rothbart
Simone Scholtz
Marianne Schwankhart
Elizabeth Sejake
Sydney Seshibedi
Siphiwe Sibeko
Dumisani Sibeko
Alon Skuy
Noor Slamdien
Sandile Ndlovu
Brent Stirton
Kevin Sutherland
Duif du Toit
Herman Verwey
Deaan Vivier
Michael Walker
Alexia Webster
Mark Wessels
Graeme Williams
Anna Zieminski
Anita van Zyl

South Korea
Seungwoo Chae
Woohae Cho

Hyungrak, Choi
Jean Chung
Han Myung-Gu
Jaeho Han
Jae Hong
Hae-in Hong
Jeon Heon-Kyun
Jo Yong-Hak
Jaegun Jung
Kang Yoon Joong
Seong-Ryong Kim
Tae Hyeong Kim
Hyunsoo Leo Kim
Kish Kim
Kim Bong-Gyu
Kim Hong Ji
Joon Hyoung Kim
Kim Kyung-Hoon
Koo Sung-Chan
Jae-Won Lee
Chi Yeol Lee
Lee Ki-Tae
Lee, Yu-Kyung
Park Jong-Keun
Se Won, Park
Min Hyeok Park
Deoksun Park
Jungmin Park
Soo Hyun Park
Jaehyun Seok
Shin InSeop
Son, Moon-Sang
Seo Young Hee

Spain
Tomàs Abella
Alesia Martínez
Delmi Alvarez
Chus Álvarez
Miguel Angel Morenatti
Jose Cruces
Carlos Alba
David Aprea Navarrete
Julio Aracil
Javier Arcenillas
Xoan A. Soler
Bernat Armangue
Pedro Armestre
Toni Arnau
David Artigas
Pablo Balbontin
JC Barberá
Edu Bayer
Daniel Beltrá
Jordi Bernado
Pep Bonet
Anna Bosch Miralpeix
Jordi Busque
Eduardo Buxens
Alfredo Caliz Bricio
Nano Calvo
Sergi Camara
Jordi Cami
Salva Campillo
Vicent Rodríguez
Juan Carlos Cárdenas
Dani Cardona
Andres Carrasco Ragel
Diego Martinez
Cristobal Castro
Arantxa Cedillo
Guillermo Cervera
Oriol Clavera Riera
Jordi Cohen
Matias Costa
Ariadna Creus
Joan Pujol-Creus
Jose Delgado Pascual
Alvaro DePrit
Alberto Di Lolli
E. Dieguez de San
Bernardo
Quico Garcia
Miguel Diez Perez
Sergio Enríquez
Tomeu Coll
Ramon Espinosa
Patricia Esteve
Alvaro Felgueroso Lobo
Marc Femenia
Erasmo Fenoy Nuñez
Claudio de la Cal
Mónica Ferreirós
Miguel A. Fonta G.
Francis Galarza
Ainara Garcia
Xoan Garcia Huguet
Àngel García
Ricardo Garcia
Héctor Garrido
Juli Garzon

Eugeni Gay Marín
Xavier Gil Dalmau
Ander Gillenea
Cesc Giralt
Joaquin Gomez Sastre
Carlos Gónzalez Armesto
Olmo González
Isabel G. Ortiz de Urbina
Pedro Armestre
César Sánchez
Luis Miguel Ruiz Gordón
María J.G.
Maysun
Oscar Guillén
Francisco de las Heras
Antonio Heredia
Nacho Hernandez
Fernando Marcos Ibanez
Diego Ibarra
Adrián Julián francisco
Josep Lago
Aitor Lara
JL Leal
Gorka Lejarcegi
Antonio Lopez Diaz
J. M. Lopez
Adriana Lopez Sanfeliu
Angel Lopez Soto
Núria López Torres
Villar López
Enrique Lopez-Tapia
Jose Lores
Hermes Luppi
Pedro Madueño
César Manso
Eduardo Manzana
Tino Soriano
Aníbal Martel
Joel Martinez
P. H. Martinez De Cripan
Javier Martinez Llona
Sergi Meca
Héctor Mediavilla
Salvy Mendoza
Cristina de Middel
Raúl Moreno
Miguel Miralles
Fernando Moleres
Alfonso Moral Rodriguez
Emilio Morenatti
Carlos Moreno
Emilio Naranjo
Angel Navarrete
Guillermo Navarro
Eduardo Nave
Daniel Ochoa de Olza
Jaume Olivet
Benito Pajares
Oscar Palomares
Paco Paredes
Alberto Paredes
Jesus Pastor
Luis Camacho
Xavier P. Moure
Héctor Pérez
Enrique Pimoulier
Oscar Pinal
Maria Pisaca
Jordi Pizarro
Ferran Sendra
Juan Plasencia
Jordi Play
Edu Ponces
Elisenda Pons
Oscar del Pozo
Dani Pozo
Ferran Quevedo
Marta Ramoneda
David Ramos Vidal
Sergi Reboredo
Markel Redondo Larrea
Eli Regueira
Borja Relaño
Inaki Relanzon
David Rengel
Miguel Riopa
Eva Ripoll
Alejandro Zapico
José Luis Roca
Lurdes R. Basolí
Arturo Rodriguez Castillo
Arturo Rodríguez
Paulino Rodriguez Villar
Daniel Casares Román
Manuel Romarís
Víctor Romero
Abel F. Ros
Abel Ruiz de León
Jesus F. Salvadores
Moises Saman
Ivan Sánchez

153

Chico Sanchez
E. Sarkisov
Leo Simoes
Iván Serrano
Miguel Sierra
Kike Taberner Tarazona
Javier Teniente
Gabriel Tizón
Miguel Toña Olaortua
Felipe Trueba Garcia
Patxi Uriz
Sergio Gonzalez
Pedro Valeros
Guillem Valle
Juanjo Valverde
Bruno Rascão
Oscar Dacosta
Oscar Vázquez
Valentín Vegara
Susana Vera
Marc Vicéns
Manu Fernández
Jordi
Enric Vives-Rubio
Alvaro Ybarra Zavala
Zaheeruddin Abdullah
Iñaki Zaldua
Piko Zulueta

Sri Lanka
Ananda S. Fernando
Asanka Gunarathna
Buddhika Weerasinghe

Surinam
Ertugrul Kilic
Roy Ritfeld

Sweden
Urban Andersson
Anders Andersson
Christian Aslund
Anna Bank
Andreas Bardell
Roland Bengtsson
Robin Benigh
Niklas Björling
Sophie Brandstrom
Albin Brönmark
Henrik Brunnsgard
David Dahlberg
Lars Dareberg
Michael Denker
Martin Edström
Robert Eliasson
Nicklas Elmrin
Åke Ericson
Jonas Eriksson
Anders Forngren
Frederik Funck
Serkan Günes
Niklas Hallen
Mark Hanlon
Paul Hansen
Krister Hansson
Anders Hansson
Fredrik Härenstam
Casper Hedberg
Robert Henriksson
Christoffer Hjalmarsson
Martina Holmberg
Pontus Hook
Ann Johansson
Jörgen Johansson
Mattias Johansson
Moa Karlberg
Jonas Fredwall Karlsson
Mia Karlsvärd
Jesper Klemedsson
Kent Klich
Tomas Königsson
Martin Von Krogh
Peter Krüger
Roger Larsson
Niklas Larsson
Jenny Leyman
Peter Lilja
Jonas Lindkvist
Lars Lindqvist
Beatrice Lundborg
Magnus Lundgren
David Magnusson
Chris Maluszynski
Markus Marcetic
Joel Marklund
Karl Melander
Linus Meyer
Jack Mikrut
Henrik Montgomery
Felipe Morales
Jonathan Näckstrand

Anette Nantell
Thomas Nilsson
Nils Petter Nilsson
Daniel Nilsson
Matso Pamucina
Fredrik Persson
Per-Anders Pettersson
Lennart Rehnman
Christian Rhen
Sebastian Sardi
Helene Schmitz
Torbjörn Selander
Lisa Selin
Marie Sjöberg
Hakan Sjostrom
Sjöström
Sara Strandlund
Aksel Sundström
Lisa Thanner
Pontus Tideman
Ann Tornkvist
Lars Tunbjörk
Joachim Wall
Johanna Wallin
Magnus Wennman
Jon Wentzel
Staffan Widstrand

Switzerland
Zalmaï
Reto Albertalli
Marco D' Anna
Philippe Antonello
Gaëtan Bally
Franco Banfi
Mathias Braschler
Christophe W. Chammartin
Fabrice Coffrini
Régis Colombo
Pavel Cugini
Alessandro Della Bella
Corrado Filipponi
Monika Fischer
Marco Frauchiger
Andreas Frossard
Max Galli
Marco Grob
Yann Gross
Christoph Gysin
Julien Heimann
Steeve Iuncker
Alban Kakulya
Reza Khatir
Patrick B. Kraemer
Miriam Künzli
Pascal Mora
Christophe Moratal
Dominic Nahr
Massimo Pacciorini-Job
Christophe Press
Jacek Piotr Pulawski
Jean Revillard
Romano P. Riedo
Nicolas Righetti
Michel Roggo
Meinrad Schade
Marcel Schmid
Adrian Streun
Olivier Vogelsang
Xavier Voirol
David Wagnières
Stefan Wermuth
Luca Zanetti

Syria
Thanaa Arnaout
Aiham Dib
Carole al Farah
Mohammad Haj kab
Mohammas Said Hasan
Wael Khalifa
Waseem Khrait
Hisham Zaweet

Taiwan
Boheng Chen
Chang Tien Hsiung
Keye Chang
Chen Chih Yuan
Chiang Yung-Nien
Amos Chiang
Chi Chih-Hsiang
Pichi Chuang
Hsieh Chia-Chang
Wei-Sheng Huang
Ching-Feng Huang
Chuang-kun-ju
Kao Cheng Chun
Shiu Min Kao
Simon Kwong

Tzu Cheng Liu
Wu Po-Yuan
Shen Chun-Fan
Huang Shih Chi
Po-Jen,Teng
Yuan-chih yang
Yen Liang-an
Rick Yi
Chen You-Wei
Chih-Wei Yu
Zhao Chun Zhang

Tanzania
Khalfan Said

Thailand
Piti Anchaleesahakorn
Vinai Dithajohn
Songwut In-Em
Pornchai Kittiwongsakul
Sarot Meksophawannagul
Jetjaras Na Ranong
Korbphuk Phromrekha
Kittinun Rodsupan
S. Saengtongsamarnsin
Manit Sriwanichpoom
Rungroj Yongrit

Trinidad and Tobago
Andrea de Silva

Tunisia
Ons Abid

Turkey
Tolga Adanali
Ozcan Agaoglu
Baris Aras
Ercan Arslan
Hasan AY
Kursat Bayhan
Elif Çakirlar
Sinan Cakmak
Necdet Canaran
Onur Coban
Erol Demirkol
Gürsel Eser
Hatice Ezgi Özçelik
Serdal Guzel
Ozan Guzelce
Ozan Kose
Aytac Onay
Cem Ozdel
Riza Ozel
Mustafa Ozer
Kayhan Ozer
Burak Isedih Ozturk
Kerem Saltuk
Tolga Sezgin
Serkan Taycan
Birol Üzmez
Yoong Wah Alex Wong
Yildirim Sugoze
Serkan Yilmaz

Turkmenistan
V. Sarkisian

Uganda
Bruno Birakwate
Maganja Johnson Grace
Nsubuga Michael

Ukraine
Aleksey Bagnyuk
Paval Bagmut
Vera Batozska
Arthur Bondar
Igor Bulgarin
Mike Chernichkin
Armen Dolukhanyan
Sergey Dolzhenko
Yuriy Dyachyshyn
Gleb Garanich
Dima Gavrysh
Kirill Golovchenko
Goncharov Michael
Alexander Grischenko
Gurniak Viktor
Vitaly Hrabar
Andrew Kravchenko
Maks Levin
Andrew Lubimov
Nataliya Masharova
Sergiy Pasyuk
Vasyl Prokopyshyn
Stepan Rudik
Sergey Shtepa
Danielsko
Anatoliy Stepanov
Olexander Techynskyy

Mila Teshaieva
Alexander Toker
Volodymyr Tverdokhlib
Ivan Tykhyi
Roman Vilenskiy

United Arab Emirates
Hussain Al-Numairy

United Kingdom
Fuat Akyuz
Ed Alcock
Jason Alden
Roger Allen
Esme Allen
Brian Anderson
Julian Andrews
Platon
Snowdon
Olivia Arthur
Elcid Asaei
Jocelyn Bain Hogg
Richard Baker
James Ball
Jane Barlow
Guy Bell
Steve Bent
Mark Bickerdike
Martin Birchall
Marcus Bleasdale
Joseph Bolt
Chris Booth
Stuart Boulton
David Brabyn
Mike Bracey
Simon Brown
Henry Browne
Clive Brunskill
Jason Bryant
Mark Bullimore
Sisi Burn
Peter Byrne
Peter Cairns
Gary Calton
Robert Canis
Richard Cannon
Matt Cardy
Mal Case-Green
Angela Catlin
Peter Caton
David Chancellor
Anthony Chappel-Ross
William Cherry
Wattie Cheung
Carlo Chinca
Daniel Chung
CJ Clarke
Bethany J Clarke
Nick Cobbing
Rogan Coles
Katie Collins
Christian Cooksey
Gareth Copley
Brendan Corr
Caroline Cortizo
Damon Coulter
Simon Crofts
Alan Crowhurst
Shawn Curry
Ben Curtis
Simon Dack
Mohamed Dahir
Nick Danziger
Prodeepta Das
Bruce Davidson
Simon Dawson
Adam Dean
Peter Dench
Adrian Dennis
Nigel Dickinson
James dodd
Kieran Dodds
John Dorkings
Paul David Drabble
Luke Duggleby
Andrew Duke
Giles Duley
Mike Egerton
Alex Ekins
Paul Ellis
Stuart Emmerson
Alixandra Fazzina
Sally Fear
John Ferguson
Rob Few
Tristan Fewings
Tim Flach
Lauren Forster
Stuart Forster
Ian Forsyth
Andrew Fosker

Peter J. Fox
Stuart Freedman
Harry Freeland
James Robert Fuller
Christopher Furlong
Robert Gallagher
Sean Gallagher
Andrew Garbutt
Stephen Garnett
Adam Gasson
George Georgiou
Dan Giannopoulos
John Giles
David Gillanders
Peter Glaser
Martin Godwin
Lydia Goldblatt
David Graham
Alistair Grant
Johnny Green
Michael Grieve
Laurence Griffiths
Stuart Griffiths
Rosie Hallam
Daniel Hambury
Gary Hampton
Alex Handley
Sara Hannant
Paul Harding
Rebecca Harley
A.L. Harrington
Brian Harris
Graham Harrison
Lionel Healing
Richard Heathcote
Scott Heavey
Mark Henley
Mike Hewitt
James Hill
Steve Hill
Paul Hilton
Liz Hingley
Stephen Hird
Neil Hodge
Alex Hodgkinson
David Hoffman
Jim Holden
Kate Holt
Rip Hopkins
Rob Howarth
David Howells
Simon Hulme
Richard Humphries
Caroline Irby
Chris Ison
Justin Jin
Wayne Johns
Richard Jones
Liz Kearsley
Stephen J.B. Kelly
Findlay Kember
Jon Kent
Ross Kinnaird
Glyn Kirk
Matt Kirwan
Dan Kitwood
Dave Kneale
Gary Knight
Colin Lane
Jason Larkin
Kalpesh Lathigra
Thomas Lay
Jas Lehal
David Levenson
Geraint Lewis
Rob Leyland
Alex Livesey
Matthew LLoyd
Mikal Ludlow
Michael Lusmore
Peter Macdiarmid
Luke Macgregor
Alex MacNaughton
Robin Maddock
Leo Maguire
David Maitland
Amber Maitland
Paul Marriott
Bob Martin
Guy Martin
Dylan Martinez
Leo Mason
Clive Mason
Jenny Matthews
Stuart Matthews
Kevin Maw
Andrew McLeish
Kieran McManus
Colin Mearns
Jamie James Medina
Toby Melville

Jane Mingay
Jeff Mitchell
David Modell
James Mollison
Jeff Moore
James Morgan
Eddie Mulholland
Neil Munns
Rebecca Naden
Leon Neal
Simon Norfolk
Zed Nelson
Peter Nicholls
Lucy Nicholson
Ian Nicholson
Graeme Nicol
Phil Noble
Pete Oxford
Laura Pannack
Fabio De Paola
Esper
Peter Parks
Nigel Parry
Gavin Parsons
Brijesh
Adam Patterson
John Perkins
Robert Perry
Charles Pertwee
George Philipas
Gareth Phillips
Francesca Phillips
Hugo Philpott
Tom Pietrasik
Tom Pilston
Olivier Pin-Fat
Steve Pyke
Louis Quail
Darren Quinton
Andy Rain
Lucy Ray
Dirk Rees
Simon Renilson
Martin Rickett
Lorna Roach
Simon Roberts
Stuart Robinson
Ian Robinson
Nigel Roddis
Paul Rogers
Will Rose
Stefan Rousseau
Mark David Runnacles
Howard Sayer
Oli Scarff
Michael Schofield
Mark Seager
John Sibley
Jamie Simpson
Guy Smallman
Paul Smith
Toby Smith
David Smithson
Lalage Snow
Carl De Souza
Ben Stansall
Darren Staples
Christopher Steele-Perkins
Jane Stockdale
Tom Stoddart
Chris Stowers
Will Strange
Paul Stuart
Alex Sturrock
Jon Super
Justin Sutcliffe
Mark Sutton
Jeremy Sutton-Hibbert
Justin Tallis
Anastasia Taylor-Lind
Alistair Taylor-Young
Edmond Terakopian
Andrew Testa
Alex Thomas
Edward Thompson
Dave Thompson
Dennis Toff
Kurt Tong
Abbie Trayler-Smith
Francis Tsang
Neil Turner
Richard Wainright
Brad Wakefield
Stuart Walker
Stuart Wallace
John Walmsley
Patrick Ward
James Wardell
Zak Waters
Barrie Watts
William Webster

Finnbarr Webster
David White
Amiran White
Neil White
Paul White
Lewis Whyld
Barney Wilczak
Andrew Winning
Vanessa Winship
Will Wintercross
Jamie Wiseman
Philip Wolmuth
Ollie Woods
Matt Writtle
Dave Wyatt
Alexander Yallop
Dave Young

Uruguay
Leo Barizzoni
Leo Carreño
Martin Cerchiari
Andrés Cuenca Olaondo
Gabriel A. Cusmir Cúneo
Julio Etchart
Giovanni Sacchetto
Quique Kierszenbaum
Christian Rodriguez
Nicolás Scafiezzo Porcelli

USA
Mustafah Abdulaziz
Jeanie Adams-Smith
Lynsey Addario
Noah Addis
Peter van Agtmael
Alaa al-Marjani
Micah Albert
Maya Alleruzzo
Afton Almaraz
Monica Almeida
Mary Altaffer
Stephen L. Alvarez
Elise Amendola
Scott Anderson
DL Anderson
Josh Anderson
Christopher Anderson
Ed Andrieski
Drew Angerer
Sara Anjargolian
Bryan Anselm
Jeff Antebi
Mario Anzuoni
Tony Avelar
Kim Badawi
David Walter Banks
Brendan Bannon
Katie Barnes
Anna Maria Barry-Jester
James Bates
David Bathgate
Nancy Battaglia
Will Baxter
Liz O. Baylen
Paul Beaty
Robert Beck
Robin Beck
Al Bello
Rob Bennett
David Bergman
Ruediger Bergmann
Nina Berman
Chris Bernacchi
Alan Berner
John Biever
Keith Birmingham
Matt Black
Gene Blevins
Victor J. Blue
John Boal
Willy Boeykens
Antonio Bolfo
Michael Bonfigli
Karen T. Borchers
B.A. Bosaiya
Mark Boster
David Bowden
Rick Bowmer
Thomas Boyd
Dominic Bracco II
Alex Brandon
M. Scott Brauer
Isaac Brekken
Kendrick Brinson
Paula Bronstein
Kate Brooks
Nathaniel Brooks
Gerry Broome

Milbert O. Brown Jr.
Frederic J. Brown
Michael Christopher Brown
Mike Brown
Andrea Bruce
Simon Bruty
Chris Buck
John Burgess
David Burnett
Alexandra Buxbaum
Renée C. Byer
Brian Cahn
Mary Calvert
Hong Cao
Lou Capozzola
Chris Carlson
J Carrier
Darren Carroll
Deb Casso
Matthew Cavanaugh
Joe Cavaretta
Gus Chan
Dominic Chavez
Ray Chavez
William Chesser
Jahi Chikwendiu
Alan Chin
Mary Chind
Nelson Ching
LiPo Ching
Paul Chinn
Daniel Cima
Daniel LeClair
Timothy Clary
René Clement
Jay Clendenin
Pat Cocciadiferro
Sarah Conard
Fred R. Conrad
Forbes Conrad
Greg Constantine
Diane Cook
Thomas R. Cordova
Sebastian Cortes
Ron Cortes
Andrew Craft
Bill Crandall
Anne Cusack
Michal Czerwonka
Jim Damaske
Anna Mia Davidson
Mike Davis
Mark J Davis
Steven Day
Sam Dean
Danfung Dennis
Bryan Denton
Bryan Derballa
Julie Dermansky
Chris Detrick
Charles Dharapak
Peter DiCampo
Brady Dillsworth
Matt Dilyard
Travis Dove
Larry Downing
Carolyn Drake
Rebecca Droke
Rian Dundon
Michael Dwyer
Todd Eberle
Michael Eckels
Charles Eckert
Aristide Economopoulos
Ron Edmonds
Debbie Egan-Chin
Rainier Ehrhardt
Matt Eich
Davin Ellicson
Sean D. Elliot
Sarah Elliott
Bruce Ely
Don Emmert
Jeff Enlow
Ronald W. Erdrich
Peter Essick
James Estrin
Dan Evans
Alissa Everett
Rich-Joseph Facun
Steven M. Falk
Christopher Farber
Melissa Farlow
Gina Ferazzi
Jon Ferrey
Stephen Ferry
Chris Fitzgerald
Edmund D. Fountain
Nikki Fox
Walter Fox
Brian L Frank

Tim Freccia
Ruth Fremson
Gary Friedman
Misha Friedman
David Furst
Sean Gallup
Preston Gannaway
Alex Garcia
Chris Gardner
Danielle Gardner
Jason Gardner
Mark Garfinkel
Morry Gash
Robert Gauthier
Sharon Gekoski-Kimmel
Rick Gershon
Dave Getzschman
Danny Ghitis
Ralph Gibson
Mark Gilchrist
Bruce Gilden
David P. Gilkey
Sean Gilligan
Melissa Golden
David Goldman
Jacob De Golish
Chet Gordon
Tom Gralish
Katy Grannan
Kyle Green
Bill Greene
Stanley Greene
Lauren Greenfield
Pat Greenhouse
Mike Greenlar
Lori Grinker
David I. Gross
Tim Gruber
Roberto (Bear) Guerra
CJ Gunther
David Guttenfelder
Robert Hallinen
Andrew Hancock
Christian Hansen
Michael Hanson
Andrew Harrer
Bret Hartman
David Hartung
Darren Hauck
Gregory Heisler
Todd Heisler
Sean Hemmerle
Andrew Henderson
Mark Henle
Jason Henry
John Paul Henry
Gerald Herbert
Lauren Hermele
Tyler Hicks
Erik Hill
Ethan Hill
Ed Hille
Eros Hoagland
Peter Hoffman
Michael Holahan
Darcy Holdorf
Jim Hollander
Derik Holtmann
Mark Holtzman
Chris Hondros
Robert Hooman
Aaron Huey
Jeff Hutchens
Walter Iooss, Jr.
Jenna Isaacson
Boza Ivanovic
Barry Chin
Lucas Jackson
Jed Jacobsohn
Julie Jacobson
Kenneth Jarecke
Len Jenshel
Cliff Jette
Angela Jimenez
Lynn Johnson
Krisanne Johnson
Joseph Johnston
David Joles
Greg S. Kahn
Doug Kanter
Eli Meir Kaplan
Anthony Karen
Ed Kashi
Ivan Kashinsky
Carolyn Kaster
Andrew Kaufman
Theodore Kaye
Reseph Keiderling
Mike Kepka
Laurence Kesterson
Carl Kiilsgaard

John Kimmich-Javier
Nick King
Scott Kingsley
T.J. Kirkpatrick
Lui Kit Wong
Paul Kitagaki Jr
Stephanie Klein-Davis
Heinz Kluetmeier
David E. Klutho
Melody Ko
Jim Korpi
Todd Krainin
Lisa Krantz
Suzanne Kreiter
Elizabeth Kreutz
Daniel Kukla
S. Mahesh Kumar
Amelia Kunhardt
Karna Kurata
Jack Kurtz
Brigitte Lacombe
Rodney Lamkey, Jr.
Inez van Lamsweerde
Nancy Lane
Justin Lane
Jeremy M. Lange
Megan Lange
Jerry Lara
Erika Larsen
Jensen Larson
B. Conrad Lau
Adam Lau
Gillian Laub
Emma LeBlanc
Streeter Lecka
Chang W. Lee
Tommy Leonardi
Mark Leong
Josie Lepe
Will Lester
Heidi Levine
William Wilson Lewis III
Ariana Lindquist
Brennan Linsley
John Locher
Jeremy Lock
Saul Loeb
John Loomis
Delcia Lopez
Dario Lopez Mills
Benjamin Lowy
Pauline Lubens
Amanda Lucidon
Matt Lutton
Patsy Lynch
Tom G. Lynn
John Mabanglo
Michael Macor
Chris Maddaloni
Charlie Mahoney
David Maialetti
Jeff Mankie
Yanina Manolova
John Marshall Mantel
Ross Mantle
James Y.R.Mao
Melina Mara
Steve Marcus
Mary Ellen Mark
Tiana Markova-Gold
Pete Marovich
Ian Martin
Saul Martinez
Pablo Martinez Monsivais
A.J. Mast
Sean Masterson
Edgar Mata
Tim Matsui
Matuschka
David Maung
Tannen Maury
Peter McBride
Phil McCarten
Patrick McCarthy
Matt McClain
John McDonough
Michael Francis McElron
Stephen McGee
Matt McInnis
Scott McIntyre
Kirk McKoy
Mel Melcon
Josh Meltzer
Eric Mencher
Susan Merrell
Rory Merry
Nhat V. Meyer
Sebastian Meyer
Doug Mills
Lianne Milton
Donald Miralle, Jr.

Genaro Molina
Yola Monakhov
M. Scott Moon
John Moore
Jared Moossy
Rebsy Morris
Peter Morrison
Laura Morton
Justin Mott
Hatem Moussa
Ozier Muhammad
Rachel Mummey
Miko Munden
Mark C. Murrmann
Adam Nadel
Matt Nager
Michael Nagle
Leah Nash
Sol Neelman
Scott Nelson
Andy Nelson
Grant Lee Neuenburg
Gregg Newton
Jehad Nga
Michael Nichols
Dewey Nicks
Landon Nordeman
Chris O'Meara
Randy Olson
Charles Ommanney
Bruce Omori
Metin Oner
Francine E. Orr
Carlos Osorio
L.M. Otero
Nick Oza
Darcy Padilla
Ilana Panich-Linsman
David B. Parker
Christopher Pasatieri
Nancy Pastor
Bryan Patrick
S. Smith Patrick
Michael Perez
Nathan Perkel
Phil Peterson
Daryl Peveto
Abigail Pheiffer
David J. Phillip
Spencer Platt
James Pomerantz
John W. Poole
Denis Poroy
Jim Prisching
David Proeber
Joe Raedle
Ramin Rahimian
Anacleto Rapping
Jason Redmond
Jim Reed
Ryan Spencer Reed
Tom Reese
Andrea Star Reese
Steve Remich
Edwin Remsberg
Tim Revell
Damaso Reyes
Eugene Richards
Paul Richards
Charlie Riedel
Joe Riis
Molly Riley
Jessica Rinaldi
Amanda Rivkin
Jeff Roberson
Larry Roberts
Julia L. Robinson
Michael Robinson Chávez
Rick Rocamora
David Rochkind
Scott Rohr
Vivian Ronay
David Root
Bob Rosato
Joel Rosenbaum
Aaron Rosenblatt
Jenny E. Ross
Marissa Roth
Matt Rourke
Dina Rudick
Stefan Ruiz
Benjamin Rusnak
J.B. Russell
Robert Sabo
Horacio Salinas
Amy Sancetta
Jonathan Saruk
April Saul
Michel Sauret
Kevin Schafer
Michael Schennum

Erich Schlegel
Kristen Schmid Schurter
Terry Schmitt
Chris Schneider
Jake Schoellkopf
Erika Schultz
Rob Schumacher
Paul D. Scott
Mike Segar
Steven Senne
Ezra Shaw
Scott Shepard
David F. Sherman
Kelly Shimoda
Jacob Silberberg
Sam Simmonds
Denny Simmons
Stephanie Sinclair
Luis Sinco
Brian Skerry
Laurie Skrivan
Matt Slaby
Brendan Smialowski
Bryan Smith
Juliana Irene Smith
Patrick Smith
Trevor Snapp
Brian Snyder
Jared Soares
Magdalena Solé
Chuck Solomon
Naomi Solomon
Chip Somodevilla
Jon Soohoo
Robert Sorbo
Alan Spearman
Todd Spoth
Tyler Stableford
John Stanmeyer
Shannon Stapleton
Larry Steagall
Dan Steinberg
George Steinmetz
Carol Allen Storey
Scott Strazzante
Rachael Strecher
Damian Strohmeyer
Joanne Rathe
Bob Strong
Anthony Suau
Justin Sullivan
Andrew Sullivan
Akira Suwa
Chitose Suzuki
Joseph Sywenkyj
Mat Szwajkos
Kayana Szymczak
Shannon Taggart
Ramin Talaie
Mario Tama
Teresa Tamura
Carlan Tapp
Patrick Tehan
Mark J. Terrill
Shmuel Thaler
Eric Thayer
Brandon Thibodeaux
Bryan Thomas
Al Tielemans
Lonnie Timmons III
Tara Todras-Whitehill
Amy Toensing
Jonathan Torgovnik
Winslow Townson
Erin Grace Trieb
Jay Trinidad
Annie Tritt
Linda Troeller
Susan Tusa
Gregory Urquiaga
Chris Usher
Nick Ut
Nuri Vallbona
Ron Vesely
Brad Vest
Jon Vidar
Sarah Voisin
Stephen Voss
Fred Vuich
Carey Wagner
Larry Wagner
Craig F. Walker
Vaughn Wallace
Susan Walsh
Paul William Warner
Jenn Warren
David M Warren
Guy Wathen
Jim Watson
Anna M Weaver
Billy Weeks

Steven Weinberg
Sandra Chen Weinstein
Laura Weisman
David H. Wells
Alex Welsh
Ethan Welty
Seth Wenig
Kristyna Wentz-Graff
Jim West
Jay Westcott
Brad Westphal
David W. Westphalen
Rodney White
James Whitlow Delano
Max Whittaker
Janine Wiedel
Stephen Wilkes
Rick T. Wilking
Michael Williamson
Mark Wilson
Lisa Wiltse
Steve Winter
Damon Winter
Dan Winters
Michael S. Wirtz
Patrick Witty
Alex Wong
Michael Woods
Steven Worthy
Peter Yang
Craig A. Young
Mohammed Zaatari
Daniella Zalcman
Mark Zaleski
Ariel Zambelich
Michael Zamora
Sheila Zhao
Chris Zuppa

Uzbekistan
Vladimir Jirnov

Venezuela
Kike Arnal
Gustavo Bandres
Jesus Orlando Baquero S.
Juan Barreto
David Fernandez
Joaquín Ferrer
Carlos Garcia Rawlins
Ivan Gonzalez
Miguel Gutierrez Gutierrez
Juan Carlos Hernandez
Nilo R. Jiménez Barrozzi
Leo Liberman
Gil Montaño
Edsau Olivares
Jacinto Oliveros
Carlos Enrique Ramirez
Luis Cobelo Manuel
Cecilia Rodriguez
Carlos Sanchez
Jimmy Villalta

Vietnam
Hai Thanh
Tran Viet Dung
Ho Anh Tien
Lai Khanh
Doan Ky Thanh
Mai Ky
Luong Phu Huu
Trung Nguyen Ngoc
Huu Nghi
Quynh Nguyen
Tran Viet Van
Hoang Minh Tri
Trinh Vo Trung Nghia
Anh Tuan

Yemen
Amira Al-Sharif

Zambia
Patrick Bentley
Thomas Nsama

Zimbabwe
Bold Hungwe
Davina Jogi
Desmond Zvidzai Kwande
Tsvangirayi Mukwazhi
Aaron Ufumeli

A great story is unique.
www.canon-europe.com/takestories

To capture the essence of a place as unique as the Camargue, you need a unique camera. The EOS 7D uses 18MP and full 1080p HD video to produce images that say more than words can. Create dramatic sequences of galloping wild horses using the 8fps continuous shooting mode. And the 100% viewfinder means no detail, no matter how small, is ever missed. Follow the journey and discover how the 7D can enable you to create your own unique story.

EOS 7D

take more than pictures.
take stories.

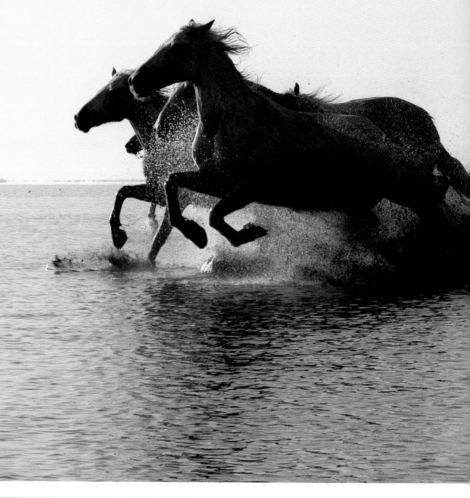

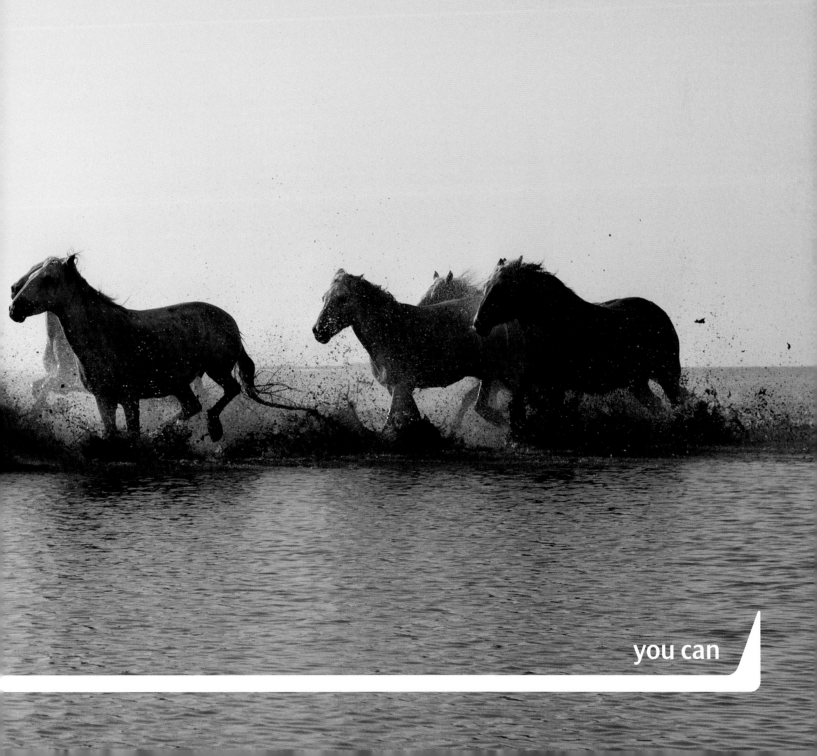

you can

beauty travels with T

For many people tulips are the symbol of Holland.

Many bulbs are transported by TNT, they bring joy to people across the globe.

Copyright © 2010
Stichting World Press Photo, Amsterdam,
the Netherlands
Schilt Publishing, Amsterdam, the Netherlands
All photography copyrights are held by
the photographers.

First published in Great Britain in 2010 by
Thames and Hudson Ltd,
181A High Holborn, London WC1V 7QX
Tel. +44 (0)20 7845 5000
www.thamesandhudson.com

First published in the United States of America
in 2010 by Thames and Hudson Inc.,
500 Fifth Avenue, New York, New York 10110
Tel. +1 212 354 3763
www.thamesandhudsonusa.com

Art director
Teun van der Heijden
Advisors
Daphné Anglès
Bas Vroege
Design
Heijdens Karwei
Production coordinator
Femke van der Valk
Picture coordinators
Rebekka Kruitbosch
Anna Lena Mehr
Nina Steinke
Captions and interview
Rodney Bolt
Editorial coordinators
Carly Diaz
Manja Kamman
Maaike Smulders
Editor
Kari Lundelin

Color management
Wim Schoenmaker
Kleurgamma Photolab, Amsterdam,
the Netherlands, www.kleurgamma.com

Paper
BVS FSC Mixed Credit 150 grams, cover 300 grams
Papierfabrik Scheufelen GmbH, Lenningen,
Germany, www.scheufelen.com
Lithography, printing and binding
Wachter GmbH, Bönnigheim, Germany,
www.wachter.de
Production supervisor
Maarten Schilt
Mariska Vogelenzang de Jong
Schilt Publishing, Amsterdam,
the Netherlands, www.schiltpublishing.com

This book has been published under the auspices
of Stichting World Press Photo, Amsterdam,
the Netherlands.

ISBN 978-0-500-97701-9

Cover photograph
Pietro Masturzo, Italy
*Women shout on a rooftop in protest against the
presidential election results, Tehran, Iran, 24 June*
World Press Photo of the Year 2009

Back cover photograph
Paul Nicklen, Canada, National Geographic
*A light-mantled sooty albatross looks down on Gold
Harbour, South Georgia, Antarctica*

About World Press Photo

World Press Photo is an independent nonprofit organization, founded in the Netherlands in 1955.
Its main aim is to support and promote the work of professional press photographers internationally.

Each year, World Press Photo invites press photographers throughout the world to participate in the
World Press Photo Contest, the premier annual international competition in press photography. All
photographs were judged in February 2010 in Amsterdam by an independent international jury
composed of nineteen professionals recognized in the field of photojournalism. Winning images are
displayed in an annual exhibition that visits 100 locations in some 45 countries, and is seen by around
2.5 million people worldwide.

Educational projects also play an important role in World Press Photo's activities. The annual Joop
Swart Masterclass is aimed at talented photographers at the start of their careers, and seminars and
workshops open to individual photographers, photo agencies and picture editors are organized in
developing countries.

For more information on World Press Photo, about the prizewinning images, the photographers and for
an updated exhibition schedule, please visit: www.worldpressphoto.org

Mixed Sources
Product group from well-managed
forests and other controlled sources
www.fsc.org Cert no. IMO-COC-029537
© 1996 Forest Stewardship Council
FSC